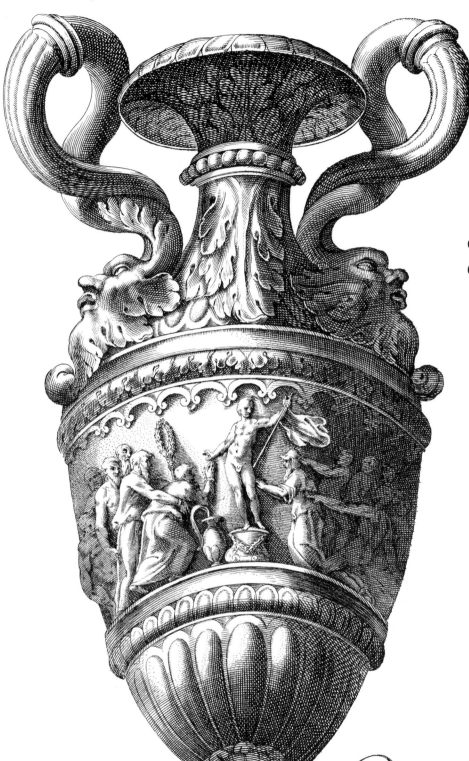

CHOICE *Twenty-One Years of*
Collecting for Scotland

POLYDORVS DE CARAVAGIO. IN.

2 CVM PRIVIL
S.C.M.tis ROMÆ

Timothy Clifford

CHOICE

Twenty-One Years of Collecting
for Scotland

National Galleries of Scotland
Edinburgh · 2005

LEGACIES AND THE NATIONAL
GALLERIES OF SCOTLAND

Did you know that you can give to the National Galleries of Scotland by way of a legacy? After taking care of your family and friends, you could consider leaving an amount in your will to support the galleries. Legacies will develop and protect the collection, and pioneer new ways for future generations to access the works. To request a leaflet and to find out more please contact the legacy officer on 0131 624 6241 or legacies@nationalgalleries.org.

Published by the Trustees of the National Galleries of Scotland on the occasion of the exhibition *Choice: Twenty-One Years of Collecting for Scotland* held at the Royal Scottish Academy Building, Edinburgh, from 2 November 2005 until 23 January 2006

ISBN 1 903278 73 2

Designed by Dalrymple
Typeset in Linotype Didot and MVB Verdigris
Printed by Die Keure, Belgium

Front and back covers: Antonio Canova 1757–1822
Details from *The Three Graces* (121)
National Gallery of Scotland, Edinburgh and
Victoria & Albert Museum, London

Frontispiece: Aegidius Sadler I *c.*1570–*c.*1609
after Polidoro da Caravaggio 1492–1543
Designs for a Vase · Engraving · 24 × 16cm
Purchased by the Patrons of the National Galleries of Scotland with assistance from the National Art Collections Fund 1996 [P 2911.159]

Foreword

This is an exhibition about the paintings and works of art that have been acquired by the National Galleries of Scotland over the last twenty-one years. There is nothing unusual about museums and galleries doing this. Indeed, I remember in the 1970s when I was at the Victoria & Albert Museum that we used to have quarterly shows of our newest treasures in the gallery, off the Brompton Road entrance. These shows, always popular, were accompanied by a handy, illustrated bulletin with detailed and scholarly accounts of the new acquisitions written by the curators. This intrigued the public and ensured that all objects were assiduously accessioned, conserved, researched, catalogued, and well presented for display. It was a correct manifestation of a national museum's role as steward for the public's interests. In Scotland we have never had the luxury of a space dedicated to new acquisitions but we always do publicise the major ones and introduce them in our bulletins, newsletters, and our annual reports. In this exhibition and in the book that accompanies it, we are experimenting with something that is a little unusual. As I am retiring at the end of January 2006, at the age of sixty, having directed the National Galleries of Scotland since 1984, it seems entirely appropriate that I show you the public – and indeed the owners of all these works – what my staff and I have been doing on your behalf.

I regret that my curators and I cannot guide you personally around the exhibition and share with you some of our excitement and enthusiasm for the works on display. I am proud of what we have been able to acquire, but I am also conscious of the many pictures and works of art that have slipped through our grasp. There will be some criticism of us not acquiring enough Scottish art but, this is not the case; anyone consulting our accession registers will find that we have acquired so many Scottish pictures that the whole of the Royal Scottish Academy Building could have been hung with them alone. We have bought images of historic Scottish sitters, commissioned many new portraits of Scottish worthies and bought large quantities of Scottish topographical views, many of extraordinarily high quality.

The show numbering some 500 items, of which only 208 are reproduced here, is an over simplified survey of the high points of our acquisitions in the past twenty-one years. It begins with a group of antique Roman marbles (a prime source of subsequent western European art), leaps forward to an iconic *Virgin and Child* painted by a Tuscan artist of the mid-thirteenth century and then begins again in fifteenth-century Europe progressing with ever increasing variety, richness and density until the present day. There are plenty of gaps – and it is none the worse for that – but it reflects what was on the market and what we could afford.

We have acquired so many of our treasures by gifts and bequests and these remain the essence of our successes. To all donors and past benefactors, who have given both in kind and money, we offer our heartfelt thanks. Their generosity is acknowledged within this book and on the labels of our exhibits.

Our first debt of gratitude must go to HM Government and, after devolution, to the Scottish Executive, and Scotland's successive First Ministers and Ministers of Culture. They have provided us with an annual purchase grant, a grant that has fluctuated and is now rather less than it was twenty-one years ago. We have been fortunate to have, from time to time, recourse to direct Treasury grants. The old Land Fund, with its successor the National Heritage Memorial Fund, has been a great provider of Treasury monies and without this support we could never have acquired our most costly masterpieces. We have benefited from other funds such as the Pilgrim Trust, the Hope Scott Trust, the Jerwood Charity, the Esmée Fairbairn Foundation and Dunard Fund. The late Sir Paul Getty was extraordinarily generous and also the late Baron Hans Heinrich Thyssen-Bornemisza. Sir Tom Farmer, by his generosity, is demonstrating his love of art and his desire to use art as a powerful instrument for education. Above all, we have been superbly supported by the National Art Collections Fund under a distinguished succession of presidents, chairmen, and directors. They have given us over £5 million and this seems to us to demonstrate their particular discrimination as connoisseurs and benefactors.

The Heritage Lottery Fund has put up a dazzling performance supporting so many of our ventures and I am especially grateful to all present and past chairman and directors. I am, however, worried that major sums of money for acquiring masterpieces seem to be much more difficult

to access and that new criteria are being introduced, which do not necessarily chime in with the collecting aspirations and activities of national institutions.

The auction salerooms, Sotheby's and especially Christie's, have most kindly engineered private treaty and in lieu offers to the National Galleries. We are grateful to them. Dealers all over the world have also been unfailingly friendly and helpful, sometimes having to wait an inordinately long period of time to be paid – I thank them most sincerely. Less often we have been approached by lawyers on behalf of private clients offering us works of art as gifts. We are grateful and would like to encourage them to be even more active.

I am aware that my period directing the National Galleries of Scotland should be viewed in the whole context of the history of the organisation since its foundation and that Scotland has been blessed by a succession of gallery directors before me who have acquired, often brilliantly, great works for the galleries. We have all operated with a small staff and dedicated trustees under hard working chairmen. I remember with gratitude and thanks the succession of trustees who have shared our excitements, and sometimes disappointments, in putting together this collection. I am indebted in particular to all my chairmen: Robert Begg CBE (1980–87), Sir Angus Grossart CBE (1988–97), the Countess of Airlie DCVO (1997–2000) and Brian Ivory CBE (2000–to the present). We are particularly grateful to GNER for their continuing generous and enlightened sponsorship, to the Friends of the National Galleries of Scotland for their munificent support, and also to my old friend and founder member of the American Associates of the National Galleries of Scotland, Mel Seiden.

I am thankful to Janis Adams, head of our publishing department, for seeing this book through the press; to Robert Dalrymple who is, in my opinion, one of the best book designers anywhere; to Anne Buddle, head of collections management, for her work on the exhibition; and to my own long-suffering personal assistant, Samantha Lagneau, who has not only puzzled out my handwriting but also typed all the texts.

SIR TIMOTHY CLIFFORD
Director-General, National Galleries of Scotland

GNER

GNER are delighted to sponsor the exhibition *Choice: Twenty-One Years of Collecting for Scotland* and to continue our support of the National Gallery of Scotland. We are sure that this unique collection will be enjoyed by many of our customers and that visitors from across the GNER network will take the opportunity to see these wonderful acquisitions under one roof.

CHRISTOPHER GARNET
Chief Executive, GNER

7

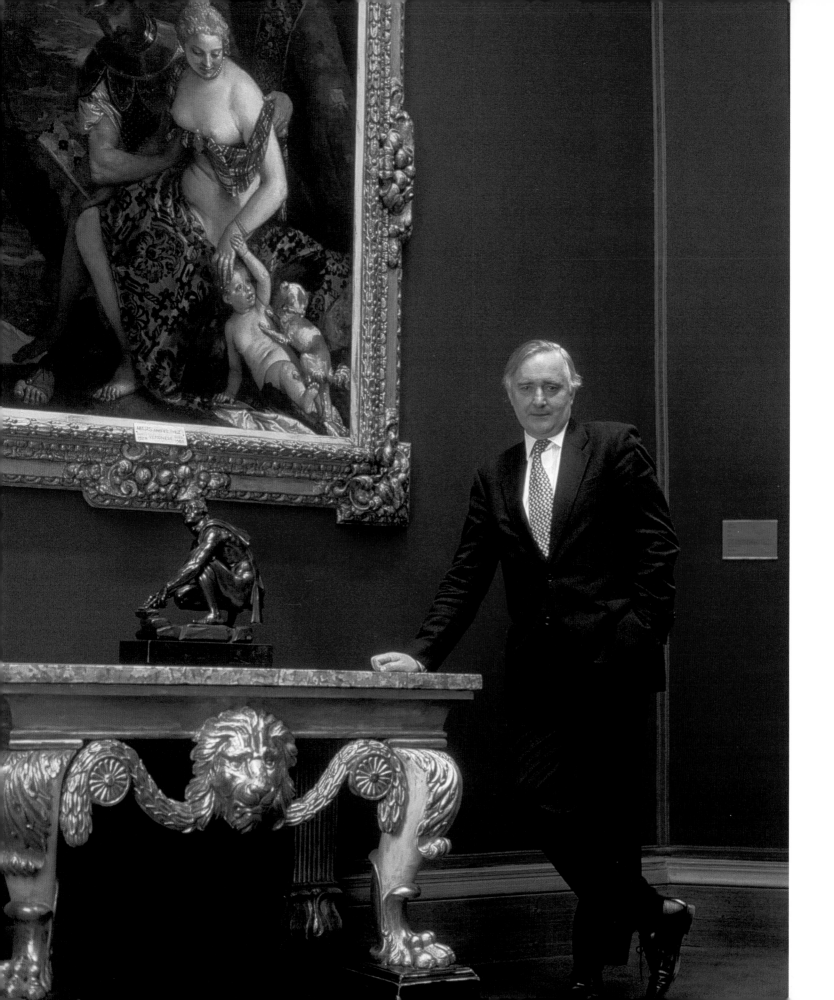

CHOICE Twenty-One Years of Collecting for Scotland

If you were faced with buying paintings, drawings, sculpture, and other works of art for a nation with an annual allocation on average of about £1.25 million how would you go about it? This was the dilemma, albeit a very pleasurable dilemma, that faced me in 1984. Of course it was not as simple as that. The money had to be accounted for and I had to convince my chairman and board of trustees that, what I was attempting to achieve, would prove to be prudent and of lasting worth. I was not to know that the duration was to be twenty-one years, in fact the normal span in Europe and America, from birth to coming of age.

My greatest single challenge was undoubtedly that which had been faced by all my predecessors since 1945, the Ellesmere/Sutherland loan, a loan that constituted probably the finest private collection of old master paintings in Europe, a collection moreover that had been in Britain since 1798 and through its custodianship puts the National Galleries of Scotland in an extraordinary and unique position amongst the galleries of Western Europe. Here is the nucleus of the collection assembled by the Orléans family, the alternative French royal house, from the early years of the eighteenth century. Before being sold in London it hung in the Palais Royale, Paris, next to the Louvre, and contained, and still contains, masterpieces by luminaries like Titian, Raphael, Poussin, and Rembrandt. Since 1945 we have been thrilled to act as hosts to these outright masterpieces. We fervently hope that, by some means or other, they may always hang where they do now as the greatest attraction, not just to the National Gallery in Edinburgh, but as an essential argument why all art lovers should make a special pilgrimage to Scotland. The Sutherland pictures will be discussed later, but we also have groups of great pictures and sculptures on loan to us from other Scottish collections, and hopefully one day they may also find a permanent home in Edinburgh. The relationship between the State and the private collector is a delicate one and one that requires constant attention. We have never, as a point of principle, forced the pace of sales from private collectors to ourselves: Scottish owners, I do believe, recognise our long-standing concerns for the fate of many of their prized possessions. Ill-considered fiscal

changes in Scotland or the UK to the great houses and their estates would endanger overnight these very special relationships, which have been carefully nurtured over generations. My trustees and staff have together concluded, after considerable debate, that it would be unwise to put aside purchase grant allocation annually, in order to cope with future potential sales. Apart from other considerations, the monies, however invested, would be unlikely to keep track with the relentlessly increasing cost of the paintings. In the meantime, all the very necessary other acquisitions for the National Galleries, in particular for the Gallery of Modern Art and the Portrait Gallery, would have to be put on indefinite hold. This would destroy the proper collecting policies of that federation of collections which constitute the National Galleries of Scotland.

Before discussing these galleries and their individual priorities for acquisitions, I should explain the structure and scope of the National Galleries and the structural changes that have taken place because, without understanding these, it would be difficult to understand how and why our collections have developed over this period. It is also probably helpful to understand a bit about my previous experience and how this has moulded *Choice*. *Choice* is an exhibition of my own selection, admittedly partial, idiosyncratic and indulgent, of some of the thousands of pictures, sculptures and works of art that we at the National Galleries have acquired for Scotland.

My family created, owned in a modest way, and were passionate about works of art. My great uncle by marriage, Thomas William Wood FZS, was a talented zoological draughtsman and book illustrator who corresponded with Charles Darwin and was regularly engraved by the brothers Dalziel. Many of Wood's drawings, those that are not in the collection of the late Paul Mellon's family or belong to the Mellon Foundation, descended to my family and, stimulated in me as a child a love and awareness of the natural world and of fine draughtsmanship. I watched birds, collected butterflies, visited zoos, and tried to draw like 'Uncle Thomas'. My grandfather, Alfred Edmund Clifford, who died before I was born, owned pictures by painters like Solimena, Reni, Giordano, Lingelbach and Storck; my father's eldest brother Robin Rowntree Clifford and his

wife Joan both painted as amateurs and exhibited at the Royal Academy, while my father, Derek, was a poet, novelist, and author. During the last war he transferred from his county regiment to the Camouflage Corps and became friendly with other camoufleurs like Gabriel White (chairman of the Arts Council), Freddie Mayor (celebrated dealer in contemporary art), Roland Penrose (friend of Picasso and collector of Dada and Surrealism) and Basil Spence (architect of Coventry Cathedral). My father painted enthusiastically, and also wrote books about garden design, Chinese lacquer, aesthetics, English watercolours and was a collector.

I won art prizes throughout my school career and then went up, like so many of my colleagues at the National Galleries of Scotland, to the Courtauld Institute, University of London, where I read History of Fine Art. At the Courtauld, I studied under such luminaries as Anthony Blunt, Anita Brookner, John Shearman, and Michael Kitson. On leaving the Courtauld in 1968 I was first employed by Manchester City Art Galleries (Paintings Department), then the Victoria & Albert Museum (Ceramics Department), then the British Museum (print room: responsible for the Turner Bequest and the British drawings and watercolours) before directing Manchester City Art Galleries, which was when I was thirty-two. After a little over six years at Manchester I was appointed to direct the National Galleries of Scotland. Never was I fortunate enough to be a 'keeper', one of the most rewarding academic positions in any museum. This has meant that throughout my museum career I suppose I hankered after those special lost years of working as a scholar and pure academic. I have travelled widely in Europe and America; my wife and I own a small house in Italy, and this has meant we particularly relish seeing pictures and sculptures in Italy within their original setting. From such experiences, I have developed my own vision, moulded by particular circumstances, and this has led to my distinctive aesthetic.

Each gallery director, or keeper, carves out their own specialist and idiosyncratic path. This could be unsatisfactory were it to be prolonged indefinitely but benefits the institution over the years, building up layers of quite different specialisms, like a rich palimpsest. How very different from some of those rather artificial institutions known to us all which only collect a highly select and narrow array of images. Such institutions, although most pleasurable in themselves, can never provide the in-depth understanding of societies and cultures that the older and more encyclopaedic galleries offer.

My policy has always been that if it is possible, and it fits in with the general shared vision of the National Galleries, curators should be encouraged to demonstrate their wide and highly specialist skills and scholarship in improving the collections. The curators themselves, it goes without saying, are the vital element of any museum or gallery and the hiring of, and their subsequent training and nurture, is the *sine qua non* of any distinguished art gallery. The theory is that, given a clearly defined budget, most curators would wish to demonstrate to the board of trustees, and their peer group, that they will buy shrewdly, acquiring authentic works in good condition and provide good value for money. It is my belief that a museum or gallery not geared to collecting has a great tendency to become moribund.

What should we at the National Galleries of Scotland be acquiring for Scotland? Should we set up 'focus groups', conduct a series of public meetings to tease out special concerns, institute visitor surveys, and attempt to put together democratically a 'shopping list'? All of us, of course, must remember the public's requirements, but I believe, using the analogy of eating out at a restaurant, that it is the chef that should choose what is available, taking into account his own cooking skills and the choice of fresh and seasonal foods available. Then we, the public, exercise our choice in selecting from that menu. Every item on that menu should have been carefully chosen. Not everything will be to everyone's taste, but a wide choice is provided to stimulate and satisfy most palettes and appetites. Changing the analogy, the conductor of an orchestra is placed in a rather similar position when deciding on an evening's programme of classic music, for he will usually introduce some unfamiliar but piquant material, to stimulate the ear and nourish the soul. The responsibility of a national institution for acquiring works of art is profound, because, over a period of years, the institution helps substantially to mould and extend the aesthetic sensibilities of a whole nation. Works of art do not just provide a stimulus for other painters or sculptors, but can provide ideas, memories and challenges, for all liberal thought. They are in themselves,

as Bernard Berenson would have said, 'life enhancing'. This surely is the essence of culture?

We have had to look again in detail at the existing collections and assess their relative strengths and weaknesses before deciding what we bought. In Scotland, on a small scale, we have a duty to provide an equivalent to the National Gallery, the Tate Galleries, the National Portrait Gallery and certain specific elements of the British Museum and Victoria & Albert Museum, in London. Never will we have the strengths of these metropolitan museums and galleries, but there is no reason why we should not strive to provide an extremely varied and really distinguished choice. I have always felt that Scots, and visitors to Scotland, should not have to travel down to London and the home counties to enjoy really great art, but see it at their ease in Scotland. Nowadays we hear a lot about 'entitlement' and certainly, like the water we drink and the air we breathe, in an ideal society the greatest visual stimulants should be available to us all for free. I am not going to digress to discuss the provision of images on the Internet, or the wider distribution of works of art through 'outreach', but I should add that we must certainly not overlook all the excellent art that is already available in Glasgow, Aberdeen, and some of the other major municipal and university collections in Scotland.

First and foremost, a nation expects to see and enjoy its own art and above all expects to have possession of definitive, comprehensive, and encyclopaedic national collections. This, to a great extent, has already been achieved, although the collections tend to divide on an east / west axis, with Glasgow being strong on West Coast / Glasgow Boys / Charles Rennie Mackintosh, while Edinburgh is particularly rich in Edinburgh and East Coast artists like Ramsay, Raeburn, Wilkie and McTaggart. Both Edinburgh and Glasgow have always attempted to buy the best of Scottish art by their contemporaries. Many Scots collect works by their 'ane folk' and so the National Galleries have historically been generously provided by gifts and bequests of Scottish art from Scottish collections. Clearly it is paramount that we should continue to benefit from this tradition. In the last twenty-one years we have put together an astonishing array of Scottish oils pre-1900, some acquired for the National Gallery on the Mound and others for the Portrait Gallery in Queen Street. Among them are oils by Gavin Hamilton (four), Allan Ramsay (two), David Allan (two), Sir Henry Raeburn (two), Sir David Wilkie (two) and the likes of David Martin, Andrew Wilson, Patrick and Alexander Nasmyth, Andrew Geddes, William Kidd, Thomas Faed, James Paterson, Robert Herdman, E.A. Hornel, 'Fra' Newbery, E.A. Walton, David Gauld, Sir

James Guthrie and Sir John Lavery (two). We can be proud of this formidable array put together in particular by Duncan Thomson and James Holloway at the Portrait Gallery and Lindsay Errington and Helen Smailes at the National Gallery.

What was not so clear twenty-one years ago was what else we should be doing, but before discussing that, I should explain the mechanism for acquiring works of art for our galleries. When I was appointed director, the system for acquiring works of art had severe drawbacks. The director, as sole (and a little later joint) accounting officer with the head of the Education Department of the then Scottish Office received monies directly from a parliamentary (Westminster) vote. The sum specifically for acquisitions, was then immediately divided and distributed between the three Gallery committees of the National Galleries. It had been intentionally skewed with a slightly more generous grant for the Gallery of Modern Art to help that Gallery catch up. The Gallery of Modern Art, which had only been founded in 1959, had just moved from the Royal Botanic Garden to its new site at Belford Road. It sought to become, if not of equal status in range and quality to the National Gallery, of real international quality. Less money had been provided for the Portrait Gallery as it was then (rightly) thought that Scottish portraits were relatively less costly. The operational process followed was for the gallery keeper (predecessor of the gallery director) to put forward a possible acquisition to his gallery's subcommittee under a chairman who was also a trustee. The work would have previously been inspected by the Conservation Department, and, if agreed by the subcommittee, the work would then be brought before the main board of trustees and duly championed by that gallery's subcommittee chairman. The director (for *director*, nowadays read *director-general*), did not attend the subcommittee, but monitored the process in retrospect and retained an ultimate right of veto.

I changed this process because, as accounting officer, the director was virtually unaccountable once the relevant funding had been redistributed to the three galleries. Historically, the director was placed in a position where he had little chance to alter the thrust and vision of the organisation, let alone the detail. It meant that keepers felt it their right to spend 'their allocation' on their departmental collection only, at the risk of the National Galleries losing out on more distinguished acquisitions for other departments. The old scheme was devised as a neat paper exercise and, on paper, it did look reasonably equitable and sound. The system however allowed for a gallery keeper, in collaboration with a gallery committee chairman, to subvert

the director's wishes. I remember vividly two or three potentially excellent purchases being blocked in this way, including a superb Meléndez *Still Life*, which is now at the Kimbell Art Museum, Fort Worth.

Following changes in legislation contained in the National Heritage (Scotland) Act of 1985 the Scottish Office intervened. The gallery subcommittees with their presiding chairmen were disbanded and a new system was introduced. In future there was to be only one board committee and the subcommittees were to be replaced by a simple pyramidal structure, with the new form of gallery committees now chaired by their keepers (later directors) and feeding up to me, and then onto the main board. The three gallery keepers were now each to be allocated a sum of a little over £100,000 to spend and then the difference of just under £1 million – the glory of the new scheme – was available in a 'pot' to be put towards one or two really major acquisitions. We then made the greatest use of tax advantages provided by HM Treasury, the support of the Heritage Lottery Fund and National Heritage Memorial Fund, the National Art Collections Fund, for a short time the Pilgrim Trust, and sometimes also had recourse to public fund-raising.

Prices of major works of art have soared during my time here and we have had to operate, with as much skill as we could muster, to acquire really special works of art. We made use of welcome monies found by our Patrons, an organisation set up by my predecessor just after my appointment, but before my arrival in post. Recently we have also benefited from subventions from our newly formed Friends organisation.

To acquire pictures for Scotland is a very different task than it is for England and this perhaps is not generally understood. The relative strengths of the holdings of the various national museums and galleries in London, and relative poverty of the collections in Edinburgh (and indeed Glasgow), do have their advantages, or at least had their advantages for me, as I shall explain later. I do believe that Scots, and visitors to Scotland, should be provided with every opportunity to understand and above all to enjoy the breadth, depth, and variety of many aspects of artistic endeavour from at least the period of Giotto and, ideally, from antiquity too. Here, for example, I have been able to add by the in lieu tax procedures an important group of ancient Roman marble sculptures from the estate of the late Lord Kinnaird (1, 2), that were displayed for nearly two hundred years at Rossie Priory, Perthshire. Similarly, we acquired in lieu of tax from the estate of the 8th Duke of Buccleuch in 2001 a wonderful pen drawing by Hendrik Goltzius, *A Head of a Man Wearing a Tasselled Hat* (33). The

circumstances of this acquisition were memorable. My wife and I were staying down at Boughton, Northamptonshire, with the duke and duchess for a ball at nearby Burghley House. On the Sunday morning afterwards we were having another look at an album of old master drawings in their collection. Both our hosts searched in vain for a 'hideous' mounted drawing by Goltzius. I was enthusiastic as I much admire the drawings of this eccentric mannerist artist. A few days after we left the drawing was re-discovered in a cupboard; the duke sent me a photograph; it turned out to be a virtuoso Goltzius performance, signed and dated November 2, 1587, and hey presto, it eventually became ours!

Londoners are wonderfully catered for, indeed provided by a positively Rabelaisian feast, but the public collections of the great galleries and museums there are still rather awkwardly departmentalised and distributed. If a member of the public in London wants to understand, say, art of the Roman baroque, he or she has to consult drawings and prints in the British Museum print room, further architectural drawings and ornament prints in the Victoria & Albert Museum, coins, medals and plaquettes at the British Museum, paintings (and still not that many baroque ones) at the National Gallery, sculpture, further medals and plaquettes, silver, jewels, textiles, ceramics, furniture and musical instruments at the Victoria & Albert Museum. The London process can be both confusing and exhausting. It is just as confusing in most European capital cities but in Edinburgh, albeit on a smaller scale, we can now provide much of this feast under one roof.

For example, when we bought Bernini's great bust of *Carlo Antonio dal Pozzo* (39) we were buying a masterpiece of sculpture of the Roman Baroque. It already had some 'relations' within the National Gallery, for the sculpture was commissioned by Cassiano dal Pozzo, learned secretary of Cardinal Francesco Barberini. It was Pozzo who had commissioned our oil by Poussin of the *Mystic Marriage of St Catherine.* It was Pozzo also who had commissioned the first set of the *Seven Sacraments* by Poussin. We already had on loan the second set of Poussins based on the Pozzo series commissioned by Paul Fréat de Chantelou, Bernini's friend and protector in Paris. Our Bernini holdings were almost non-existent – so we bought two drawings by him, a scatter of magnificent medals designed by him, a couple of bronze statuettes after his design, and a medallic portrait of Carlo Antonio dal Pozzo the Younger (Cassiano's heir and subsequent owner of our marble bust). We also acquired a very beautiful drawing after an antique relief made for Cassiano dal Pozzo and, finally, an astonishing realistic beautiful portrait in oils of Bernini by his Genoese friend

and collaborator, G. B. Gaulli called 'Baciccio' – that is worthy of Courbet (43).

Around the nucleus of that one Bernini bust we consolidated a group of his contemporaries and followers, so that his all embracing contribution to the arts could be enjoyed and studied more fully, adding drawings by Albani, Cortona, Ferri, Testa and Volterrano.

The National Galleries have become, at least during the last twenty-one years, not so much a fine picture gallery with a print room attached, as an encyclopaedic gallery, resembling the Fitzwilliam Museum, Cambridge or the Ashmolean Museum, Oxford, but still with the proviso that the mass of decorative art objects, over which we have no control, remain in Edinburgh at the National Museum of Scotland on Chambers Street. Maybe in, say a century's time, these collections at Chambers Street will join with the National Galleries pictures? In this Scotland of a hundred years hence, visitors may be able to enjoy, say, a Delft vase beside a painting by Steen, a Louis XV commode beside a

painting by Boucher, furniture designed by Robert Adam beside paintings by Ramsay, a Morris tapestry next to a Rossetti painting, a Rietveldt chair next to an abstract by Mondrian, and – it goes without saying – furniture and flatware by Charles Rennie Mackintosh beside his paintings and watercolours. There would also be sculptures, collages, prints, ceramics and tapestries all designed by Sir Eduardo Paolozzi. The National Galleries of Scotland might then become a great universal art museum like the Metropolitan Museum of Art, New York or the Louvre, Paris.

To me, the narrow division of art into *fine* and *applied* is an outdated concept, as in a twenty-first-century context they can be so much better studied and enjoyed as one. Too much specialisation is a narrowing experience which can seriously damage our understanding of art. People in the fifteenth and sixteenth centuries would daily have experienced the unity of the arts without even remarking upon it, and certainly would have had no conception of our current academic attitudes. The new Louvre, which not long ago had the perfect opportunity to reorganise, preferred to continue with its former curiously illogical gallery arrangements, divided up into separate fiefdoms, while more recently the Getty Museum has actually broken down its former, more unified, holistic displays into separate departmental galleries. In a small way we at the National Galleries now endeavour to tell the story of art as a unity. We have collected around key objects, constructing small 'habitats' and 'environments' in which works of art have greater meaning from being put near each other.

To create this more all embracing type of art gallery, the curatorial staff at the National Gallery have had their responsibilities extended. When I arrived there was Dr Keith Andrews, keeper of prints and drawings, with his assistant and then there were other assistant keepers responsible for Scottish and English paintings, Italian and Spanish paintings, French paintings etc. Keith, whom we all much loved, retired, but his print room remained an area of special interest for us. Hugh Macandrew, Michael Clarke and I saw ourselves as old print room hands – Hugh had worked with the drawings at the Ashmolean while Michael and I had both worked in the British Museum print room. There was little fear amongst ourselves that Scotland's major print room was to be downgraded. Rather, we wanted to provide it with greater resources: we employed an assistant keeper and junior staff responsible for the day to day running of the department. Now, under the new arrangements, each curator is responsible for his own country's paintings, drawings, prints, and sculpture. It is a logical step – after all, if you are to catalogue a painting

or a sculpture, you have to know if preparatory drawings exist or if the image was engraved. It also makes sense as you are expected to speak the relevant language, to travel extensively in that country, and now to study a wide variety of works of art from that country.

Staff have also been encouraged to consider the original setting of works of art, the height that they were intended to be seen, the original lighting conditions, frames, plinths and supports. Frames were often designed by artists, so they should never be just of special concern for carvers and gilders, but to all who are seriously interested in pictures – whether in the fourteenth century or indeed the twenty-first century. Ill-considered re-framing can not only destroy a crucial link in the history of connoisseurship but seriously reduce a painting's impact. Frames act as a theatrical proscenium arch, divorcing everyday life from magic. Furniture was often made in the same or similar workshops and, I believe, for some periods and schools of art, is an essential adjunct. It provides a strong architectural foundation for the pictures, further indicates the period and environment in which the picture was painted and, practically, provides a protective 'apron' in front of the picture without necessitating the use of ropes to keep the public removed from the picture's surface. During my time, and following the precedent of one of my predecessors, Stanley Cursiter (director 1930–1948), parade furniture has now been widely introduced at the National Gallery of Scotland and the Scottish National Portrait Gallery. We have tried to acquire appropriate furniture, not using money specifically intended for purchasing fine art. Some years ago I managed to do this employing some unspent balances of the old Property Services Agency (PSA) but, sadly, this opportunity only presented itself once. We bought sets of seat furniture, pairs of commodes, clocks and console tables, many of palace quality, all on one day and all in London. From time to time we have tried to add to this nucleus by gifts or subventions from our Patrons. It might be argued that we should first have borrowed such pieces from the National Museums of Scotland, and indeed we did, but our needs were far greater than they could supply. The fine octagonal galleries of the Mound demand symmetry and are greedy for grandeur.

The National Gallery on the Mound went through a cleansing phase of 'modernity' (and is bound to do so again), when the furniture and sculpture were removed, the walls were clothed in fustian cloth and the floors sparkled with narrow, bright yellow floorboards. An attempt at reconstructing and redecorating the ground floor picture galleries was made, encouraged by my friend Ian Gow, the great authority on both our architect W. H. Playfair and our first 'decorator' D. R. Hay (protégé of Sir Walter Scott). This had its consequences for our collecting activities as now, once again, pictures were to be hung from floor to ceiling, and moreover in logical chronological order. Large pictures hung in the principal parade galleries, small pictures in a small 'kunstkammer' and, also upstairs, in what the warding staff aptly call the 'back bedrooms', while the *Seven Sacraments* by Poussin, on long loan from the Dukes of Sutherland, were returned to their ground floor octagon, in a room specially redecorated to provide the appropriate aura of contemplation and gravity. The marble floor was laid to copy *Confirmation*, the banquette, covered in black horsehair to copy the 'bed' on which Christ reclines in *Penance*, and the oil lamp loosely copied from that in *Eucharist*. The approach may be a little theatrical but nothing in comparison to the way they were shown by their original owner Paul Fréat de Chantelou, each one had its individual curtain, and these were drawn back by the owner for the delectation of the viewer. Gian Lorenzo Bernini, we know from Chantelou's diary in 1665, went down on his knees to them in adoration. He said, 'You have shown me the merit of an artist who makes me realise I am nothing.'

The National Gallery is an archetypal nineteenth-century cabinet for displaying great paintings that has a history stretching back via the British Institution Gallery, Dulwich Picture Gallery, the Picture Gallery at Attingham, to the Galleria Doria Pamphilij, Rome, and the Tribuna of the Uffizi, Florence. Once reconstructed this cabinet has only needed adjustments here and there to provide appropriate impact. Hanging picture galleries is not unlike laying out landscape gardens. You need vistas, variations of lighting, changes in texture, dignity, a little humour and considerable attention to detail.

In 1987 Benjamin West's *Alexander III of Scotland Rescued from the Fury of a Stag by the Intrepidity of Colin Fitzgerald* (98) was not just bought as West's masterpiece, or a crucial image in the rehabilitation of Highland culture after the '45 Rising, but bought specifically as a massive theatrical backdrop for an enfilade of galleries. I blocked it going to the National Gallery of Art, Washington partly because I knew we had an ideal position where to hang it. Similarly we bought the large Weenix, *Landscape with a Huntsman and Dead Game* (61) because it made a perfect pendant, as a Dutch picture, in the Dutch room facing van Dyck's *Lomellini Family*, to a large Flemish picture in the Flemish room. A seventeenth or eighteenth-century collector would have understood perfectly this raison d'être.

When we bought the Weenix we knew of its provenance from William Randolph Hearst. It was subsequently at RKO and then Paramount Studios as a glamorous backdrop

for a Bob Hope movie of 1946. What we discovered later was that it was painted for a wealthy Portuguese Jew for his new house at 99 Nieuwe Herengracht, Amsterdam in 1689. The quality was never in doubt. It needed a good frame and a superb mid eighteenth-century English example was found for it by Wiggins at the then high price of £55,000. People soon forget how much something cost, they only remember the impact that the object makes on them.

The National Gallery of Scotland has always been very poor financially compared with the other great Galleries of the world. During the last twenty one years we have had to use all the skill, charm, cunning, even subterfuge we could muster to acquire good works of art. We have regularly visited dealers all over Europe and America, attended sales (sometimes at quite obscure locations), queued long, been first in on private and press views, and frequently have had to make instant decisions, often searching afterwards hurriedly to find the cash. I have had tragic disappointments when I have failed to buy overlooked masterpieces, like the *Fata Morgana* marble by Giambologna, to which I will return later. These things happen but, I believe, we have also been daring, discovering masterpieces like the unfinished Correggio which belonged to the Princes Altieri, Rome and subsequently to the Scottish painter Sir David Wilkie (23). Having 'discovered' this picture at a dealer's less than a mile from Trafalgar Square, there was a concerted attempt by certain people to undermine its probity, although it had recently been published by the former keeper of the National Gallery, Cecil Gould, and its authenticity confirmed in letters by Professor Sydney Freedberg. They were both acknowledged connoisseurs and moreover authors of monographs on Correggio. I could see no reason to believe that the Correggio was not genuine and, despite the fact we had no financial support from other funding bodies, we bought it, and my trustees were quite right to support me. Happily we did not have to pay a Correggio price. The picture is of great distinction. It was owned and much admired by Wilkie, who refers to it often in his letters, and admitted that it much influenced his own work, so, whatever its autograph status turns out to be, it plays a fascinating role in the development of Wilkie's art.

There is something to be said for museums and galleries acquiring objects of distinction which are anonymous because, if the object really is fine, one day one is sure to arrive at the correct attribution. This year we have bought a fine early sixteenth-century work entitled *Portrait of a Man* (11), which comes from the celebrated Payne Knight collection, Downton Castle, Herefordshire. It may well be by Jan Gossaert called 'Mabuse', but, on the other hand, it may not. Unlike dealers, we and our successors will be caring for such treasures hundreds of years hence, and so we have no overwhelming necessity for instant answers. During my period in Scotland I have bought, or agreed to be bought, several objects of fine quality that have been wrongly attributed by their owners or agents, or were bought with no firm attribution, but this seems entirely sensible, as long as the price reflects this.

There is the vexed issue of condition. The fastidious can put too much weight on this and forget we are not buying postage stamps, or freshly issued banknotes, but works of art that have often been in circulation for centuries. Surely what really matters is whether the object is marvellous and moving, and not whether it is a clean and perfect example of something which is genuine, but perhaps indescribably dull? My predecessor, Colin Thompson (director 1977–84), bought in 1975 *The Virgin and Child* that had belonged to Ruskin and is thought by some to be by Andrea del Verrocchio. Over a third of the picture is skilfully repainted and the picture is almost certainly not by Verrocchio. But, I am regularly thankful that he bought it, for, partial wreck though it may be, what remains is utterly glorious and undoubtedly a masterpiece. This year we bought a fine finished drawing by Agostino Masucci for the *The Solemnisation of the Marriage of Prince James Stewart with Maria Clementina Sobieska at Montefiascone* (1719), a very large oil that used to hang in Hamilton Palace and is now in our Portrait Gallery. The drawing had suffered a little from both water staining and silverfish but, after conservation, it has been transformed, once again, into a delightful work of art.

Since my arrival we have always striven to buy preparatory drawings for pictures in our collection. I remember doing this when I was at Manchester where I bought, for example, numerous studies by Lord Leighton over an extended period for his masterpiece *Captive Andromache*, one of the largest oils in Manchester City Art Galleries. It is most instructive for the public within one collection to be able to follow something of the gestation of a picture. For the National Gallery of Scotland we bought at a Christie's auction in New York a red chalk study for Erminia in the large oil of *Erminia Finding the Wounded Tancred* (55), which we had secured in 1996 from Castle Howard. On another occasion we bought Léger's black ink study of a workman with a rope for his great oil of *Les Contructeurs*, already in the Gallery of Modern Art. Sometimes we have acquired an oil study and subsequently the finished picture, like Faed's *Queen Margaret's Defiance of the Scottish Parliament*. It might be noticed that portraits and subjects associated with the House of Stuart and their court are always being acquired by the National Galleries. Notable is Maurice-Quentin de

la Tour's *Prince Charles Edward Stuart* (77) bought at Christie's London in 1994, a masterpiece of the pastellists art in a most handsome contemporary frame. Almost as arresting is the handsome silver and gilt wood *ostensorio* bearing the arms of the prince's brother, Henry Benedict, Cardinal York (76). There is a happy symmetry in this acquisition because many years previously I had acquired for Manchester City Art Galleries a large beaten copper and parcel gilt pascal candlestick, also bearing the arms of Cardinal Henry Benedict. I was assured by the dealer from whom I bought it – in spite of it being ornamented with the Stuart arms and a cardinal's hat surmounted by a royal closed crown – that these were the arms of a celebrated Florentine nobleman!

I consider if a bona fide dealer makes a mistake in an attribution and if I want to acquire the work for my gallery, I do not have to point out his error. The situation is, of course, entirely different when one is buying from a private individual, who needs guidance and will expect to receive impartial advice. We have always tried to foster excellent relations with private owners and especially those in Scotland. After all, the nation's treasures, whether in private or public ownership, are being stewarded for eternity and for all our delight. Members of the curatorial or conservation staff of the National Galleries of Scotland are, I believe, always welcomed in private collections as persona grata, and this is just how it should be. Incidentally, it is curious how few of us museum professionals serve as trustees and executors of the great estates, for we, unlike the auctioneers, are in an excellent position to give reliable and unbiased advice that can sometimes protect collections from being dispersed. I have no wish to strip our historic collections of their pictures and sculptures but, if great objects regrettably have to be sold, I hope owners will always consider offering them by private treaty sale to us. This is a course of action that, with a delicate adjustment of the 'douceur', or even hybrid handling of in lieu arrangements, can be hugely beneficial to both seller and buyer. Often both we and the most responsible auction houses arrive at compromises that satisfy all parties. Were it not for the operating of such procedures, we would rarely be able to acquire really first rate pictures and works of art.

Sometimes paintings have been offered in lieu in situ against tax liabilities, like the fine group of portraits by Francis Cotes at Cawdor, Nairn, or the fine full-length of *John Ker, 3rd Duke of Roxburghe* by Batoni at Floors Castle, Kelso. Batoni's full-lengths of 'milordi' on the Grand Tour are the quintessential trophies of the period, suffused with grace and arrogance. We managed to acquire *Alexander, 4th Duke of Gordon* (86) directly from Goodwood House,

Sussex, a painting of great splendour that had previously hung at Gordon Castle. It is good to add these characteristic works by Batoni to our existing holding of portraits in oil such as *Princess Cecilia Mahony Giustiniani, James Bruce of Kinnaird*, and the handsome group of drawings, that formerly belonged to that great Scottish portrait painter, Allan Ramsay. We have also been fortunate to have on long-term loan Batoni's magnificent *The Sacrifice of Iphigenia*, through the generosity of the Earl of Wemyss and March from Gosford House, Longniddry. This was a picture cleaned by the National Galleries and first published by James Holloway, director of the Scottish National Portrait Gallery.

The National Galleries have many pictures and sculptures on long loan, some of which we hope may find their way into our permanent collection. We were fortunate in this way to acquire in 1989 El Greco's *Allegory (Fábula)* (32), one of the outright masterpieces by this artist in the United Kingdom, which had hung on our walls for many years. I can now admit that, fearful that the National Heritage Memorial Fund would not support its candidacy, two Scottish artists painted pictures derived from it to demonstrate its especial significance within Scotland's collection. I believe the idea was suggested by our very good friend the late Lord Charteris, then chairman of the National Heritage Memorial Fund. We also bought very recently Titian's superb *Venus Anadyomene* (17) from the estate of the Dukes of Sutherland, one of an inestimably important group of pictures on loan since 1945 from the Ellesmere collection to the National Gallery. Four were bought in 1984 by my predecessor, Colin Thompson, from the same loan, namely a Metsu, de Hooch, Lotto and Jacopo Tintoretto. This outstanding collection, the nucleus of which formerly belonged to the Orléans Family and hung in Paris in the Palais Royale, has been in the United Kingdom since 1798, where most of it has been on public access. Much of the cream of the collection has been on loan to Edinburgh since 1945, including masterpieces by Raphael, Titian, Rembrandt, Van Dyck, and Poussin. Directors and trustees alike have always considered this private collection especially sacrosanct. This long-term loan puts Scotland in a class of its own.

It is with pictures like these in the forefront of our minds that we struggle to acquire other pictures of the finest quality. We have certainly been helped by the generosity of former owners acting in close co-operation with the Capital Taxes Office. I am thinking of Lady Juliet Tadgel's superb George Stubbs of *The Marquess of Rockingham's Arabian Stallion Led by a Groom at Creswell Crags* (95) painted for her ancestor, which she expressly wished should be allocated to the National Galleries of Scotland and was accepted in lieu

of Inheritance Tax in 2001. Not only is it our first Stubbs oil but also a triumph of equine art, a shining Arab stallion held by his groom, isolated within the sublime rocky landscape of Creswell Crags, a locus that hints at the terrible pent-up strength of this docile beast. Another wonderful example is the recent acquisition of the *Weeping Woman* (174), an etching of 1937 by Pablo Picasso full of anguish and emotion made at the time he was painting *Guernica*. It was allocated to us in 2005 in lieu following the particular wish of Joanna Drew, a good friend of ours. This icon of tragedy, was given by Picasso to his friend and biographer Roland Penrose and is so inscribed. In turn it was given by

A: de Winter Excudit-

Anthonie de Winter
1652/3–after 1707
after Wolfgang Hieronymous
von Bommel b.1667–fl.1700
*A Confrontation Between
a Cat and Dog*
Engraving · 14.5 × 17.5cm
Purchased by the Patrons of
the National Galleries of
Scotland 1998 [P2992.49]

Roland to Joanna. The name of Penrose is central to recent developments in our collection of twentieth century art and I will return to it again.

We have been fortunate in Scotland with our acquisitions but they have not come easily. There is often intense competition and we are at a disadvantage compared to the London institutions. I remember buying for Manchester in 1978 a splendid full-length fancy picture of *A Peasant Girl Gathering Faggots in a Wood* that had previously been de-accessioned from the Beaverbrook Art Gallery, New Brunswick. I bought this from Agnew's and expended considerable energy acquiring it. We made it the centre of a small exhibition of Gainsborough's works already in Manchester. Imagine my distress when, immediately afterwards, the most beautiful oil of *Two Greyhounds*

Coursing a Fox was allocated to Kenwood, London, in spite of the potent arguments we had had put forward for acquiring it. The metropolitan based trustees as a body had visited the Iveagh Bequest, Kenwood, shortly before the allocation, and thought it would make a handsome addition to that institution, Kenwood. Kenwood House had previously made no attempt to buy works by this quintessentially British master. There seemed then a tacit understanding that the greatest art should only be seen in London, and its cultural satellites of Oxford and Cambridge. London already has many of the greatest and most comprehensive collections in the world. Surely Scotland, and any of the great regional galleries that are prepared to make a *real* effort, should be allocated most of the great treasures that are awarded in lieu of tax to go just a little way to correct this imbalance? With Scottish devolution no adjustment was made to transfer certain key objects of especial Scottish interest to museums north of the border (*pace* the removal of the Stone of Destiny from Westminster Abbey, which I believe was silly; seriously compromising the integrity of King Edward's throne). Temporary loans are one thing, but they do not provide the joy of permanent possession that is necessary for the self-confidence and pride of nationhood.

Early in 1987 I negotiated to be allocated to Scotland Van Gogh's *Sunflowers*, as a hybrid arrangement from Mrs Helen Chester Beatty's collection, a picture that had been for sometime on loan to the National Gallery, Trafalgar Square. The National Gallery already had a finer example, so passed up a very possible in lieu allocation to themselves, while not advising that it should be offered to other British institutions. It could have been offered to Scotland and would have made a splendid addition to our small collection of works by this master. Shortly afterwards a fine oil by Constable, *Stratford Mill: The Young Waltonians* was added to the collection of Trafalgar Square. It belonged to a Glaswegian family who had made their fortune from whisky. There are in Scottish public collections only two oils by Constable and this was the last oil in private hands that I knew of that had strong Scottish associations. Most of Constable's extensive oeuvre is in public collections in London. The late Lord Morris of Castle Morris, chairman of the Museums and Galleries Commission, in association with the then Arts Minister, was responsible for that allocation. In frustration I wrote remonstrating to the then Prime Minister, Mrs Thatcher.

I could so easily produce a roll call of losses of major works of art that could or should be gracing Scotland's national collections. How different we are from the Americans. If an American from say Boston or Philadelphia hails

from that city he usually gives his works of art to his native city and only very rarely to the federal capital, Washington.

From time to time, I have taken risks on Scotland's behalf but risks make for great collections. In 1989 I spotted illustrated in a Christie's South Kensington catalogue of principally garden sculpture and furniture to be sold at Wrotham Park on 13 September, what looked as though it was a marble sculpture of real importance. Lot 232 was simply described as 'an 18th century white marble half length figure of the Venus Marina'. I rang my chairman, who happened to be away, consulted one of my senior trustees and the keeper of the National Gallery, cancelled all my meetings for the following day and immediately caught a plane to London. As the auction sale was in the country, and I would have found some difficulty getting there at such short notice, I telephoned a friend, Daniel Katz, who was (and is) one of the major sculpture dealers. I learnt that he was to be in Paris the following day but he was, however, happy to provide me with a bed for the night and the use of his chauffeur driven car for the following day. I was bursting with excitement for I had recognised in the marble what I believed was a key lost work by Giambologna, the so-called *Fata Morgana* (the Arthurian spirit – Morgan le Fay) sculpted for Bernardo Vecchietti for a grotto in the garden of his villa outside Florence called 'Il Riposo'. Chatting idly with Mr Katz after dinner I asked him if he could keep a secret and not act upon what I was about to divulge to him. I found out he had not even seen the sale catalogue. When I showed him the Christie's catalogue with the rather poor small illustration he also immediately recognised the piece, instantly saying that he was now not going to Paris and drove with me the following morning to the private view. Christie's estimate was £3,000–4,000. We found the marble scratched and filthy, propped up in the long grass beside assorted garden seats and jardinières. There were very few people viewing the sale and, those that were, looked as though they certainly would not recognise it. Mr Katz suggested that we should go back to London and that his chauffeur should bid in the afternoon on my behalf. Although I understood his reasoning, I thought the risk was too great and so we agreed to return together to London, view the Kensington and Chelsea Antiques Fair, but be back in good time for the sale. When we returned to Wrotham Park the marquee was packed. I was amused to see an old friend and the former chairman of my Patrons at Manchester City Art Galleries, John Wilbraham, who was trying to buy for himself a pair of stone lions. I tipped him off to watch the bidding for a certain lot number, as it might well prove entertaining. When my lot came up the bidding started sluggishly. I had

given the chauffeur the instruction to bid up to £500,000 and thought we could just find that money. The sluggish bidding soon soared and it was between Mr Katz's chauffeur and someone I did not recognise who had a very small dog on a lead. At £500,000 the chauffeur stopped and then Mr Katz, who was sitting beside me, agreed to continue the bidding on his own behalf but on the strict understanding that I was given first refusal – with a nominal commission to himself. Somewhere over £800,000 he stopped and the sculpture was bought by the man with the dog.

We tried to find out who had bought the sculpture, but with no immediate success. However, within about three days it transpired that the bidder was in the employ of Mrs Pat Wengraff, the discriminating London sculpture dealer, in association with Artemis (then backed by the Banque Lambert, Brussels). I immediately asked her for first refusal and suggested a quick profit. No price was suggested, but the piece was cleaned and restored. The price of £5 million was asked, which I balked at. The sculpture had a fascinating provenance much of which was later described by Michael Bury of the University of Edinburgh in an article in *Apollo* magazine (February 1990). Sadly when I was abroad on a sabbatical, the sculpture came up before the Reviewing Committee of the Export of Works of Art and it was permitted to be exported, in spite of being the last marble by Giambologna in private hands and having been in Britain since the eighteenth century. By a curious stroke of fate I believe it was for sometime in the collections of the Earls of Fife at Duff House, one of our partner galleries. The *Fata Morgana* now graces the Joey Tanenbaum Collection, Ontario.

All however was not entirely lost because twenty-four lots further on in the same auction sale was offered an ornate 'gout grec' marble pedestal supported on the backs of four turtles. It was described as 'late eighteenth / early nineteenth white marble plinth' estimate £3,000–5,000. I recognised this as a typical example of the work of Joseph Wilton and almost certainly after the design of the architect Sir William Chambers. We bought it for £8,800 and the Patrons paid for it. Subsequently we discovered it had been made by Wilton to Chambers's design for Lord Charlemont (friend of Adam and Piranesi) for Charlemont House, Rutland Square, Dublin. It supported a marble copy of the Medici Venus. I then bought Wilton's original drawing for it from my learned colleague from Courtauld days, Dr Terry Friedman.

When I was on the Museums and Galleries Commission, I was involved with a possible solution for the ultimate fate of Canova's great sculpture of *The Three Graces*.

Commissioned by the 6th Duke of Bedford we had hoped to persuade his descendants to keep this sublime sculpture at Woburn Abbey in lieu but also 'in situ' within the small temple especially designed for it. We failed to achieve this as the family wanted to use the *tempietto* for a commercial function. There were then various attempts to sell the group abroad, in particular to the Getty Museum in Los Angeles. The story is well known and I will not weary readers by repeating it. Suffice it to say that the Canova's export was stopped, we agreed to share its acquisition with the Victoria & Albert Museum, and raised the money in 1995 by a public appeal and vastly generous support from the National Heritage Memorial Fund, the National Art Collections Fund, John Paul Getty II and Baron Hans Heinrich Thyssen-Bornemisza. After sharing periods of five years and five about the sculpture is now in Scotland for a period of seven years before returning to London for a period of seven years, a cycle which is scheduled to continue ad infinitum.

In the last twenty-one years three major Michelangelo drawings have been offered by the auction houses. Although we have tried to compete, we have lost all three of them and the reason for this is largely because the National Heritage Memorial Fund and Heritage Lottery Fund are fearful of supporting the acquisition of really costly works on paper that, by their nature, can not be continuously exposed to light. It is sad that an artist that many people would argue was the greatest that ever lived is not, and now probably never will be, available to the Scottish public within our permanent collections. Yet in the past we were fortunate to acquire an exquisite double sided sheet drawn in silverpoint by Leonardo da Vinci, a *Studies of a Dog's Paws* (10) and two excellent drawings by Raphael, one a *Kneeling Nude Woman* (13) for one of his frescoes in the villa Farnesina, Rome and the other a compositional study for his *Madonna of the Fish*, now in the Museo Nacional del Prado, Madrid (14). Through the good offices of Christie's, we made use of private treaty sales using favourable tax concessions for works of art that were previously tax exempt. The brutal truth is that the monies available to Scotland nowadays rarely allow us to compete with private transatlantic collectors.

I suppose the most distinguished picture that I have ever been involved in acquiring was Botticelli's *Virgin Adoring the Sleeping Christ Child* (9) painted in the early to mid-1480s and for very many years hanging at Gosford House, East Lothian, the property of the Earls of Wemyss and March. In 1999 we had to find the equivalent of $23,000,000 in eighteen days and this, spectacularly we managed to achieve simply because everyone approached was over-whelmed by its haunting beauty and provided wonderful support. I was never told it was on the market, but was tipped off by a journalist friend, Paul Jeromack, in New York. The intention had been that it was bought by the Kimbell Art Museum, Fort Worth. That luckily was never to be. The Scottish Executive came up with special funds as did the Bank of Scotland, the Royal Bank of Scotland, Dunard Fund, Sir Tom Farmer, the Heritage Lottery Fund, the National Art Collections Fund and Mr and Mrs Kenneth Woodcock. The National Art Collections Fund under Sir Nicholas Goodison championed the acquistion and provided the most reassuring and enthusiastic support.

Michael Clarke, director of the National Gallery, has consistently worked closely with me on these acquisitions, usually helped by the appropriate specialist curator within the gallery. He has transformed our holdings particularly of French late eighteenth and early to mid-nineteenth-century paintings, drawings, and sculpture. By concentrating on this field over a period of years we now have a remarkable and comprehensive group of works by artists after the death of Boucher and before the onset of Impressionism, which it is difficult to parallel elsewhere in the United Kingdom. Together we have also bought works by Swedish and Danish artists of the golden age, believing that Edinburgh should be considered one of the Nordic capitals. The cultures of Denmark and Scotland are neatly united with Bertel Thorvaldsen's *Sir Walter Scott* (133), a lost marble spotted unattributed by its former owners on a stall at Portobello Road, London, and sold to us in 1993 with the most generous financial assistance of the National Heritage Memorial Fund and National Art Collections Fund.

Duncan Thomson, keeper and former director of the Portrait Gallery (1982–97), followed by his successor as director, James Holloway, have both made some outstanding additions to the collection. The Gallery bought privately from the present Duke of Hamilton a full-length portrait by Daniel Mytens of his ancestor the *James Hamilton, 1st Duke of Hamilton* (48), clad in a suit of silver thread foiled by a blue silk velvet curtain, the epitome of carolean aristocratic refinement. The duke was tried for treason by Parliament and subsequently executed at Whitehall on the very same scaffold as King Charles I, less than six weeks later. Mytens was supplanted as court painter to the king by Anthony van Dyck and Van Dyck's fine oil of the *Princess Elizabeth and Princess Anne* (47), the king's daughters, which had previously been on loan to our National Gallery, was purchased from the British Rail Pension Fund by the Portrait Gallery with generous assistance from the Heritage Lottery Fund, the National Art Collections Fund and a

special subvention from the Scottish Office. The variety of acquisitions has been astonishing with commissioned portraits of the likes of *Jo Grimond*, by Patrick Heron, *Alec Douglas-Home* by Avigdor Arikha, *Mick McGahey* by Maggi Hambling, *Danny McGrain* by Humphrey Ocean, *Gavin Hastings* by David Mach and *Robbie Coltrane* by John Byrne (194). I have not been directly involved in any of these commissions but many have been inspired. Acquisitions, however, like the great Allan Ramsay of *Sir Hew Dalrymple, Lord Drummore* (83) and Sir Henry Raeburn's *James Hutton* (94), the founder of modern geology, bought three years earlier, are not only triumphs of the portraitists' art but works of art worthy of the greatest international collections.

The art market is much governed by fashion, so the trick is to go against fashion if you dare. For instance, the portraits of Gainsborough, Reynolds, Ramsay and Hoppner that commanded huge prices in the United States during the 1920s when promoted by Joseph Duveen and his rival dealers will never be so costly again. We have admirable paintings by them already so had little need for more. We have, however, added portraits of two important sitters by Sir Joshua Reynolds, *John Murray, 4th Earl of Dunmore* (87) and *Professor Adam Ferguson* (both acquired 1992), as well as a beautiful chalk study of a girl by Gainsborough from the estate of Sir Steven Runciman (71). I noticed when a student that European renaissance and baroque medallions and plaquettes were unfashionable in spite of being designed by great artists and modelled by distinguished sculptors. So, when I arrived in Scotland I started to buy judiciously such material, often for modest sums and usually supported by money from our Patrons. We could still buy medals by Pisanello, Riccio, Antico, Moderno and Cellini or ones designed by Dürer and Bernini for sums of little more than £1,000. How else are the National Galleries going to be able to buy distinguished works by such great artists?

Now the National Gallery of Scotland, largely thanks to the support of the Patrons, possess one of the finest collections of medals in the United Kingdom, outside London, Oxford, and Cambridge. It must not be forgotten that the National Museums also have a handsome collection, and this is particularly comprehensive for Scottish medals. I hope, after my retirement, the collection will continue to grow, for it would be rewarding to feel that visitors will increasingly learn to enjoy these miniature masterpieces that combine images of great sitters with complex allegory, arcane iconography, heraldry and architecture.

We are told that the best things come in small parcels and this can certainly be true with works of art. We have continued to collect indefatigably glass paste medallions of Scottish sitters by James Tassie, of Pollokshaws (103–5), and have even added further sulphur casts of classical gems and cameos to add to our superb existing holdings. I have also encouraged the collecting of miniatures and this has been carried out admirably by Dr Stephen Lloyd of the Portrait Gallery, himself an authority on the celebrated miniaturist Richard Cosway.

The Gallery of Modern Art, when I first arrived, had just moved to its new location at Belford Road and I well remember the opening ceremony performed by the then secretary of state, the Rt Hon. George Younger MP, on 14 August 1984. I had already been appointed to the directorship but was not in post. Douglas Hall was then keeper and he retired in 1986 at the age of sixty after twenty-five years guiding and, indeed to a great extent creating, this remarkable new gallery. In those days acquisitions were the result of debates in the gallery subcommittee chaired by Professor Hamish Miles, with a team consisting of amongst others, Jack Notman (who gave much guidance to the look of the new gallery), the artist Jack Knox, and the collector Gabrielle Keiller. Another distinguished artist Earl Haig, who had served on this board, had just retired. I remember us agreeing to buy in 1984 Léger's *'Les Constructeurs': l'équipe au repos* (179) and a fine ink study for it the following year, and the splendid Robert Delaunay, *L'Equipe de Cardiff* (160), about which we were slightly worried because it was grubby; the conservation department dared not clean it because of the artist's use of fugitive materials. The Lyonel Feininger, a tall townscape in gun metal colours of a church with a spire (151), was another memorable addition from Douglas Hall's time. In 1987 we appointed Richard Calvocoressi, then a bright young Turk from the Tate Gallery, who had previously worked at the Gallery of Modern Art. Amongst many other fields he was an expert on Oskar Kokoschka, and bought for us a brilliant crayon drawing of *Alma Mahler* (152), which I consider numbers amongst the finest of all our drawings in the National Galleries. Particularly I admired his acquisition of the great Ernst Barlach oak carving *Das Schlimme Jahr 1937* (169), a moving totem of suffering whose title referred to Hitler's notorious exhibition of so-called 'Degenerate Art'. In 1990 the gallery bought a remarkable watercolour *Mont Alba* (161) by Charles Rennie Mackintosh which, shamefully, was only the second work we have acquired by this outright Scottish genius. A unique revolving white bookcase, which was acquired the previous year, had been designed for Catherine Cranston's house in Glasgow (146). It wounds me to consider how often this artist was ignored by my predecessors as if the strong holding of his work in

Glasgow sufficed. We also bought a scintillating Vuillard of *Two Seamstresses in the Workroom*, not much larger than a picture postcard. It had once belonged to one of my distinguished predecessors, Stanley Cursiter (director 1930–48).

In 1988 we held at the Royal Scottish Academy an exhibition largely of Dada and Surrealist art from a private collection entitled *The Magic Mirror*. It all belonged to Gabrielle Keiller, a much loved former member of the Gallery of Modern Art's advisory comittee; a few of these works of art had formerly been in the collection of her friend Sir Roland Penrose. Richard Calvocoressi worked all his charm on Gabrielle – whose late husband Alexander Keiller's family had originated in Dundee – and in 1989 she kindly gave us Marcel Duchamp's *Boîte-en-Valise*, a small leather suitcase of sixty-nine miniature reproductions of Duchamp's works made between 1935–1941 (171). This was followed by the purchase, by private treaty, of three masterpieces: Picabia's *Fille née sans mère* (156), Giacometti's small suggestive wooden sculpture *Objet désagréable à jeter* (168) and René Magritte's shaped canvas depicting a nude female torso *La Représentation* (173). Eventually Mrs Keiller would

bequeath us her entire collection. Richard went on to buy in 1988 Lucian Freud's *Two Men* (193), a picture completed too late to be included in our own exhibition devoted to Freud that year.

We bought six works by Sir Eduardo Paolozzi from Mrs Keiller, including two large bronzes of the 1950s. These presaged in several years to come the magnificent Paolozzi Gift of more than 3,000 objects. The latter gift was largely due to an agreement where Sir Angus Grossart, my chairman (1987–97) and I persuaded Eduardo to make this most generous donation, which included the contents of his studio and his archive.

The Henry Moore Foundation in 1990 helped us buy Antony Gormley's *Present Time*, a cruciform double figure in lead more than three metres high. Gormley had been working on a series of works cast from his own body, when, in 1987, he was a scholar at the British School at Rome where I was working on Bernini. Richard continues to strengthen our modern sculpture collection and has shown considerable and sustained interest in contemporary German art, buying in 1989 with the help of the National Art Collections Fund the roughly hewn and painted wooden *Figure with Raised Arm* (190) by Georg Baselitz. This constituted quite a contrast, if not a shock, to the classic Renaissance sculptures that we were then acquiring for the National Gallery. Richard took Baselitz to tea with us in East Lothian and I then discovered Baselitz had built up a major collection of prints by Northern Mannerists, which I subsequently saw exhibited at Berlin.

We were fortunate to receive at this time so many wonderful gifts from Mrs Margaret Neillands, Mrs Hope Scott, and collections bequeathed by Miss Elizabeth Watt and Mr H.J. Paterson. Were it not for such manifest generosity our collections of modern art could not possibly have developed so exponentially over such a short period. Richard was also careful to acquire the best of Scottish art and, accordingly, between 1989 and 1990 amassed sixteen works from John Bellany, by a combination of gifts and purchases. At Bellany's best, in oils like *Kinlochbervie* (which we had acquired a bit earlier in 1986), he produced what I consider to be some of the most psychologically penetrating and tragic Scottish paintings of the twentieth century.

Later we bought Alexander Stoddart's witty *Heroic Bust: Henry Moore* and hope we will have one day a comprehensive selection of the best works of this virtuoso. In 1993 we acquired, partly by gift and partly through the generosity of Charles Booth-Clibborn, twenty-four prints by Alan Davie, a really distinguished Scottish artist who for many years has worked outside Scotland. Undoubtedly the two greatest acquisitions we made during 1991 were Henry Moore's

21

The Helmet (180), a lead excavated head resembling the interior of a spiral shell, and Joan Miró's striking *Maternité* (162), a haunting response to microscopy and the agents of human fertility. By degrees Richard was buying up works from Penrose and Keiller and inexorably strengthening Scotland's holding of Dada and Surrealism. Indeed in 1994 we went on to buy the archive and library of Sir Roland Penrose that contained some 1,200 files and 10,000 books and periodicals. Then in 1995 this was capped by the superb bequest of Gabrielle Keiller's library including surrealist bookbindings and a deluxe edition of Duchamp's *Green Box*. It was the creation of the Heritage Lottery Fund in 1994 that allowed us, in 1995, to purchase, also with the help of the National Art Collections Fund, twenty-six works from the Penrose estate including major works by Tanguy, Magritte, Dalí, Delvaux, Masson, Man Ray and Max Ernst and the very important Picasso collage *Tête* of 1913 (153). When Gabrielle Keiller died in 1995 she bequeathed us the rest of her superb collection of Dada and Surrealist works.

The year 1995 also saw the successful negotiation of both the Eduardo Paolozzi Gift and the acquisition, from Lothian Regional Council, of the former Dean Orphanage (on Belford Road, Edinburgh) masterminded by our then chairman, Sir Angus Grossart. The Paolozzi Gift, criticised by some at the time, will, I believe, in the years to come be recognised as one of the signal achievements of the National Galleries; most will acknowledge Paolozzi, at his best, to have been the most original and pioneering artist born in Scotland in the twentieth century. The artist's old friend, the Earl of Snowdon, opened the new Gallery in the presence of our new chairman ('Ginnie') the Countess of Airlie in March 1999.

Some asked, after I had redecorated and redisplayed first Manchester City Art Gallery and then the National Gallery of Scotland on the Mound, how I might respond to a gallery of twentieth-century art. My response, working with Richard, the architect Sir Terry Farrell, his wife Sue, and Eduardo Paolozzi is encapsulated in the Dean Gallery and Paolozzi Gift. Here again you experience 'crowded' displays, the intentionally dramatic use of natural light, varied floor textures, and coloured walls. Features all used before at Manchester and at the Mound but in an old master context. Paolozzi's studio in Dovehouse Street was recreated while his colossal and dramatic gleaming *Vulcan* (199) was intentionally confined within his own customised neo-classical chamber complete with trabeated and coffered Paolozzi ceiling. Art objects were displayed juxtaposed with ethnographica and animal skulls. The vision may have been idiosyncratic but it was one in which many

of us – including the artist – shared. Much of the great collections of Dada and Surrealism which had been acquired by Richard were melded together with those gifted by Paolozzi, an artist who owed so much to the Dada and Surrealist works of art that had belonged to Penrose and Keiller.

The two galleries, now straddling Belford Road, continue to astonish with their urgency and appetite for fine things. For instance we acquired a mass of material by Joseph Beuys through the Heritage Lottery Fund and the National Art Collections Fund in 2002 (185,186), a superb construction by Naum Gabo, sculptures by Tony Cragg (192), Dan Graham and Rachel Whiteread. Even Tracey Emin and Damien Hirst (197) have not been overlooked. Over these last twenty-one formative years of contemporary artistic endeavour, the Gallery of Modern Art has grown in a quite remarkable way, and will continue to grow.

Photography is *the* art form of the present era and I have tried to respond to that challenge. When I arrived, apart from the great Hill and Adamson collection and the massive holdings in the Portrait Gallery of portrait photographs and cartes de visite, our collections were ill balanced and quite poor. After the acquisition of the huge Riddell collection, and various other generous gifts, we changed from the nomenclature of 'Scottish Photographic Archive' to Scottish National Photography Collection. I appointed Dr Sara Stevenson to be full-time curator, identified a specific purchase grant allocation, engaged an assistant and, I hope, over the years have made my contribution to encouraging the development of catalogues, exhibitions, conferences, research and debate around this wonderfully exciting subject. I have never believed that these collections sat naturally within the Portrait Gallery's purview and hope that either the proposed Scottish National Photography Centre on the Old High School on Calton Hill becomes a reality, and we transfer our collections there, or the collections in the future will separate along gallery lines with a collection of portrait photography remaining at Queen Street, a collection of pre-1900 photographs being placed at the Mound and post-1900 at Belford Road. This would be the logical extension of our collecting policy and would much enrich the constituent parts of our National Galleries complex. The Scottish public perhaps have little idea how rich the National Galleries' collection has become – in 1984 my first year in Scotland we acquired about forty-eight photographs, but in the following three years around 12,550. The National Galleries of Scotland have made a real contribution to making the Scottish public more aware of this challenging and burgeoning art form.

Art galleries are not judged by their buildings but the

collections within them. The growth of a state's collections constitutes something of a clear indicator of that country's cultural aspirations. I have been fortunate to take on a fine collection put together by generations of distinguished directors and their staff. Over the last twenty-one years major resources of time and effort have been expended on transforming Scotland into one of the great small art gallery collections of the world. So many people have been remarkably generous to us, few could be mentioned in this rapid and very partial survey. I am informed that the National Galleries of Scotland over the period under discussion have been given more money by the National Art Collections Fund than any other body within the United Kingdom. We are so grateful to them and hope they consider their monies well spent. To all those artists who have created these remarkable works; to all those generous benefactors, donors, funds, Friends and Patrons of the National Galleries of Scotland and above all my patient, loyal and forbearing trustees and staff I dedicate this memorial of a task in progress. I adore these collections which have given me such infinite pleasure. They belong to all of you, our public, and I do hope they give you and will continue to give you much delight, instruction and entertainment.

SIR TIMOTHY CLIFFORD

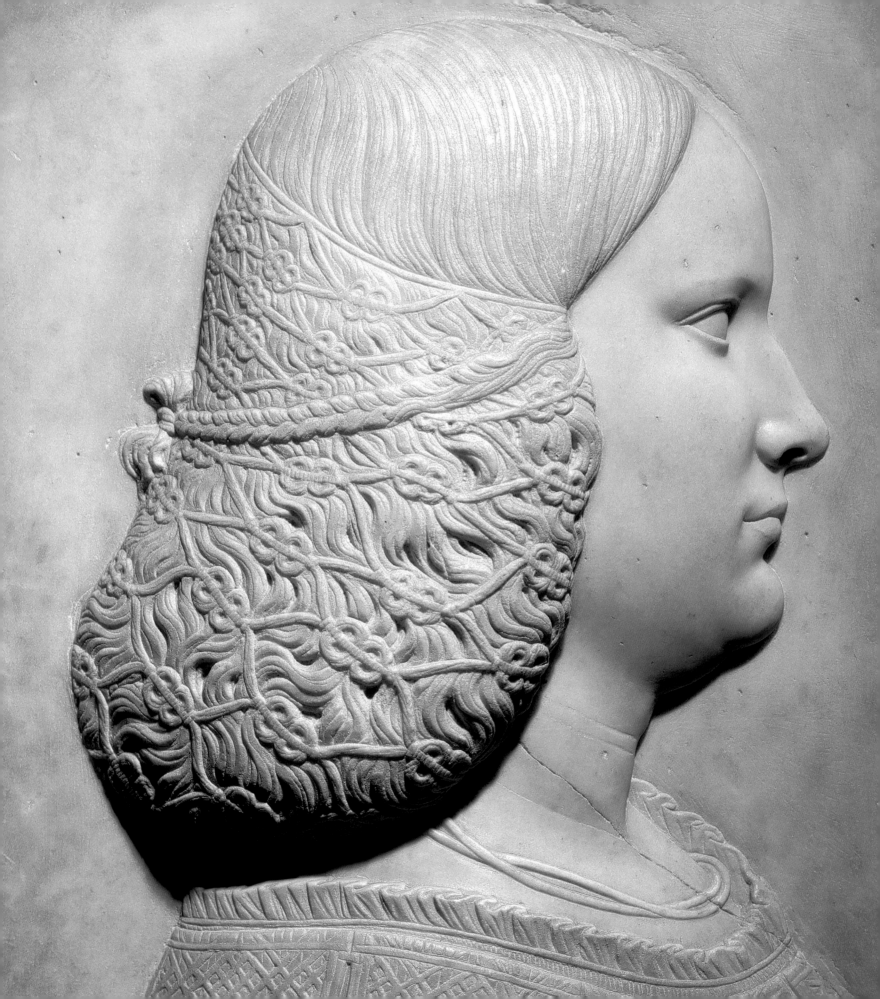

BEFORE
1500

26 **1** Roman, first century AD (Hadrianic 117–138 AD)
Head of a Bearded Man (?Barbarian)

Marble · 49.5cm high
Accepted in lieu of Inheritance Tax from the estate of the 9th Baron
Kinnaird, Rossie Priory, Perthshire 2002 [NG 2725]

2 Roman, first century AD (in the archaic Greek style)
*Altar with Reliefs of Hercules Stealing the Tripod from Apollo
and the sides with Mercury Sacrificing to Priapus and a
Standing Hoplyte, Naked Resting on his Spear*

Marble · 73.7cm × 73.7cm × 48.3cm
Accepted in lieu of Inheritance Tax from the estate of the 9th Baron
Kinnaird, Rossie Priory, Perthshire 2002 [NG 2726]

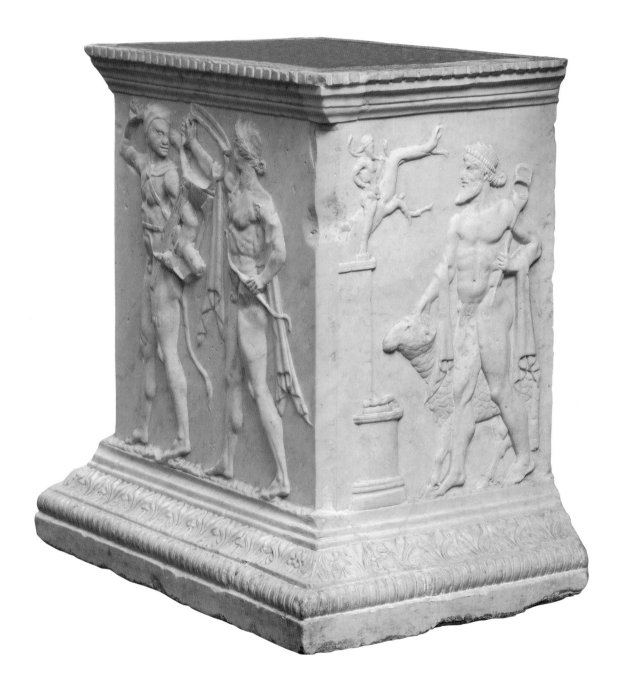

28

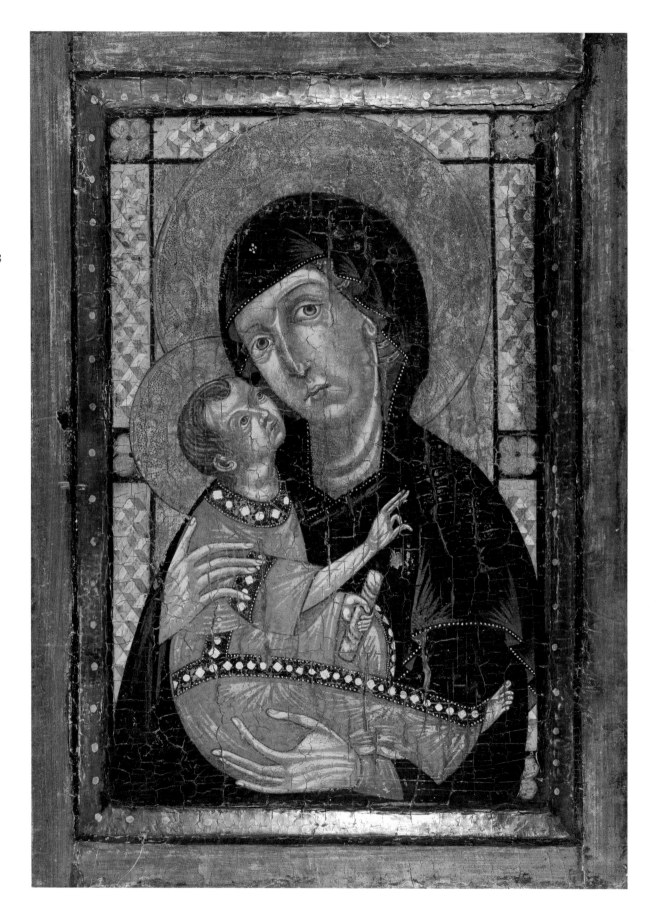

3 Italian (?Tuscan), mid-thirteenth century
Virgin and Child

Oil on panel · 62.5 × 45.5cm
Gift of A. Kardo Sessoeff 2005

4 Follower of Lorenzo Ghiberti,
late fifteenth century
Virgin and Child

Polychromed and gilded stucco on a timber pedestal
74 × 52cm
Gift of A. Kardo Sessoeff 2005

5 Bertoldo di Giovanni *c.*1420–1491
Obverse: *Sultan Mohammed II* 1430–1481
Reverse: *Victory Triumphant over Greece, Trebizond
and Asia*, 1451

Bronze · 9.4cm diameter
Purchased with assistance from the National Art
Collections Fund, with a contribution from the Patrons
of the National Galleries of Scotland 1990 [NG 2519]

6 Attributed to Nicolò di Giovanni Cocari
called Nicolò Fiorentino, active 1443 – after 1477
Relief of Virgin and Child

Terracotta · 74 × 36cm
Purchased with assistance from the Patrons of the
National Galleries of Scotland 1997 [NG 2665]

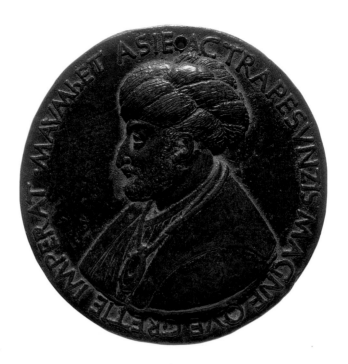

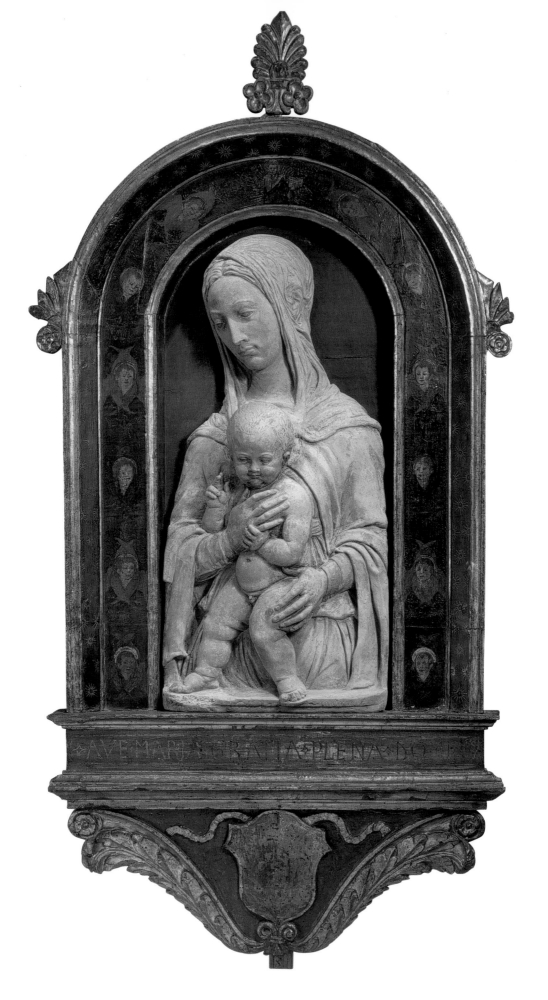

7 Attributed to
Giancristoforo Romano *c*.1465–1512
Portrait of a Noblewoman, *c*.1500–5

Marble · 42 × 36cm
Purchased with assistance from the Patrons of the
National Galleries of Scotland 1990 [NG 2522]

8 Francesco Marti active 1479–after 1535
The Madonna del Soccorso, *c*.1471–84

Bronze · 18.4 × 10.2cm
Purchased 1991 [NG 2550]

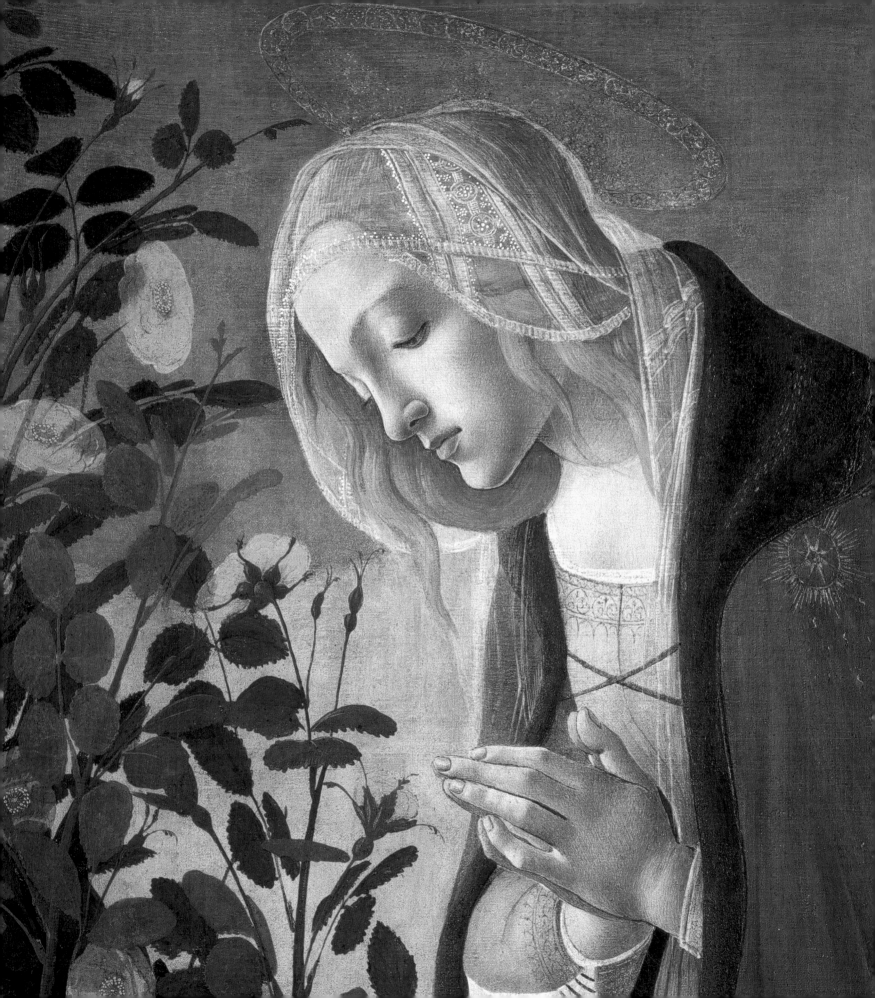

9 Sandro Botticelli
(Alessandro Filipepi) 1444/5–1510
*The Virgin Adoring the Sleeping
Christ Child*, c.1485

Tempera and gold on canvas · 122 × 80.3cm
Purchased with assistance from the Heritage
Lottery Fund, the National Art Collections
Fund, the Scottish Executive and corporate
and private donations 1999 [NG 2709]

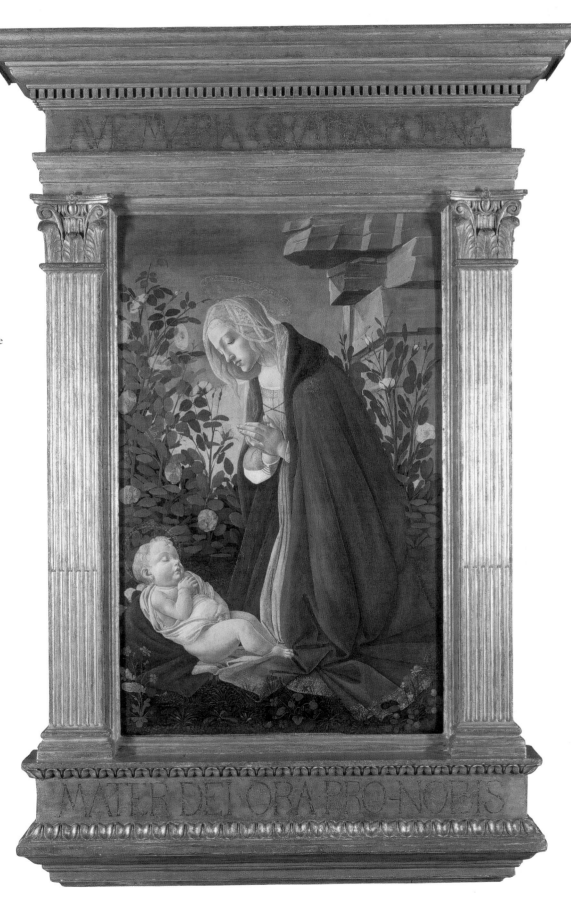

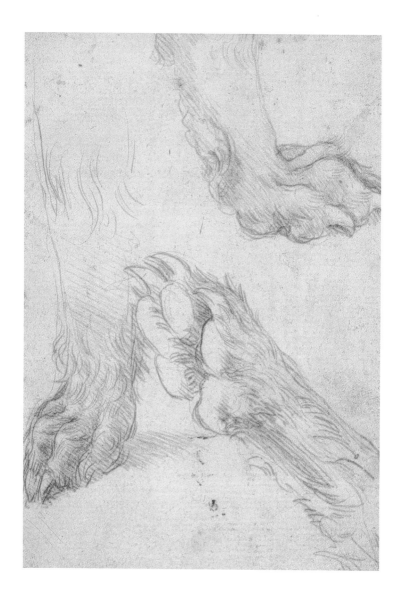

10 Leonardo da Vinci 1452–1519
Studies of a Dog's Paw, c.1480 [recto and verso]

Metalpoint on paper coated with a pale pink preparation
14.1 × 10.7cm
Purchased by Private Treaty with assistance from the
National Art Collections Fund 1991 [D 5189]

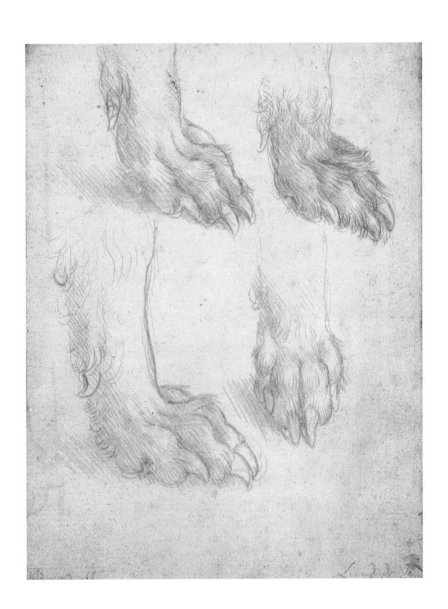

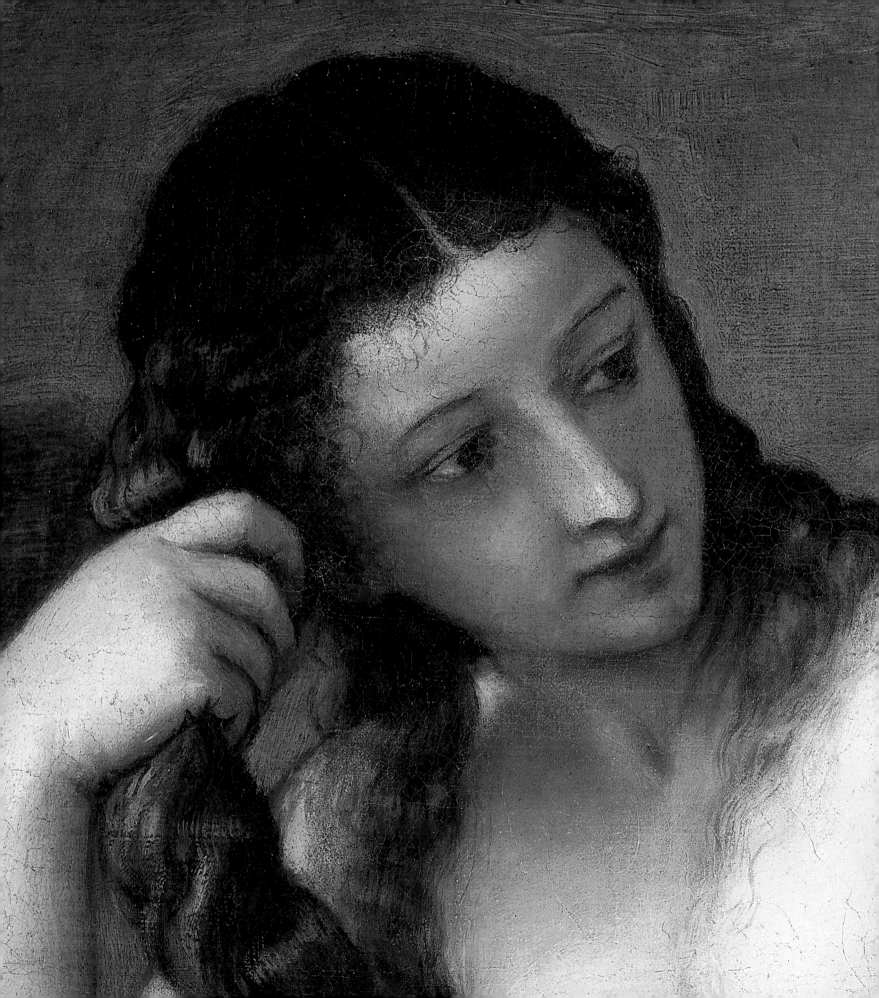

1500

1600

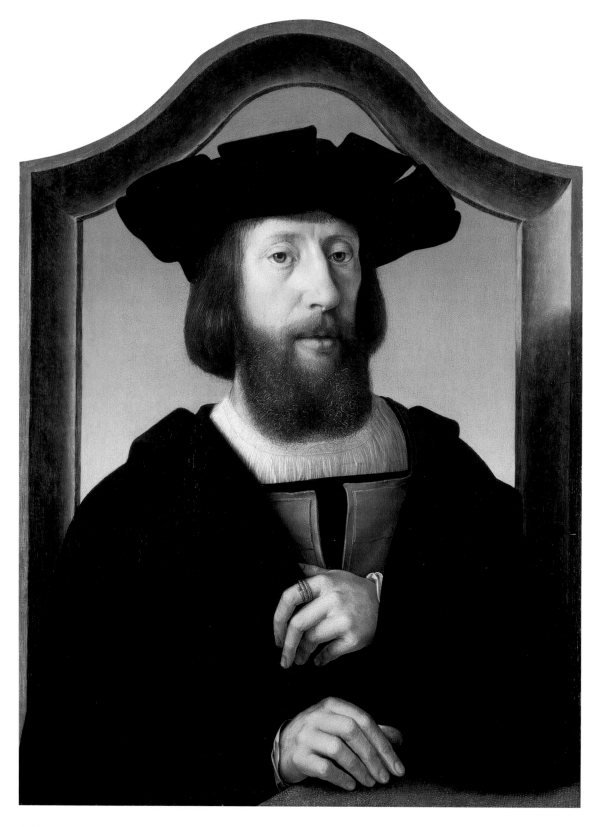

11 Netherlandish School (?Jan Gossaert called 'Mabuse') *Portrait of a Man*, *c*.1520–5

Oil on panel · 60.7 × 45.5cm
Purchased by Private Treaty with assistance from the National Art Collections Fund 2005 [NG 2779]

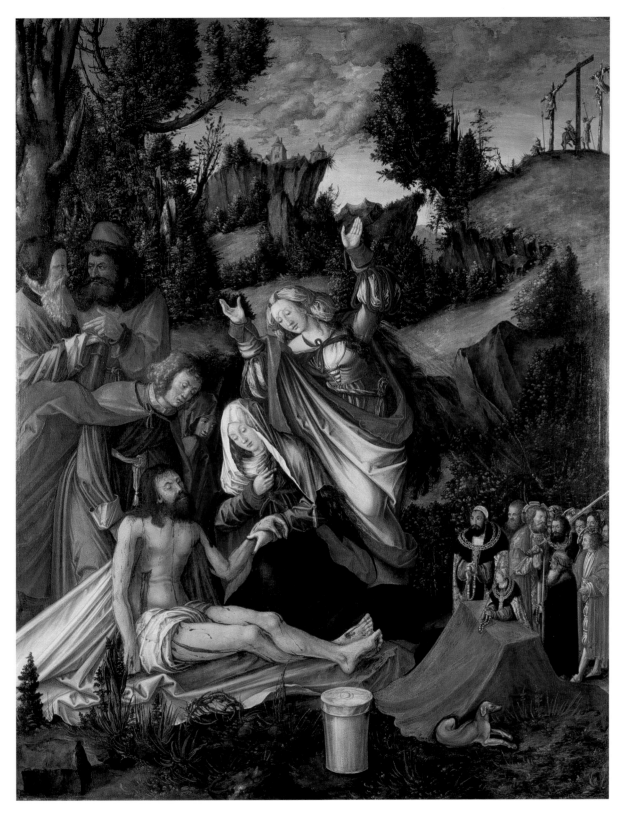

12 Franconian Master *The Lamentation of Christ with a Group of Donors, c.*1515

Oil on panel · 120.5 × 97cm

Purchased with assistance from the National Art Collections Fund 1997 [NG 2689]

42

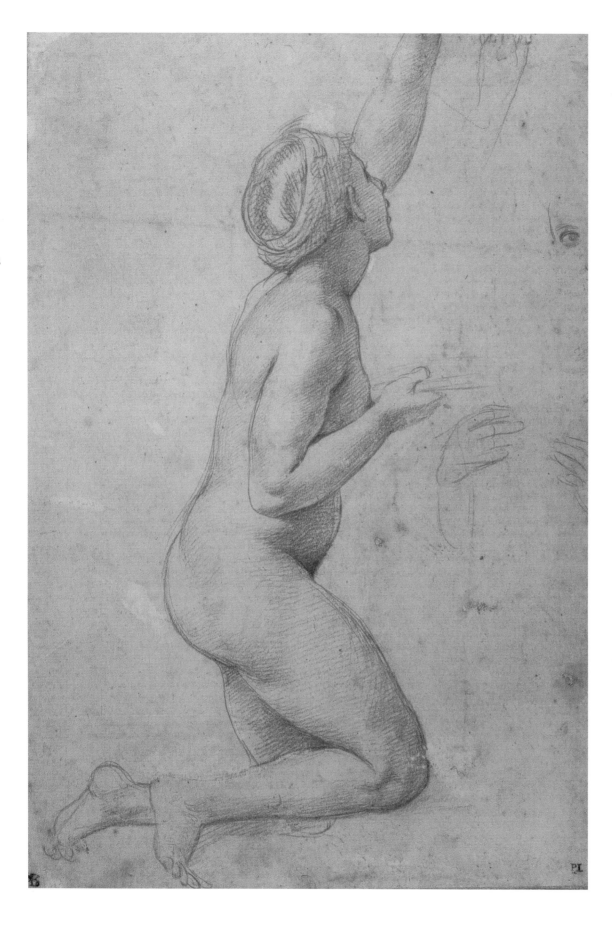

13 Raphael (Raffaello Santi)
1483–1520
*A Kneeling Nude Woman with her
Left Arm Raised*, c.1518

Red chalk, with touches of black
chalk, over stylus underdrawing on
off-white paper · 27.9 × 18.7cm
Purchased by Private Treaty with
assistance from the National
Heritage Memorial Fund, the
National Art Collections Fund and
the Pilgrim Trust 1987 [D 5145]

14 Raphael (Raffaello Santi)
1483–1520
*The Virgin and Child Enthroned
with the Archangel Raphael and
Tobias, and St Jerome*, c.1512–14

Brush and brown wash heightened
with white over black chalk on paper
25.8 × 21.3cm
Purchased by Private Treaty with
assistance from the National
Heritage Memorial Fund, the
National Art Collections Fund and
funds from the estate of Keith and
Rene Andrews 1992 [D 5342]

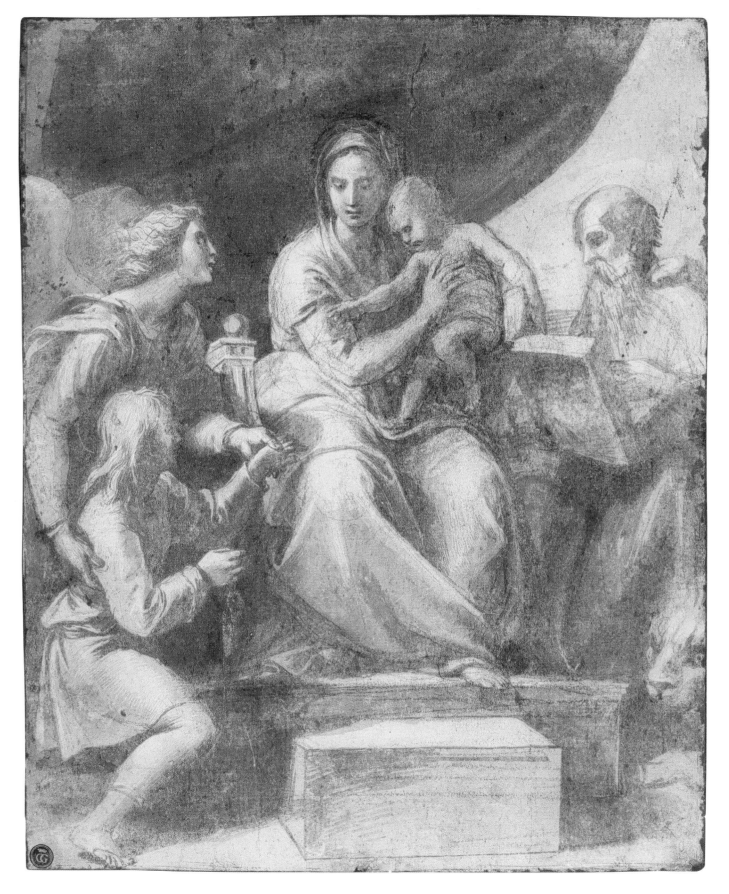

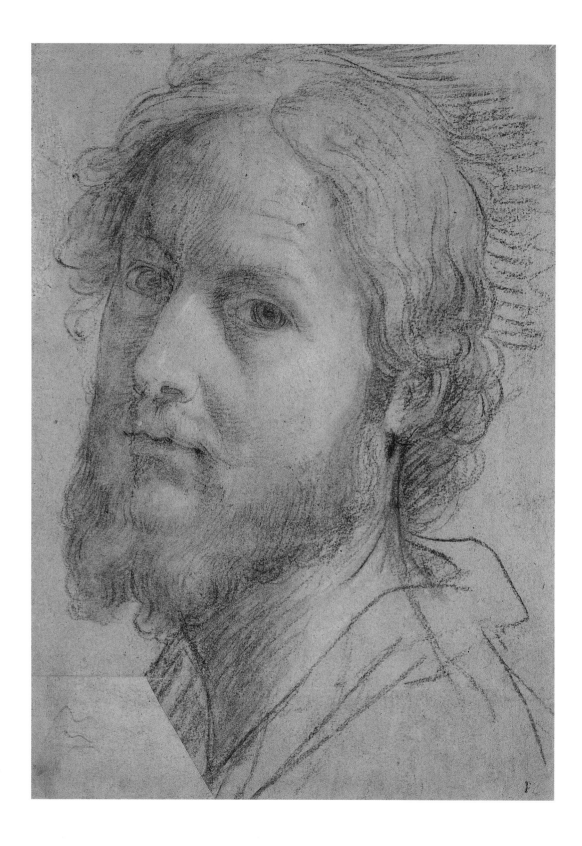

15 Palma Vecchio
(Jacopo Negretti) *c.*1480–1528
*Self-portrait, c.*1510

Black and white chalk on blue paper
25.6 × 18.5cm
Keith Andrews Bequest, 1989
[D 5296]

16 Giovanni Cariani
*c.*1485– after 1547
Saint Agatha, 1516–17

Oil on canvas · 69 × 58cm
Purchased with assistance from the
National Art Collections Fund 1989
[NG 2494]

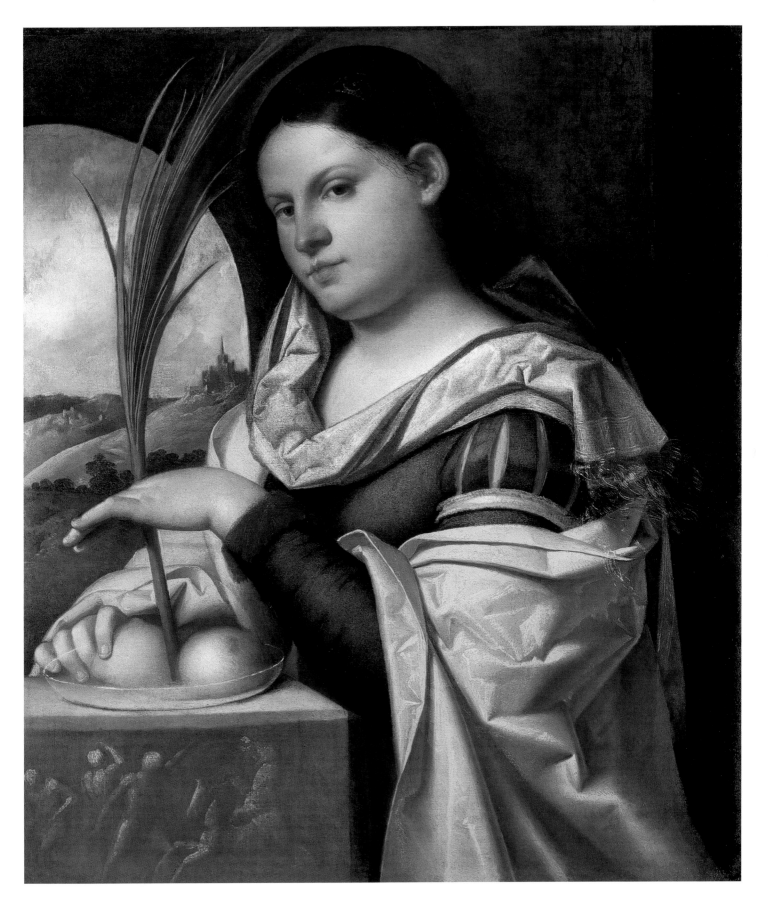

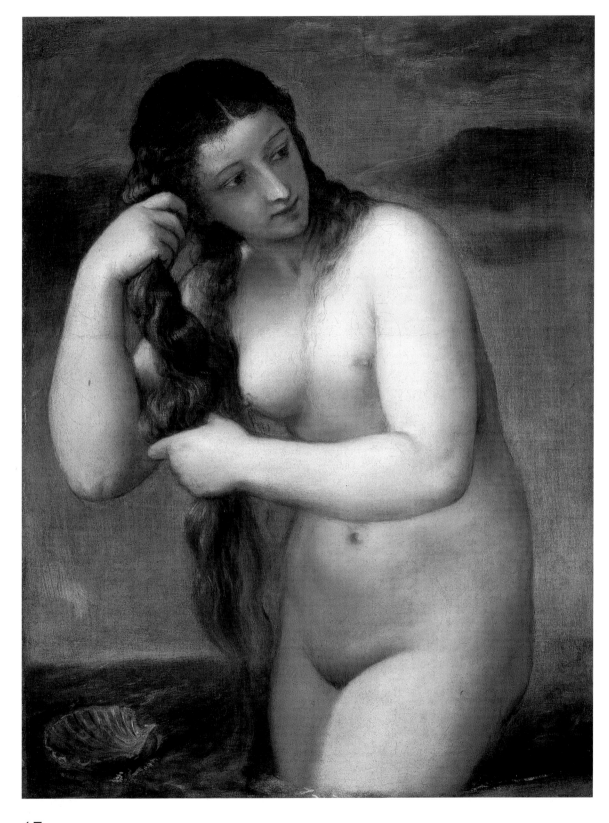

17 Titian (Tiziano Vecellio) *c.*1485/90–1576 *Venus Rising from the Sea ('Venus Anadyomene'), c.*1520

Oil on canvas · 75.8 × 57.6cm · Acquired from the trustees of the 7th Duke of Sutherland, partly in lieu of Inheritance Tax, with assistance from the Heritage Lottery Fund, the National Art Collections Fund (including a contribution from the Wolfson Foundation) and the Scottish Executive 2003 [NG 2751]

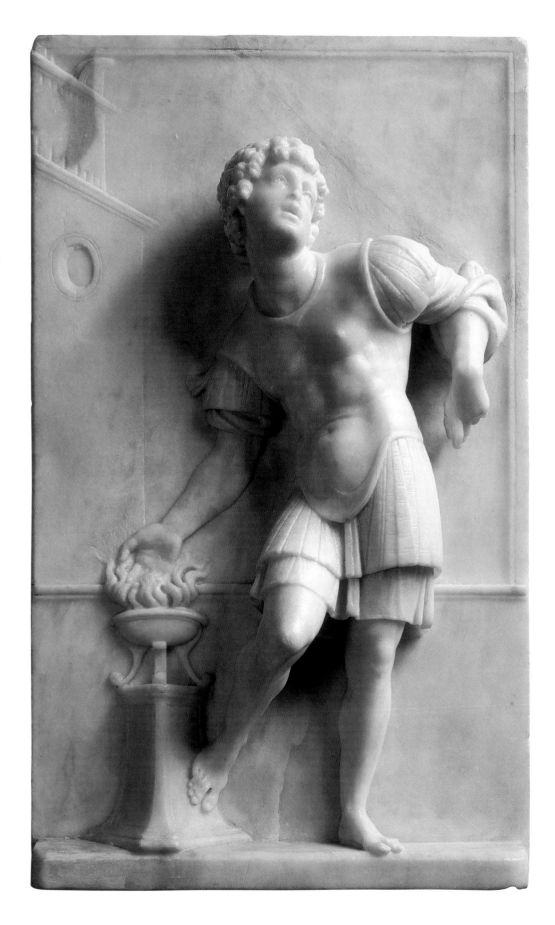

48

18 Giovanni Maria Mosca
active 1507–1573
Relief of Mucius Scaevola, c.1520–5

Marble · 34.5 × 21cm
Purchased with assistance from the National Art
Collections Fund 1988 [NG 2460]

19 Hans Krafft, the Elder 1481–*c.*1542
after a design by Albrecht Dürer 1471–1528
Obverse: *Dedication Medal of the City of
Nuremberg for Emperor Charles V (1500–1558)*;
Reverse: *The Imperial Eagle of the Holy
Roman Empire*, 1521

Silver · 7.2cm diameter
Purchased 1993 [NG 2566]

20 Benvenuto Cellini 1500–1571
Obverse: *Giulio de' Medici, Pope Clement VII
(1523–1534)*
Reverse: *Moses Striking the Rock*, 1534

Silver gilt · 3.8cm diameter
Purchased 1993 [NG 2565]

21 Antonio Abondio 1538–1591
Obverse: *Portrait medal of Girolamo Scotti*
Reverse: *Hand Grasping Vipers Surrounded by
an Olive and Palm Branch*, 1580

Silver · 6.8cm diameter
Purchased 1992 [NG 2553]

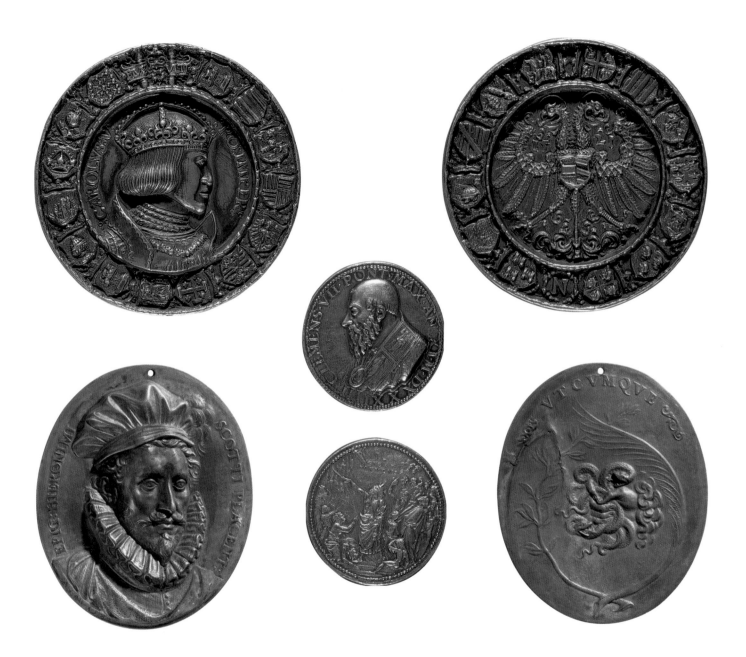

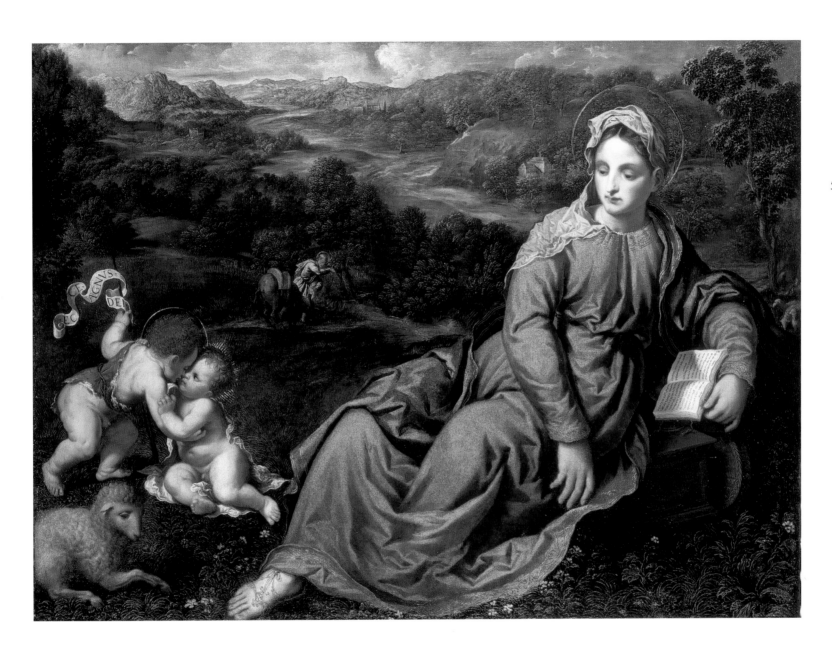

22 Paris Bordon 1500–1571
*The Rest on the Flight into Egypt, c.*1540–50

Oil on canvas · 104 × 140.8cm
Accepted by HM Government in lieu of Inheritance Tax
from the estate of the late Colonel W. Y. Stirling of Keir and
allocated to the National Gallery of Scotland, with a
contribution from gallery funds 1996 [NG 2651]

23 Attributed to Correggio (Antonio Allegri) c.1489–1534 *An Allegory of Virtue, c.1525–30*

Oil on panel · 100 × 83cm · Purchased 1993 [NG 2584]

24 Attributed to Girolamo Mirola *c.*1530/5–1570 *Apollo and the Muses, c.*1560–70

Pen and brown ink and wash, heightened with white, on paper washed pale blue-grey; squared in black chalk · 36.2 × 49.4cm
Keith Andrews Bequest 1989 [D 5295]

25 Parmigianino (Francesco Maria Mazzola) 1503–1540 *The Virgin and Child, c.*1530

Red and black chalk heightened with white over stylus on paper · 17 × 13.4cm
Purchased with the assistance from the National Heritage Memorial Fund and the National Art Collections Fund 1991 [D 5196]

26 Italian (?Naples) *c.*1550–60

A sarcophagus shaped cassone richly decorated with armorials
and trophies within a Doric frieze

Walnut · 206 × 68 × 64cm
Purchased 2005 with the generous assistance of Lord Rothschild
and Ms Lisbet Koerner 'in honour and recognition of Sir Timothy
Clifford's historic achievements for the National Galleries of
Scotland'.

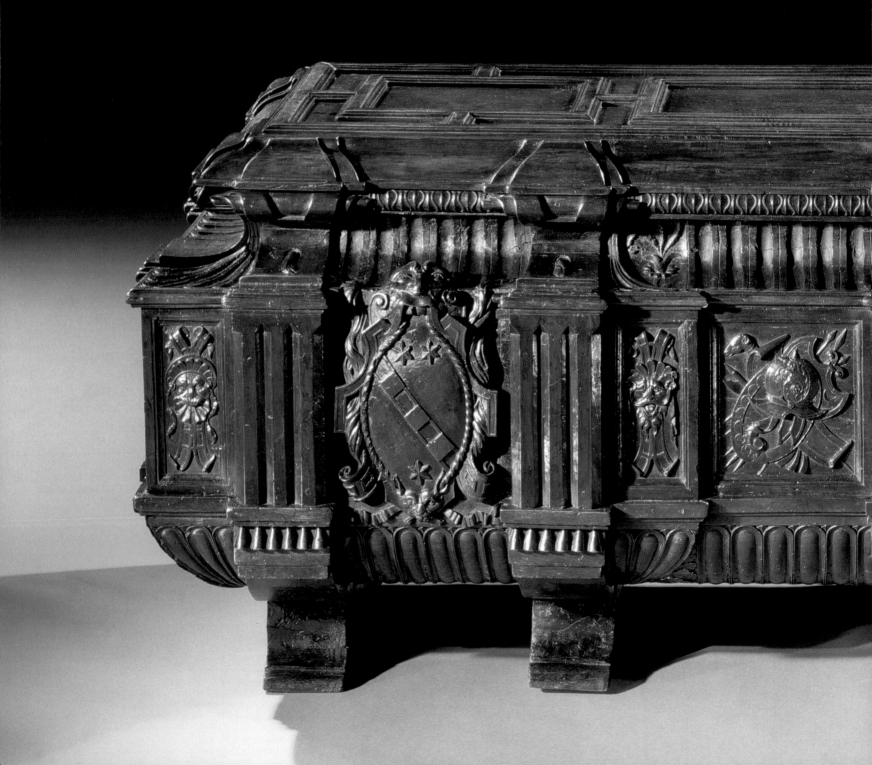

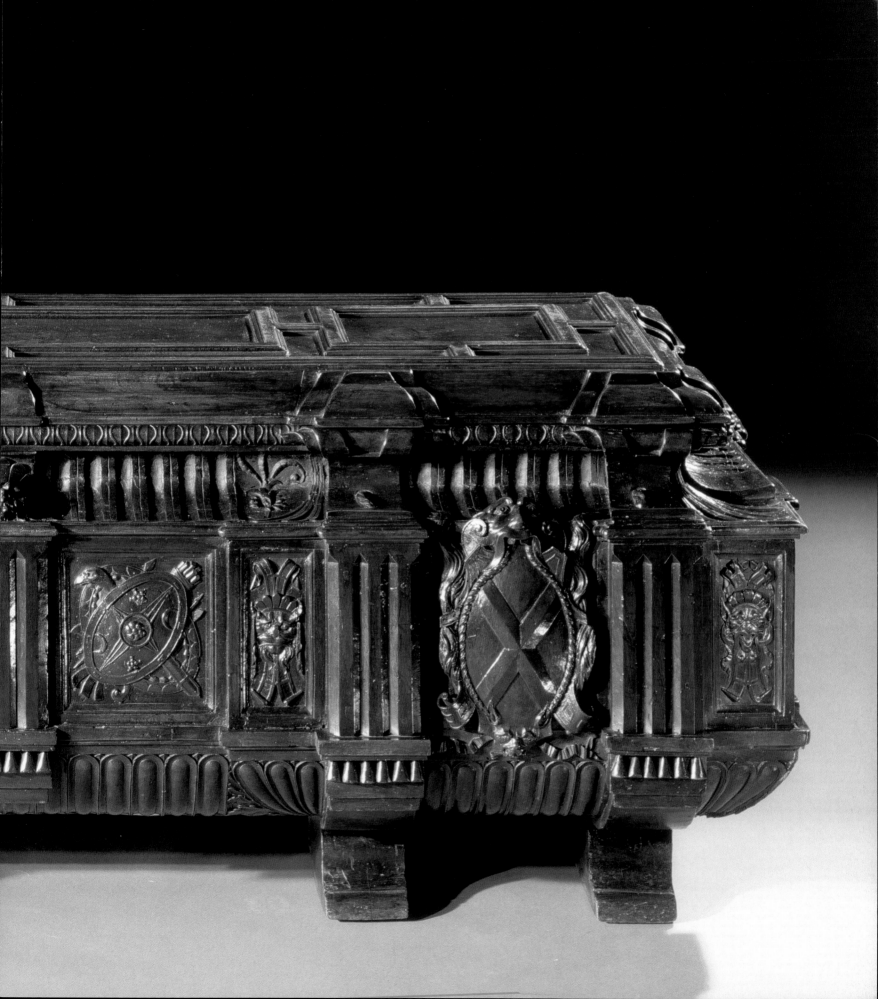

27 Giovanni Battista Castello (il Bergamasco) *c.*1509–1569

Design for a tapestry: Psyche Telling her Sisters of her Lover, c.1560–2

Pen and brown ink and wash over black chalk; squared in black chalk · 30.3 × 27.7cm
Purchased 2003 [D 5556]

28 Flemish Tapestry, Brussels, *c.*1560–5

Psyche before Venus, after Giovanni Battista Castello (il Bergamasco) c.1509–69

Wool and silk · 358 × 305cm
Purchased 1999 [NG 2705]

59

29 Giulio Sanuto active *c.*1540–after 1588
Apollo and Marsyas (after Agnolo Bronzino), 1562

Engraving on three sheets · 54 × 132cm
Purchased 1986 [P 2851]

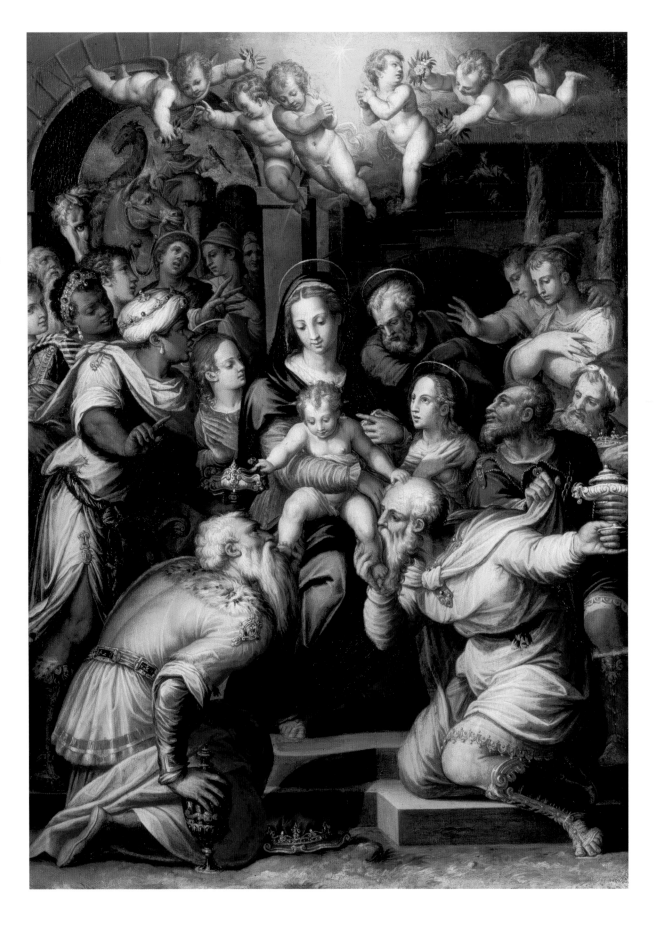

30 Giorgio Vasari
1511–1574
The Adoration of the Magi

Oil on panel · 65 × 48cm
Purchased with assistance
from the National Art
Collections Fund 2005

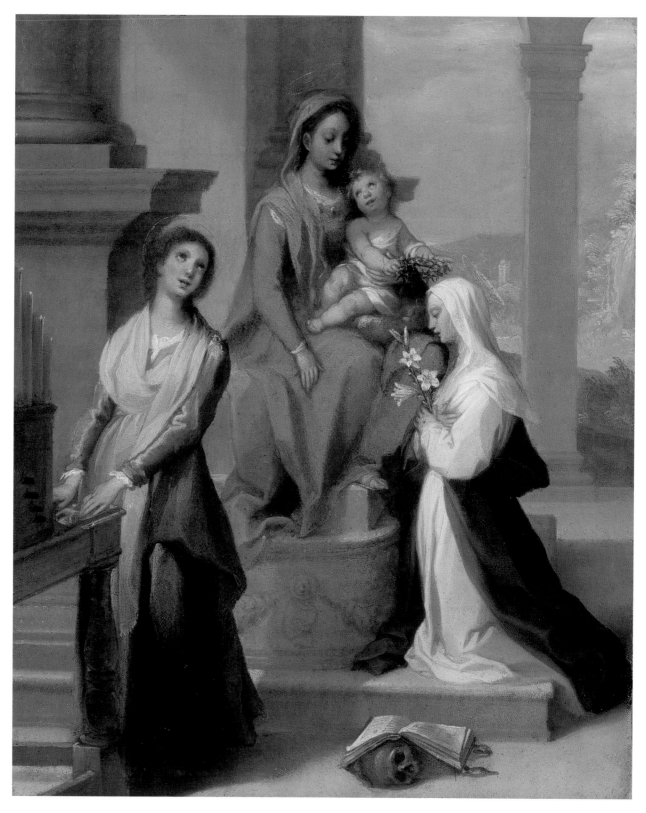

31 Francesco Vanni 1563–1610

The Virgin and Child with Saint Catherine of Siena and Saint Cecilia, c.1600

Oil on copper · 26 × 21cm · Purchased 1999 [NG 2703]

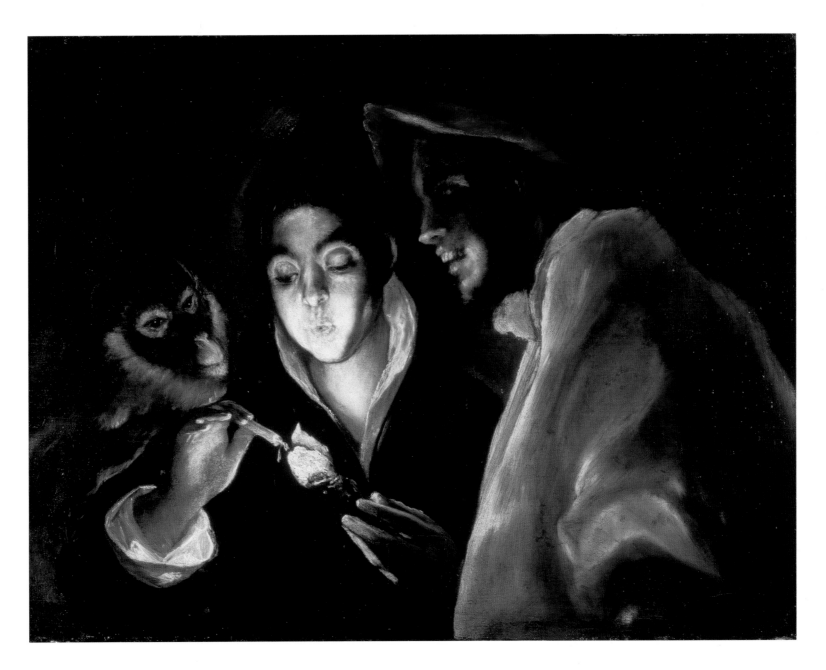

32 El Greco (Domenikos Theotokopoulos) 1541–1614
An Allegory (Fábula), c.1585–90

Oil on canvas · 67.3 × 88.6cm
Acquired by Private Treaty from the estate of the late Mark Oliver,
partly in lieu of Inheritance Tax, with assistance from the National
Heritage Memorial Fund and the National Art Collections Fund
(including a contribution from the Wolfson Foundation) 1989
[NG 2491]

66

33 Hendrick Goltzius

1558–1617

A Man Wearing a Tasselled Hat,
24 November 1587

Pen and brown ink on paper
47.5 × 35.4cm
Accepted by HM Government in
lieu of Inheritance Tax from the
estate of the 8th Duke of
Buccleuch and allocated to the
National Gallery of Scotland 2000
[D 5507]

34 Denys Calvaert

1540–1619

*The Holy Family with the Infant
Saint John the Baptist in a
Landscape, c.*1590–1600

Oil on copper · 42 × 32cm
Purchased with assistance from
the Patrons of the National
Galleries of Scotland and the
National Art Collections Fund
1987 [NG 2447]

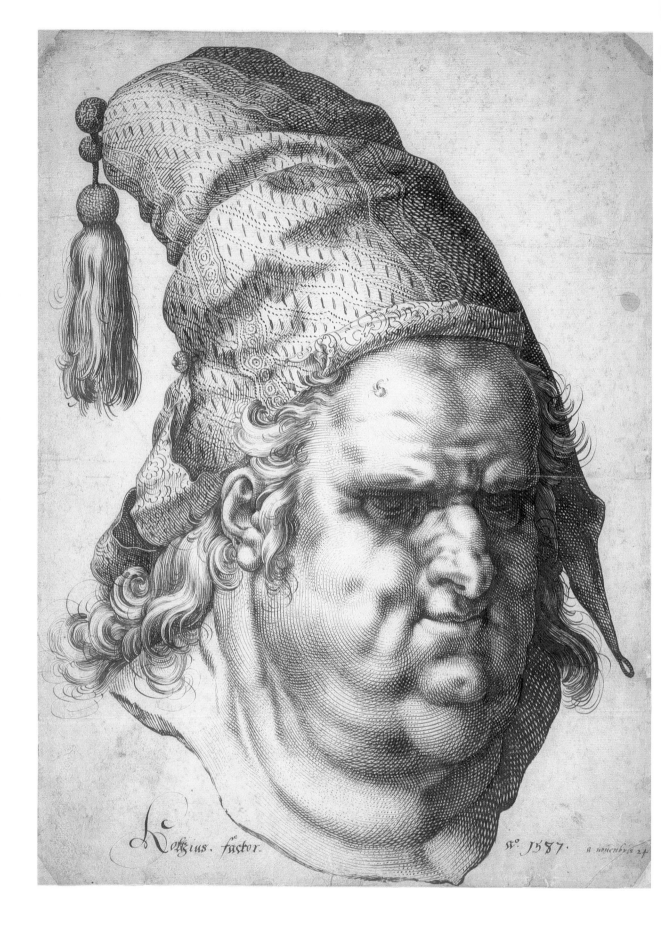

68

35 Venetian, attributed to Nicolò
Roccatagliata active 1593–after 1636
*An Andiron with a Figure of Jupiter, c.*1600

Bronze · 119cm high
Purchased with assistance from the National
Heritage Memorial Fund and the National Art
Collections Fund 1997 [NG 2660]

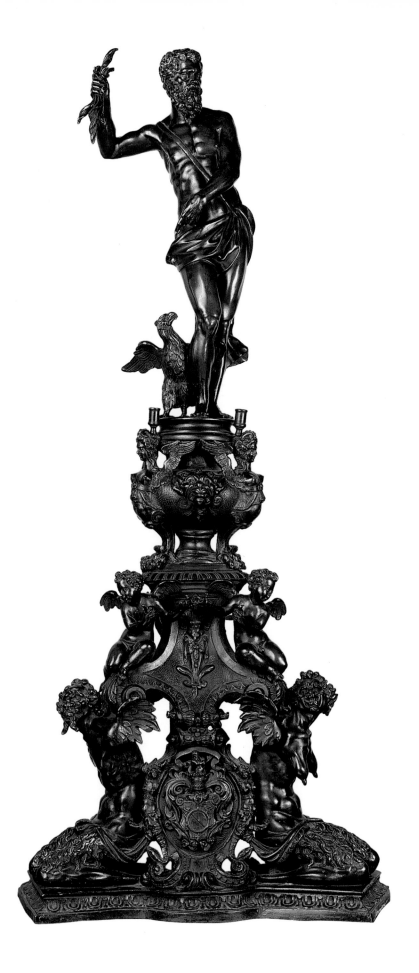

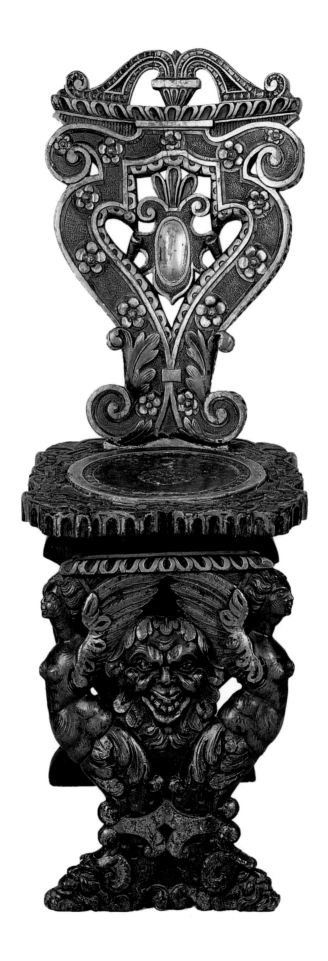

36 Venetian

A Chair of so-called 'Sgabello da Pozzo' type

Walnut, carved, parcel gilt and silvered
113 × 38.6 × 43.5cm
Purchased 1989

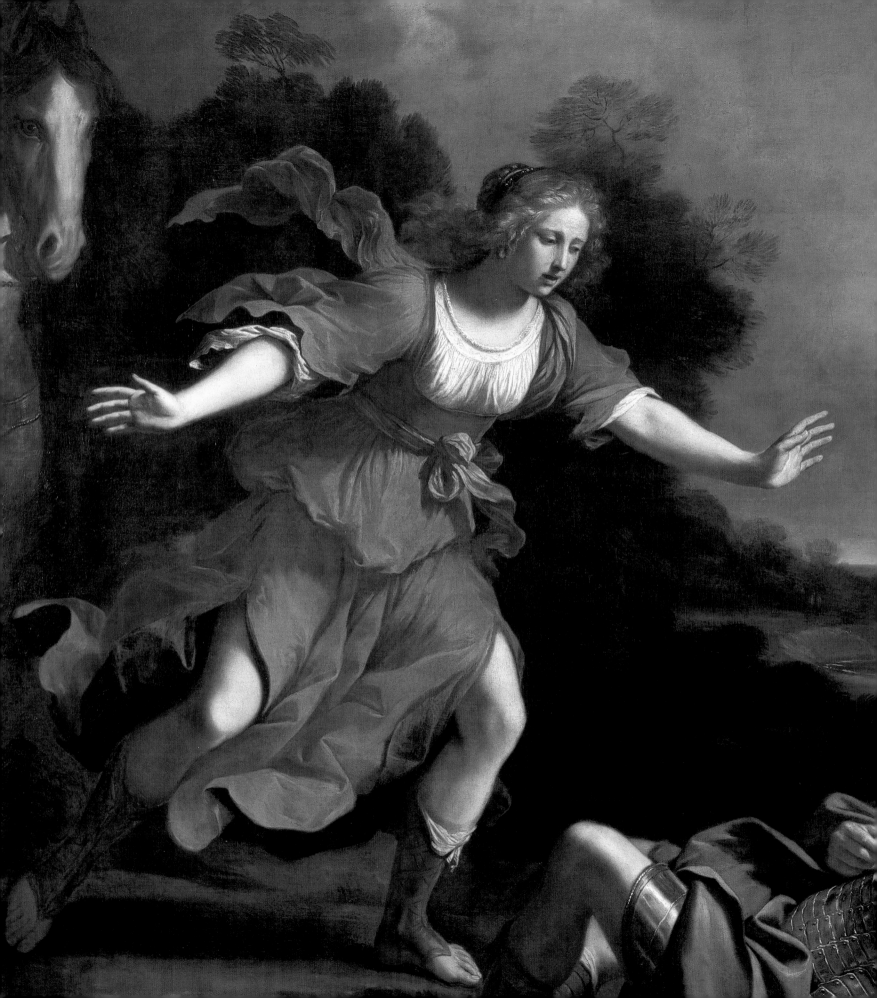

1600
1700

37 Domenichino
(Domenico Zampieri) 1581–1641
Study of Saint Jerome, 1612–14

Black and white chalk on faded blue-grey
paper · 39.5 × 35.2cm
Purchased 2003 [D 5557]

38 Giulio Cesare Procaccini
1574–1625
*The Virgin and Child with the Infant
Saint John and Attendant Angels,
c.1610*

Oil on panel · 51 × 36.5cm
Purchased with assistance from the
Heritage Lottery Fund and the National
Art Collections Fund 1995 [NG 2647]

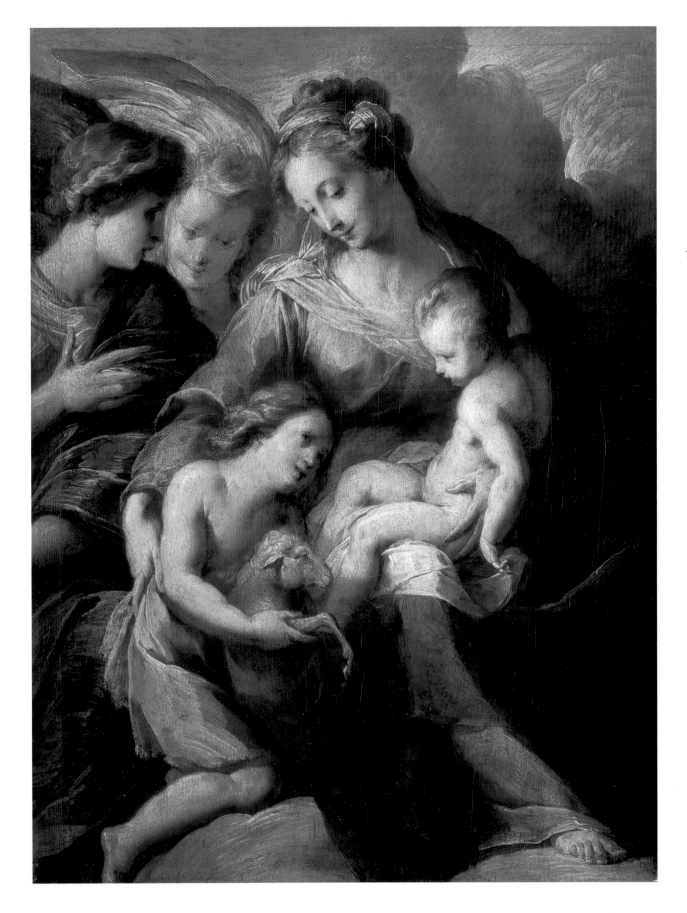

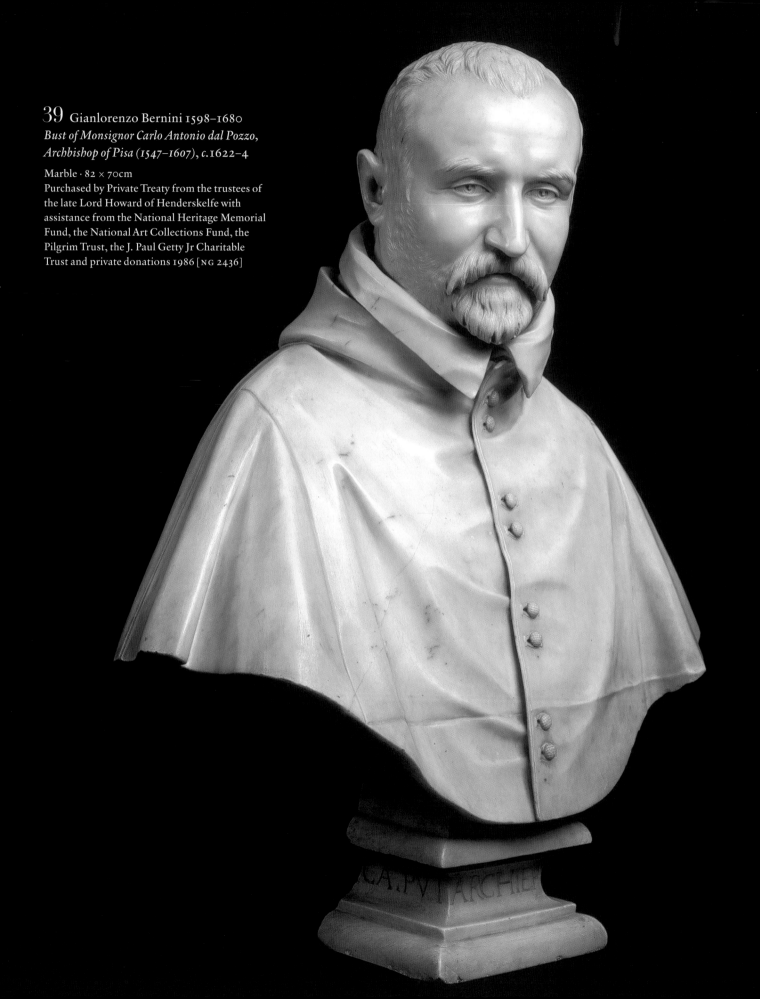

39 Gianlorenzo Bernini 1598–1680
Bust of Monsignor Carlo Antonio dal Pozzo,
Archbishop of Pisa (1547–1607), c.1622–4

Marble · 82 × 70cm
Purchased by Private Treaty from the trustees of
the late Lord Howard of Henderskelfe with
assistance from the National Heritage Memorial
Fund, the National Art Collections Fund, the
Pilgrim Trust, the J. Paul Getty Jr Charitable
Trust and private donations 1986 [NG 2436]

40 Gianlorenzo Bernini 1598–1680 *Design for a Monument to Pope Innocent X Pamphilij, c.*1654

Pen and brown ink and wash · 46.6 × 32.8cm
Purchased with assistance from the National Art Collections Fund 1997 [D 5429]

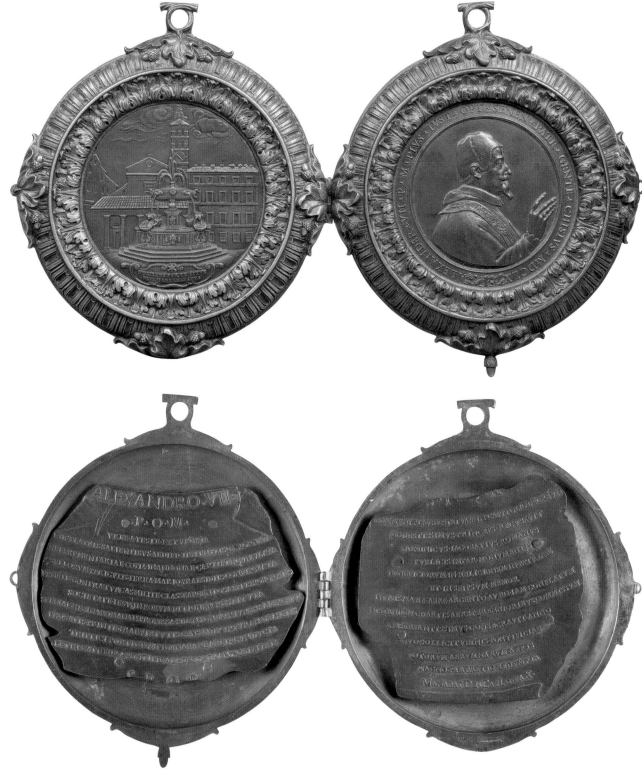

41 Gioacchino Travani 1634–1675
after a design by G. L. Bernini 1598–1680
Obverse: *Portrait medal of Pope Alexander VII Chigi*
Reverse: *The Fountain in Piazza of Sta Maria in Trastevere*, 1661

Bronze · 9.2cm diameter · Purchased 2005

42 Gianlorenzo Bernini 1598–1680
Design for the Tomb Slab of Cardinal Carlo Emanuele Pio da Carpi (1568–1641),

Pen and brown ink and wash over black chalk · 29.2 × 24.2cm
Purchased with assistance from the National Art Collections Fund
and the Foundation for Sport and the Arts 1992 [D 5329]

43 Giovanni Battista Gaulli
(il Baciccio) 1639–1709
*Portrait of Gianlorenzo Bernini
(1598–1680), c.1675*

Oil on canvas · 99 × 74.5cm
Purchased with assistance from the
National Art Collections Fund 1998
[NG 2694]

44 Giovanni Battista Gaulli
(il Baciccio) 1639–1709
The Sacrifice of Isaac, c.1685–90

Pen and brown ink and wash,
heightened with white, over black
chalk, on blue paper · 31.9 × 23.3cm
Purchased with assistance from the
National Heritage Memorial Fund
and the National Art Collections
Fund 1992 [D 5328]

45 Rembrandt van Rijn 1606–1669
Christ at Emmaus, late 1630s

Pen and brush, gallnut ink on paper · 22.6 × 16.1cm
Purchased 1985 [D 5131]

46 Rembrandt van Rijn 1606–1669
Christ Presented to the People (Ecce Homo), 1655

Drypoint · 35.8 × 45.5cm
Accepted in lieu of Inheritance Tax from the estate of Violetta Harris and
allocated through the National Art Collections Fund 1992 [P 2878]

47 Sir Anthony van Dyck 1599–1641
Princess Elizabeth (1635–1650) and Princess Anne (1637–1640), 1637

Oil on canvas · 29.8 × 41.8cm
Purchased with assistance from the Heritage Lottery Fund, the Scottish Office
and the National Art Collections Fund 1996 [PG 3010]

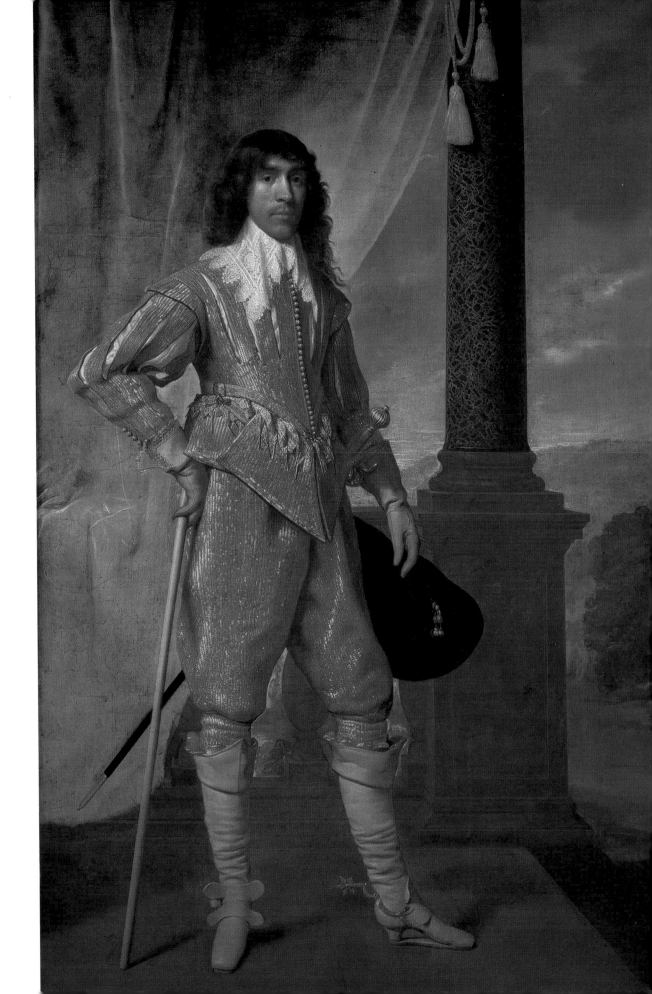

48 Daniel Mytens

*c.*1590–*c.*1647

*James Hamilton, 1st Duke
of Hamilton (1606–1649)*, 1629

Oil on canvas · 221 × 139.7cm
Purchased with assistance from the
National Art Collections Fund, the
National Heritage Memorial Fund
and the Pilgrim Trust 1987
[PG 2722]

84

50 Bernardo Strozzi
1581–1644
*The Cook, c.*1620–30

Oil on canvas · 174.6 × 160cm
Purchased with assistance from
the National Art Collections
Fund 2004 [NG 2767]

49 Bartolomé Esteban Murillo 1617–1682
*A Young Man with a Basket of Fruit (Personification of 'Summer'), c.*1665–70

Oil on canvas · 102 × 81.5cm · Purchased by Private Treaty with assistance
from the National Art Collections Fund 1999 [NG 2706]

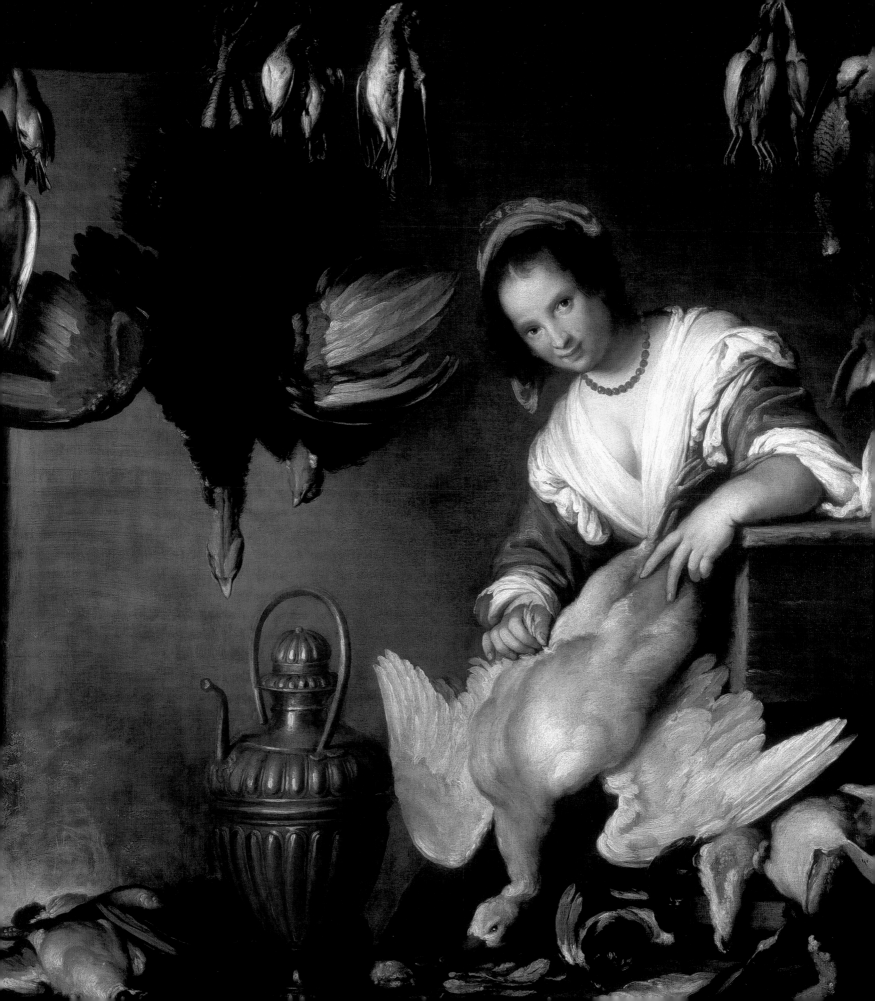

51 Pietro da Cortona
1596–1669
*Saint Ivo Intervening on
Behalf of the Poor, c.*1660

Black chalk and grey wash
heightened with white on light
brown paper; squared in black
chalk · 43.3 × 30.7cm
Purchased with assistance from
the National Heritage
Memorial Fund and the
National Art Collections Fund
1992 [D 5327]

52 Ciro Ferri 1634–1689
The Meeting of Saint Francis and Saint Dominic, c.1660–65

Red and black chalk heightened with white (partly oxidized),
squared in black chalk · 25.9 × 39cm
Purchased with assistance from the Foundation for Sport and the Arts
and the National Art Collections Fund 1992 [D 5337]

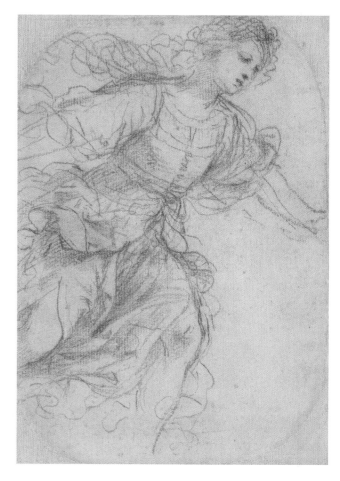

53 Guercino (Givanni Francesco Barbieri) 1591–1666
The Prophet Jeremiah, c.1626/7

Black and white chalk on grey-blue paper · 42.5 × 39.5cm
Purchased 2005 [D 5591]

54 Guercino (Giovanni Francesco Barbieri) 1591–1666
Erminia Running with Outstretched Arms, c.1650

Red chalk · 19.4 × 14cm
Purchased with assistance from the National Art Collections Fund 1997 [D 5424]

55 Guercino (Giovanni Francesco Barbieri) 1591–1666
Erminia Finding the Wounded Tancred, 1650–1

Oil on canvas · 244 × 297cm
Purchased by Private Treaty with assistance from the Heritage Lottery
Fund, the National Art Collections Fund, and corporate and
private donations 1996 [NG 2656]

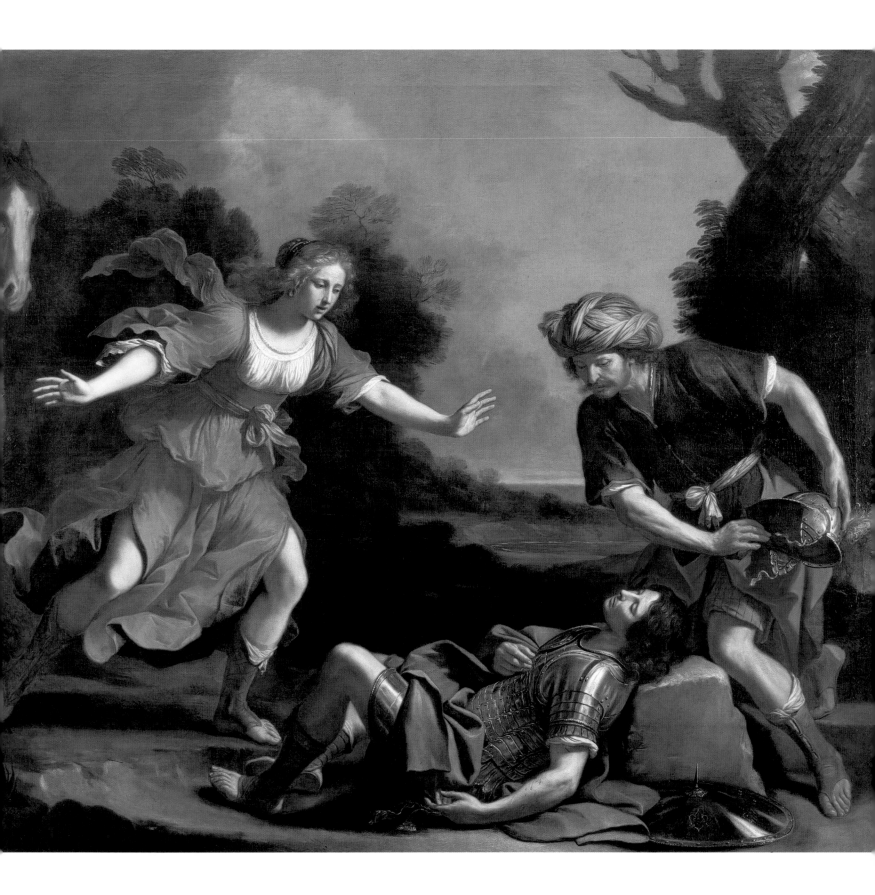

90

56 Jan van Kessel 1626–1679
*Still Life of Flowers and Grapes Encircling a
Monstrance in a Niche, c.1660–79*

Oil on copper · 70 × 105.5cm
Purchased 2002 [NG 2740]

57 John Michael Wright 1617–1694
Susanna Hamilton, Countess of Cassillis (1632–1694), 1662

Oil on canvas · 72.4 × 61cm
Purchased 1986 [PG 2687]

Marquis of Tweeddale and Family.

58 Attributed to John Baptiste de Medina 1659–1710

John Hay, 1st Marquess Tweeddale (1626–1697) and his Family, c.1694

Oil on canvas · 141 × 184cm
Purchased with assistance from the National Art Collections Fund and the
Heritage Lottery Fund 1999 [PG 3155]

St Andrews from the East

59 Philips Koninck 1619–1688
Extensive Landscape, 1666

Oil on canvas · 91 × 111.8cm
Purchased by Private Treaty 1986 [NG 2434]

60 John Abraham Slezer c.1650–1717
View of St Andrews, c.1693

Pen and ink and grey wash on paper · 19.8 × 42.1cm
Purchased by the Patrons of the National Galleries
of Scotland 1993 [D 5364]

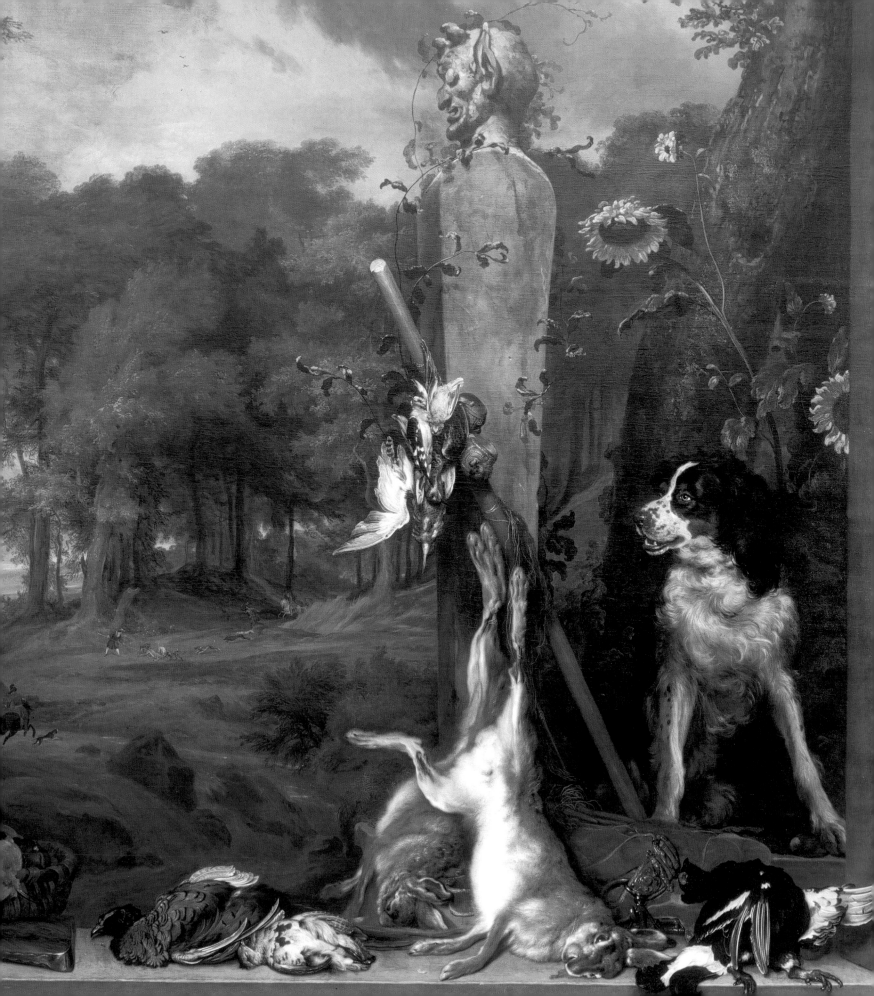

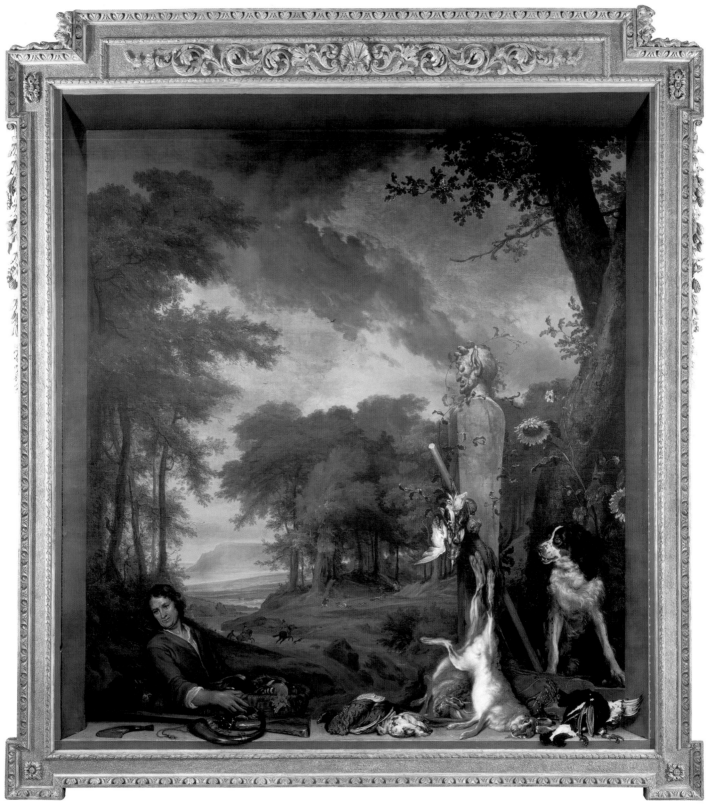

61 Jan Weenix c.1642–1719
Landscape with a Huntsmen and Dead Game (Allegory of the Sense of Smell), 1697

Oil on canvas · 344 × 323cm · Purchased 1990 [NG 2523]

1700
1800

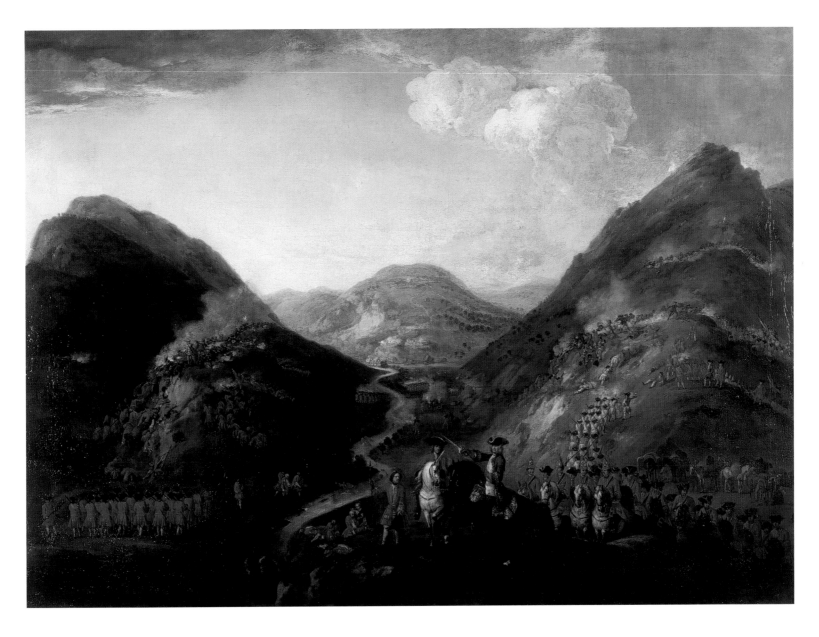

62 Peter Tillemans *c.1684–1734* *The Battle of Glenshiel 1719*, 1719

Oil on canvas · 118 × 164.5cm

Purchased with assistance from the National Heritage Memorial Fund and the National Art Collections Fund (Scottish Fund) 1984 [PG 2635]

63 Jean Louis Lemoyne 1665–1755
Philippe, Duke of Orléans (1674–1723), Regent of France, 1720

Bronze · 40cm high
Purchased with assistance from the Patrons of the National Galleries of
Scotland and the National Art Collections Fund 1998 [NG 2695]

64 Giacomo Antonio Ponsonelli 1654–1735
The Immaculate Conception

Marble · 111cm high
Purchased with assistance from the National Arts Collection Fund 2005

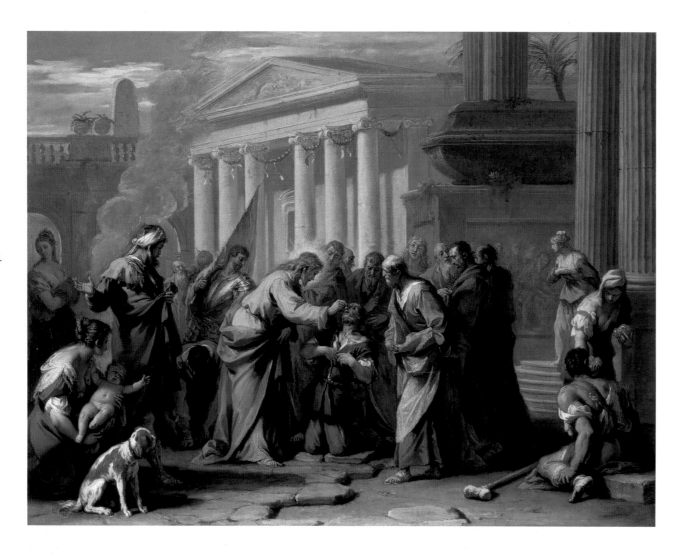

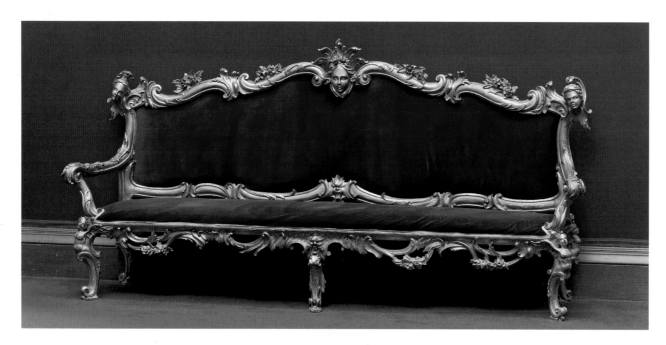

70 Etienne Jeaurat
1699–1789
A Family in an Interior, c.1745

Black and red chalk heightened
with white on paper · 48 × 64cm
Purchased 1993 [D 5360]

71 Thomas Gainsborough
1727–1788
A Study of a Young Girl, 1745–50

Black chalk heightened with white
on paper · 38.7 × 24.6cm
Bequeathed by the Hon. Sir Steven
Runciman CH 2000 [D 5526]

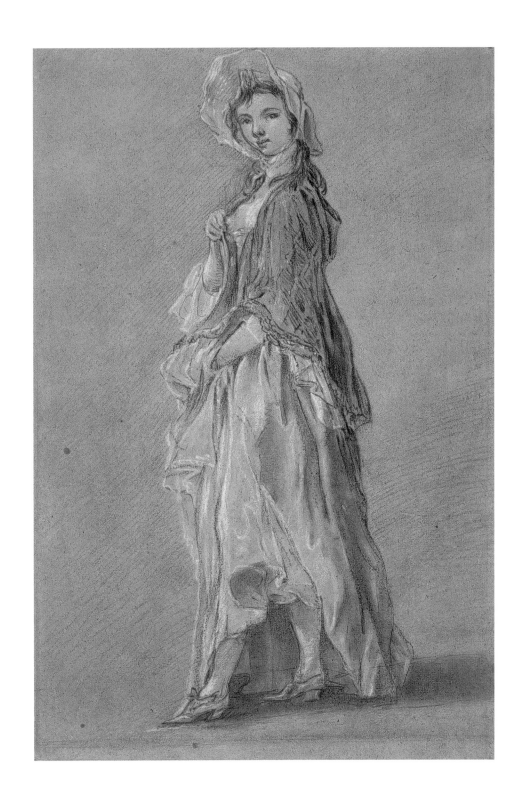

72 François Boucher 1703–1770
A Pastoral Scene ('L'Offrande à la Villageoise'), 1761

Oil on canvas · 231.5 × 91cm
Purchased by Private Treaty 1986 [NG 2440]

73 François Boucher 1703–1770
A Pastoral Scene ('La Jardinière Endormie'), 1762

Oil on canvas · 232 × 91cm
Purchased by Private Treaty 1986 [NG 2441]

74 François Boucher 1703–1770
A Pastoral Scene ('L'Aimable Pastorale'), 1762

Oil on canvas · 231.5 × 91cm
Purchased by Private Treaty 1986 [NG 2442]

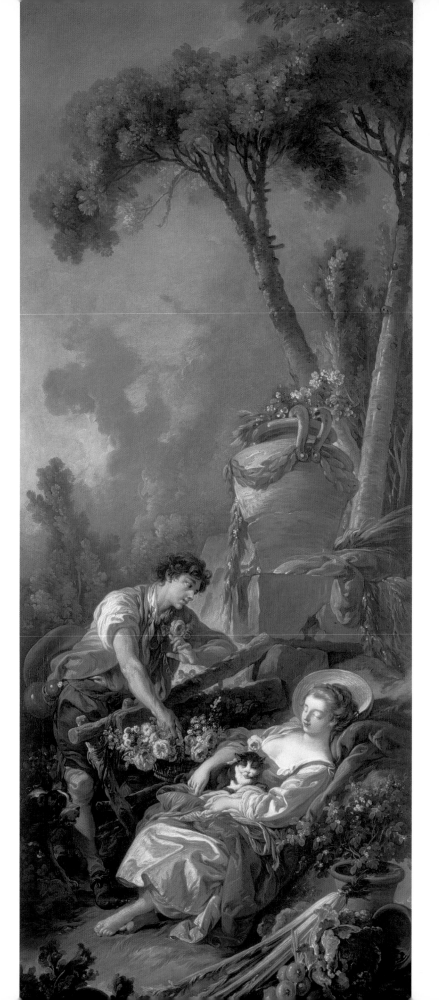

112 **75** Roman School
James III and his Court in Front of the
Palazzo Muti During the Celebrations
of the Appointment of Prince Henry as a
Cardinal, July 1747, c.1747

Oil on canvas · 195.6 × 297.2cm
Purchased with assistance from the
National Lottery through the National
Heritage Memorial Fund and the
National Art Collections Fund 2001
[PG 3269]

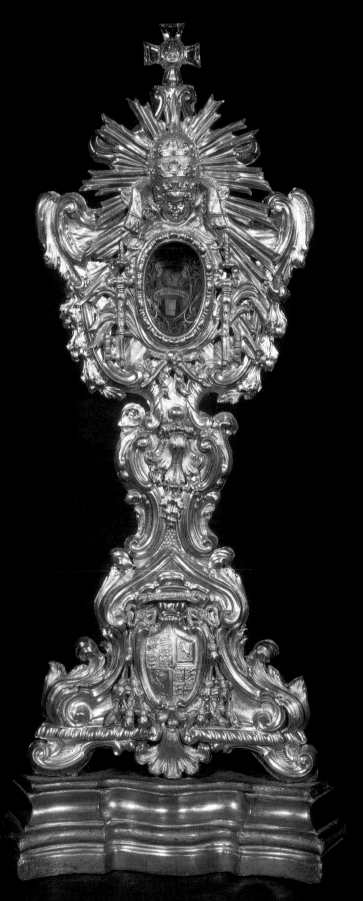

76 Roman
Reliquary of Saint Peter and Saint Paul, with the Arms of Henry Benedict, Cardinal York (1725–1807), c.1760–5

Silver and gilt bronze with rock crystal finial, wood backing and gilt wood base
59.6cm high
Purchased 1992 [PG 2906]

77 Maurice-Quentin De La Tour
1704–1788
Prince Charles Edward Stuart (1720–1788), 1748

Pastel on paper · 61 × 51cm
Purchased with assistance from the National Art Collections Fund 1994
[PG 2954]

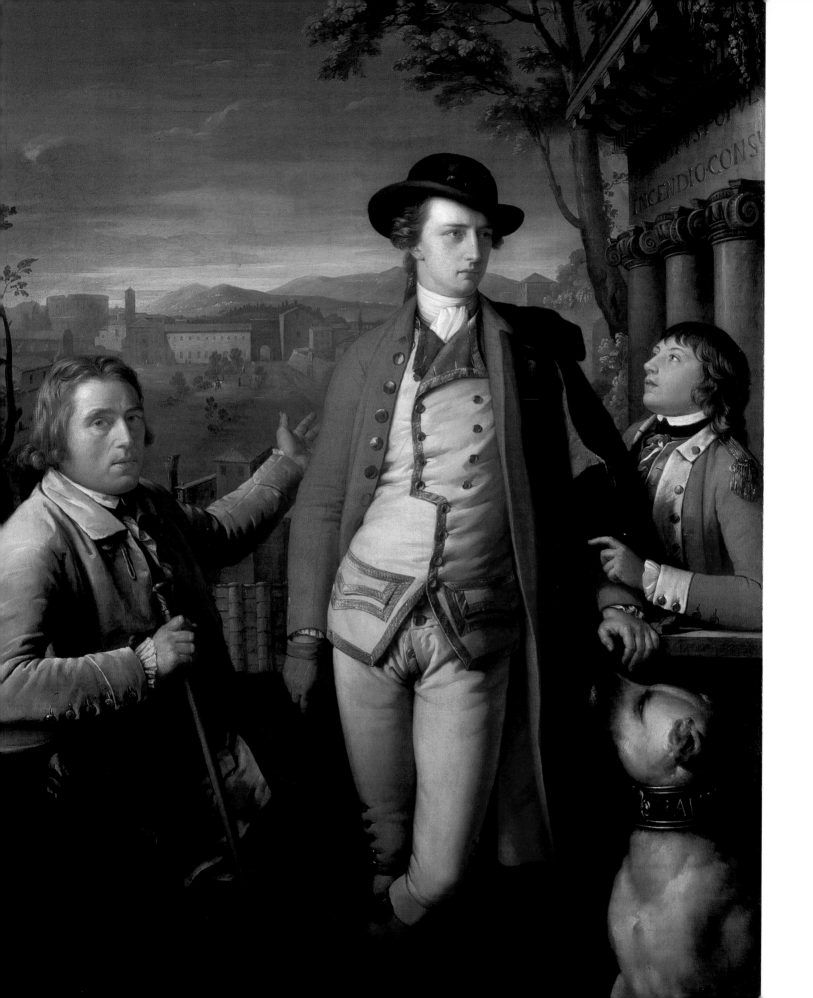

78 Gavin Hamilton 1723–1798
Douglas Hamilton, 8th Duke of
Hamilton and 5th Duke of Brandon,
1756–1799 (with Dr John Moore, 1730–
1802, and Sir John Moore, 1761–1809,
as a young boy), 1775–7

Oil on canvas · 183 × 144.7cm
Purchased with assistance from the
Heritage Lottery Fund and the National
Art Collections Fund 2001 [PG 3265]

79 Ozias Humphry 1742–1810
Prince Charles Edward Stuart
(1720–1788), 1776

Black chalk on paper · 34.2 × 23.5cm
Purchased 1995 [PG 2991]

80 Pietro Fabris, active 1768–78

Kenneth Mackenzie, 1st Earl of Seaforth (1744–1781) at home in Naples:
A Fencing Scene, 1770

Oil on canvas ·35.5 × 47.6cm
Purchased with the assistance of the National Art Collections Fund 1984 [PG 2610]

81 Pietro Fabris, active 1768–78
Kenneth Mackenzie, 1st Earl of Seaforth, (1744–1781), at home in Naples: A Concert Party,
with Wolfgang Amadeus Mozart playing the harpsichord, 1770

Oil on canvas · 35.5 × 47.6cm
Purchased with the assistance of the National Art Collections Fund 1984 [PG 2611]

82 Paul Sandby 1731–1809

Horse Fair on Bruntsfield Links, Edinburgh, 1750

Watercolour over pencil on paper · 24.4 × 37.4cm
Purchased by Private Treaty 1990 [D 5184]

83 Allan Ramsay 1713–1784

Sir Hew Dalrymple, Lord Drummore (1690–1755), 1754

Oil on canvas · 127 × 102.2cm
Purchased with assistance from the National Heritage Memorial
Fund and the National Art Collections Fund 1989 [PG 2800]

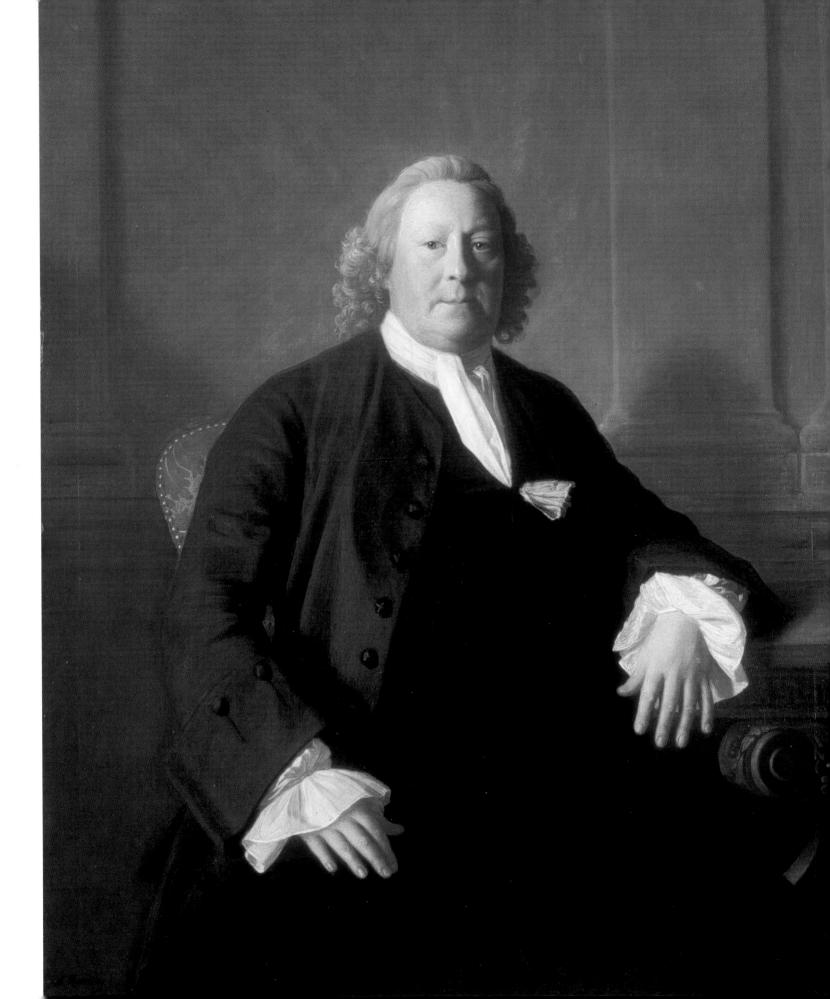

84 Gavin Hamilton 1723–1798
Andromache Bewailing the Death of Hector, c.1759

Oil on canvas · 64.2 × 98.5cm
Purchased with assistance from the Barrogill Keith Bequest Fund 1985 [NG 2428]

85 Gavin Hamilton 1723–1798
James Dawkins and Robert Wood Discovering the Ruins of Palmyra, 1758

Oil on canvas · 309.9 × 388.6cm
Purchased with assistance from the National Lottery through the Heritage
Lottery Fund and the National Art Collections Fund 1997 [NG 2666]

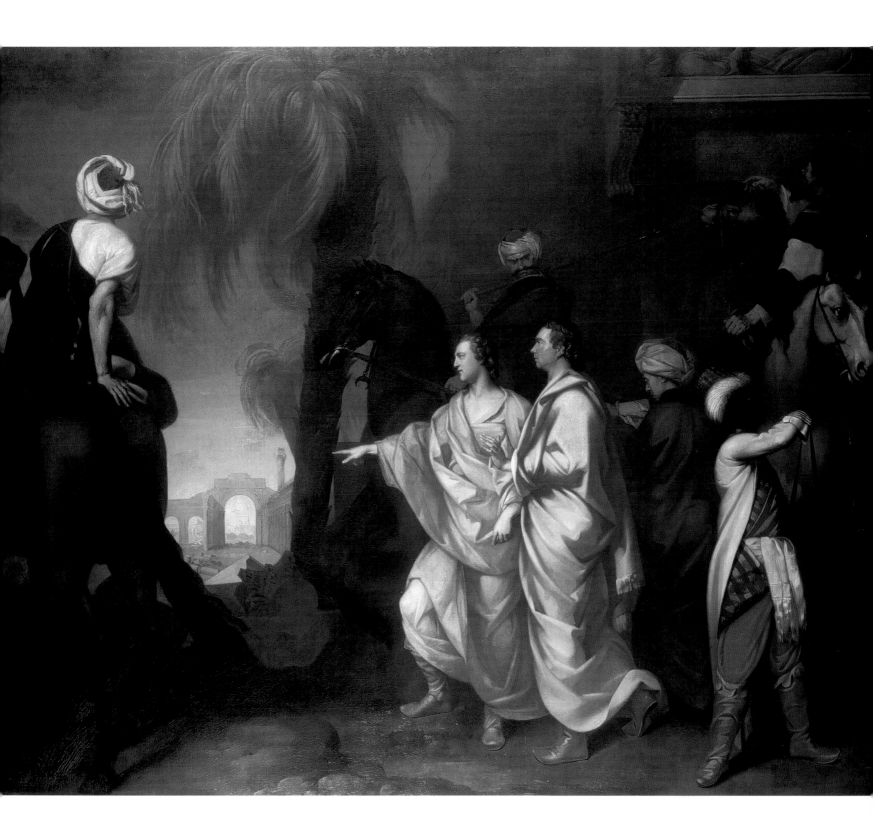

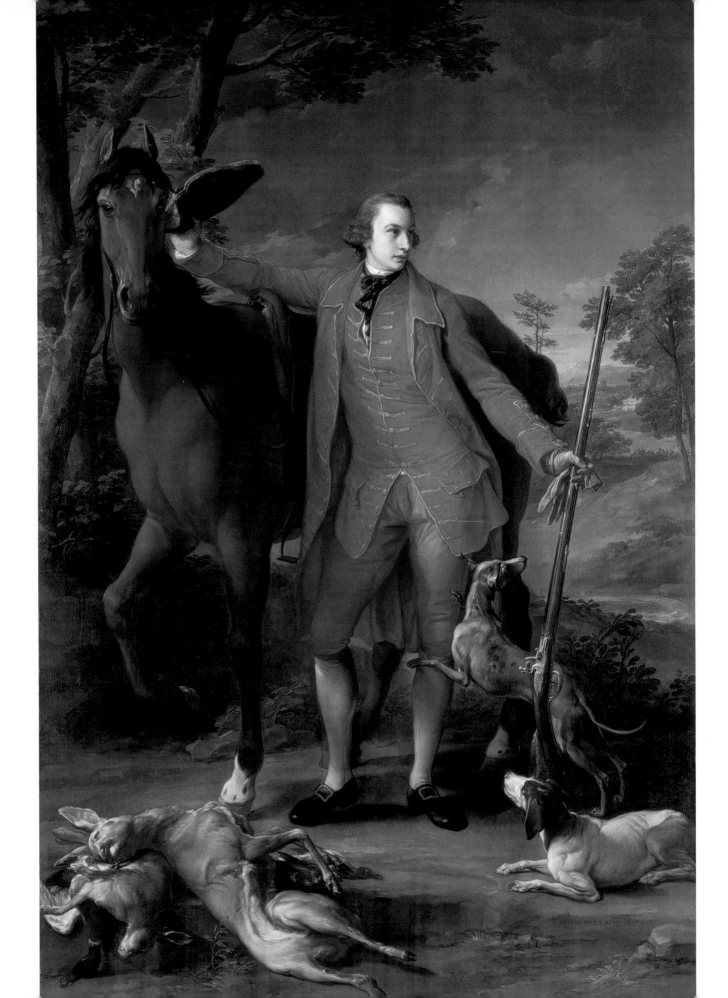

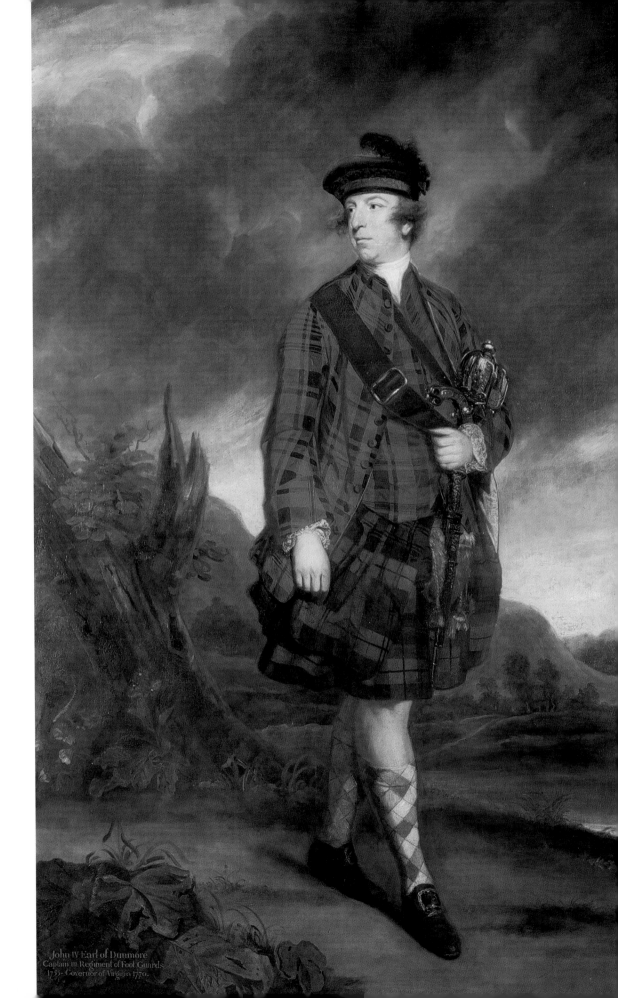

86 Pompeo Girolamo Batoni

1708–1787

Alexander Gordon, 4th Duke
of Gordon (1743–1827), 1764

Oil on canvas · 292 × 192cm
Purchased by Private Treaty with
assistance from the National Heritage
Memorial Fund and the National Art
Collections Fund 1994 [NG 2589]

87 Sir Joshua Reynolds

1723–1792

John Murray, 4th Earl of Dunmore
(1730/1–1809), 1765

Oil on canvas · 238.1 × 146.2cm
Purchased with assistance from the
National Heritage Memorial Fund
and the National Art Collections
Fund 1992 [PG 2895]

88 Archibald Skirving 1749–1819

*Self-portrait, c.*1789–90

Pastel · 7.3cm high
Presented by Mrs Nancy Butcher 1999 [PG 3148]

89 John Brown 1749–1787

Jane Maxwell, Duchess of Gordon (1749–1812),
Wife of 4th Duke of Gordon, 1786

Pencil on paper · 49.3 × 32.6cm
Purchased with assistance from the National Art
Collections Fund 2001 [D 5525]

90 Joseph Wilton 1722–1803
*Design for an Octagonal Marble Plinth
Standing on Four Turtles, c.*1767

Brown ink and grey wash on paper
17.4 × 8.2cm
Purchased by the Patrons of the National
Galleries of Scotland 1990 [D 5186]

91 Joseph Wilton 1722–1803
*Octagonal Marble Plinth Standing on
Four Turtles, c.*1767

White marble · 96.5 × 73.5 × 73.5cm
Purchased by the Patrons of the National
Galleries of Scotland 1989 [NG 2515]

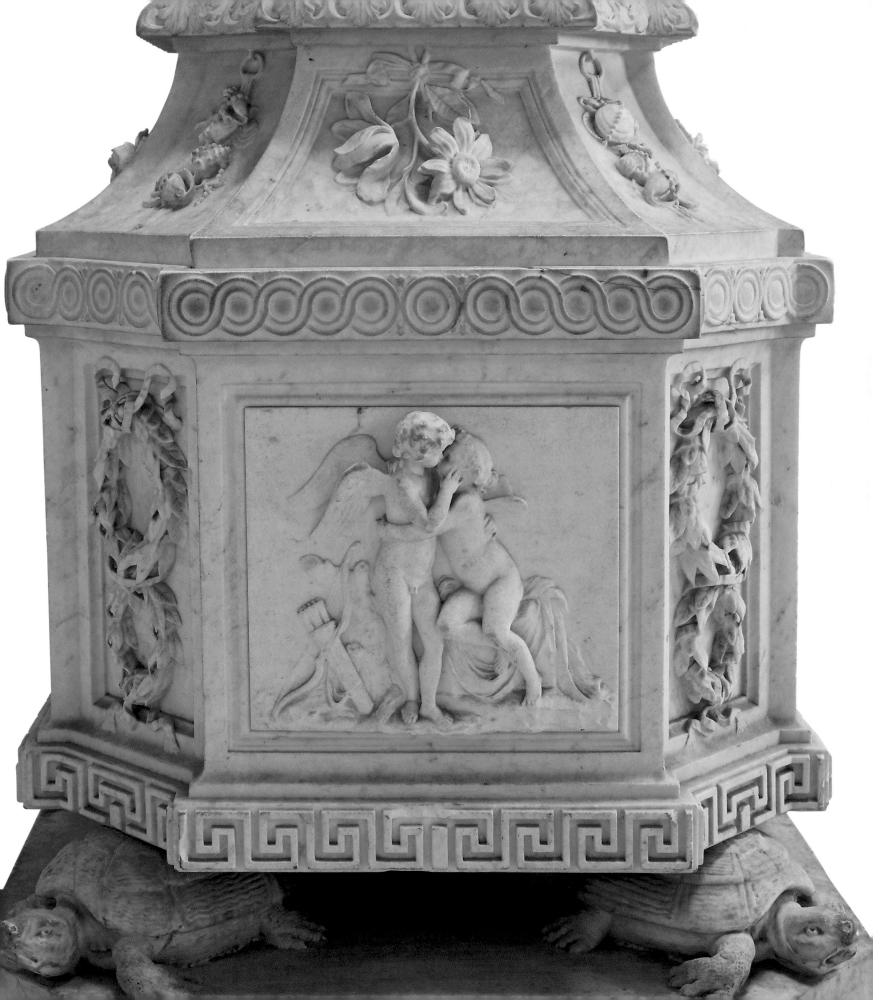

92 David Allan 1744–1796 *A Highland Dance*, c.1780

Brush and watercolour over pencil on paper · 29.4 × 80.4cm
Purchased by the Patrons of the National Galleries of Scotland 1990 [D 5185]

93 Robert Adam 1728–1792 *Cullen Castle, Banffshire, c.1770–80*

Pen and brown ink and grey wash over black chalk on paper · 35.6 × 51cm
Purchased 1991 [D 5325]

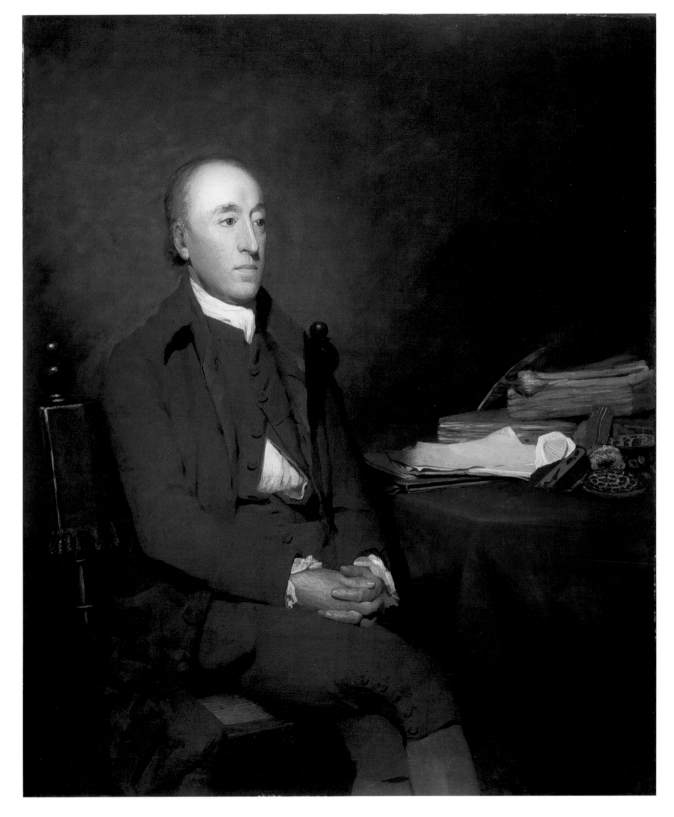

94 Sir Henry Raeburn 1756–1823 *James Hutton (1726–1797), c.*1789/90

Oil on canvas · 125.1 × 104.8cm

Purchased with assistance from the National Art Collections Fund and the National Heritage Memorial Fund 1986 [PG 2686]

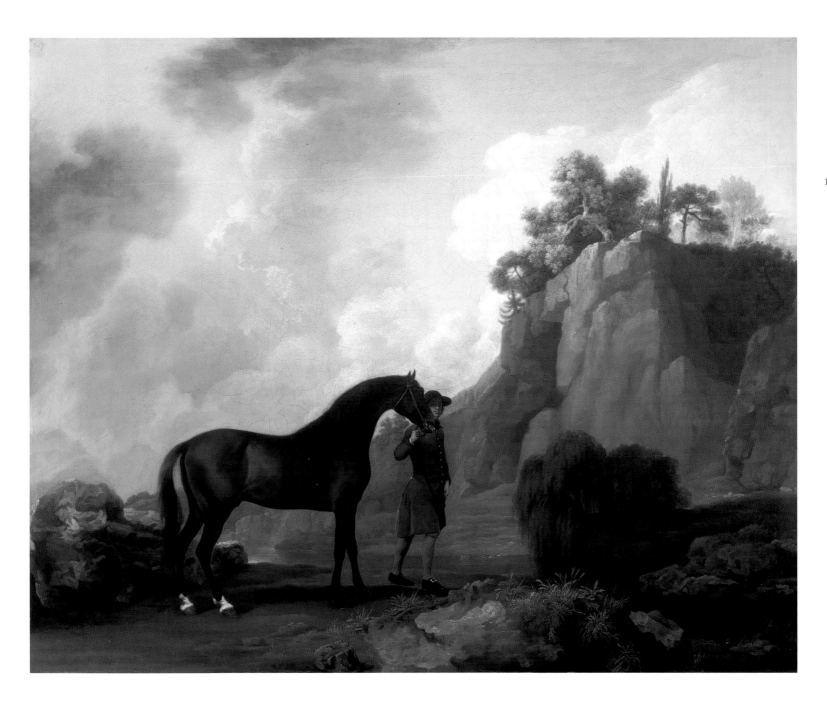

95 George Stubbs 1724–1806

The Marquess of Rockingham's Arabian Stallion Led by a Groom at Creswell Crags, c.1780

Oil on canvas · 97.8 × 123.2cm

Accepted by HM Government in lieu of Inheritance Tax from Olive, Countess Fitzwilliam Chattels
Settlement and allocated to the National Gallery of Scotland 2002 [NG 2724]

96 Johan Tobias Sergel 1740–1814
Ceres Searching for Proserpina, Goddess of the Underworld (one of a pair), 1786

Plaster · 106.7cm high
Purchased 1994 [NG 2630 A]

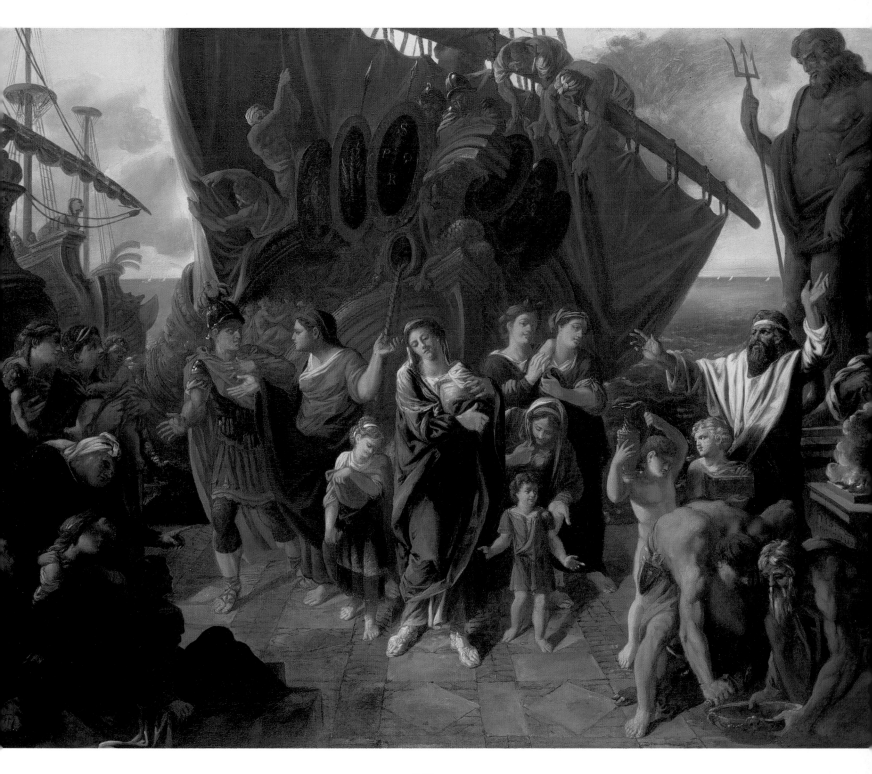

97 Alexander Runciman 1736–1785
Agrippina Landing at Brundisium with the Ashes of Germanicus, 1781

Oil on canvas · 100.2 × 133.2cm
Accepted by HM Government in lieu of Inheritance Tax from the estate of the Hon. Sir Steven
Runciman CH and allocated to the National Gallery of Scotland, 1992 [NG 2544]

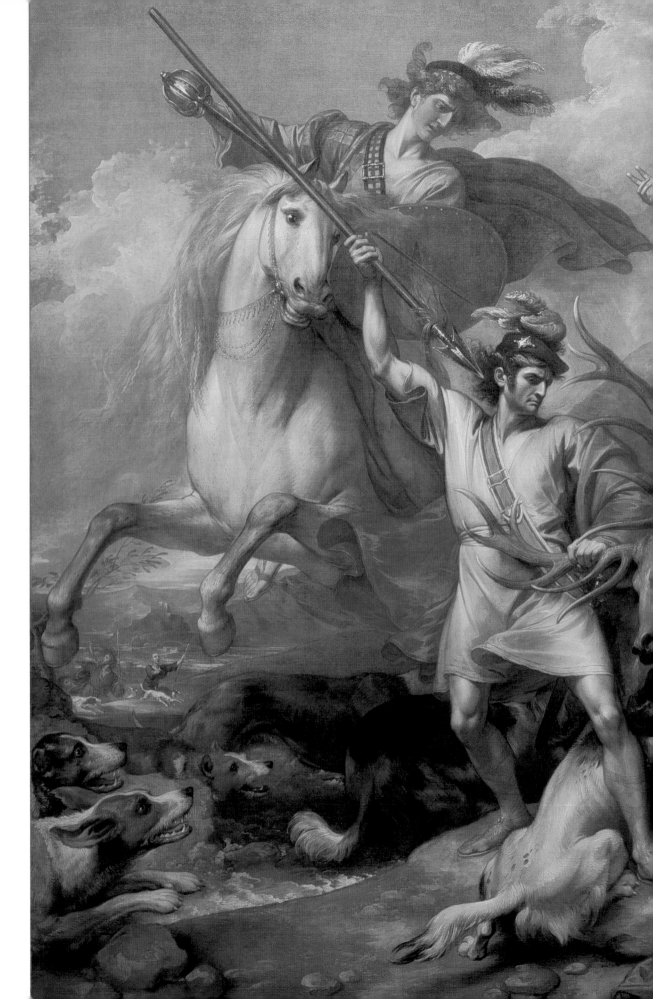

138 **98** Benjamin West
1738–1820
*Alexander III of Scotland
Rescued from the Fury of a
Stag by the Intrepidity of
Colin Fitzgerald
('The Death of the Stag'),*
1786

Oil on canvas · 366 × 521cm
Purchased with assistance
from the National Heritage
Memorial Fund, the National
Art Collections Fund (William
Lang Bequest), Ross and
Cromarty District Council
and Dennis F. Ward 1987
[NG 2448]

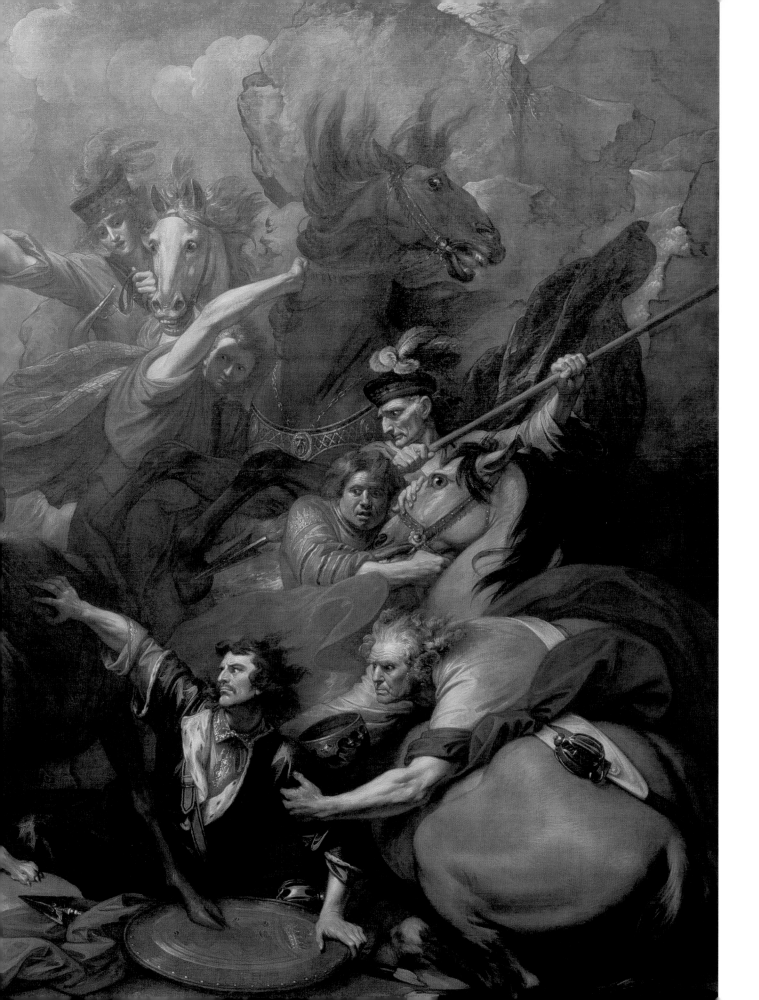

99 Richard Cosway 1742–1821

The Countess of Hopetoun with her Daughters, Jasmin and Lucy, c.1790

Pencil and watercolour on laid paper · 23.5 × 14.3cm
Purchased 1994 [D 5370]

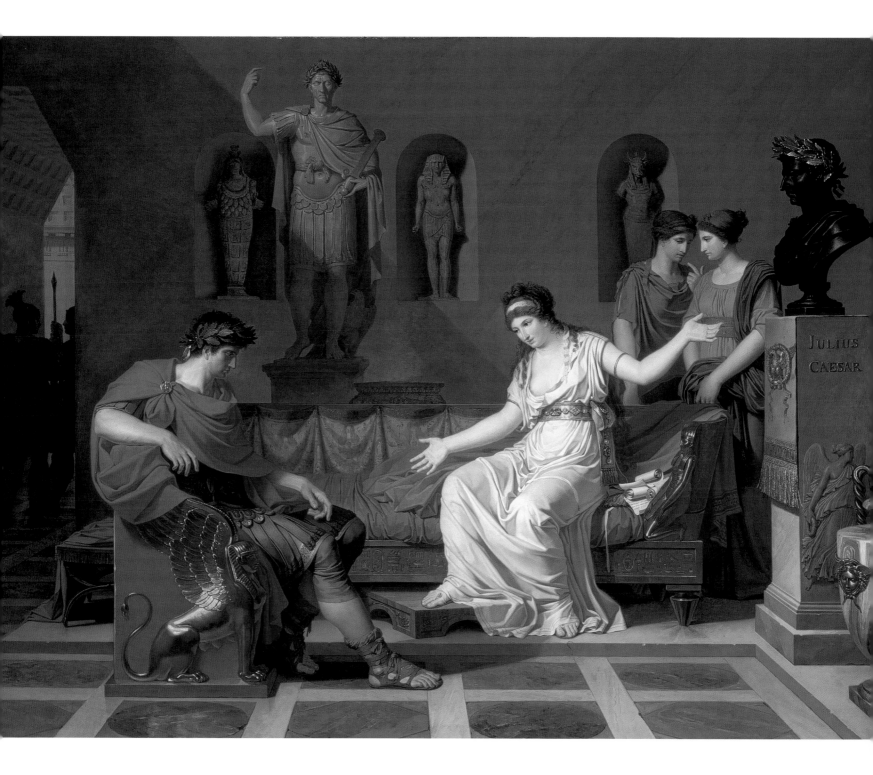

100 Louis Gauffier 1761–1801

Cleopatra and Octavian, 1787–8

Oil on canvas · 83.8 × 112.5cm
Purchased with assistance from the National Art Collections Fund 1991 [NG 2526]

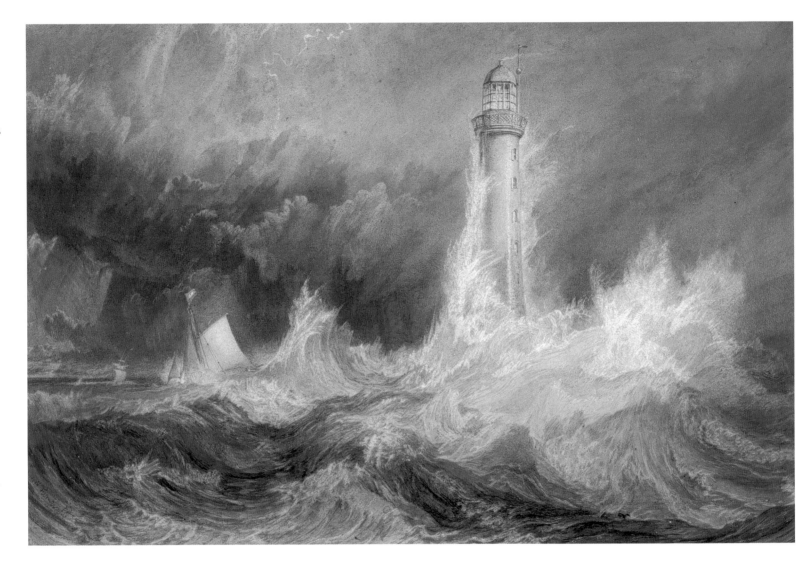

101 Joseph Mallord William Turner 1775–1851
*Bell Rock Lighthouse, c.*1798

Watercolour and gouache with scratching out on paper · 30.6 × 45.5cm
Purchased by Private Treaty Sale 1989 with assistance from the National Heritage
Memorial Fund and the Pilgrim Trust [D 5181 A]

102 Joseph Mallord William Turner 1775–1851
Mount Snowdon, Afterglow, 1798/9

Watercolour and some scraping out on paper · 52.7 × 75.6cm
Mrs Peggy Parker Gift 1991 [D 5284]

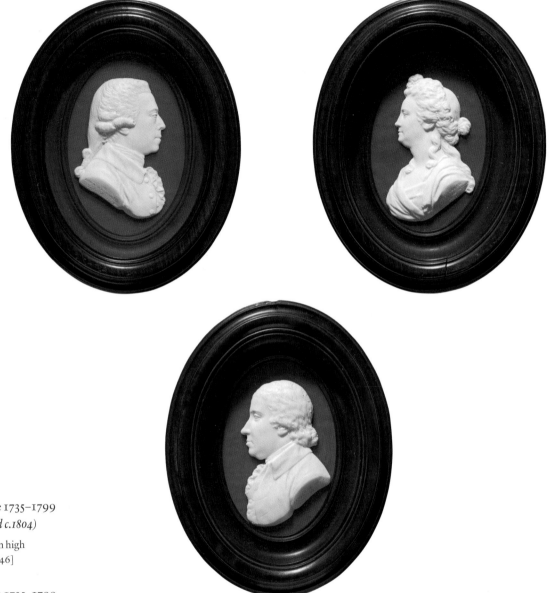

103 James Tassie 1735–1799

John MacGouan (died c.1804)

Paste medallion · 7.4 cm high
Purchased 1991 [PG 2846]

104 James Tassie 1735–1799

*Elizabeth Carnegie, Countess of
Hopetoun (1750–1793)*

Paste medallion · 7.6 cm high
Purchased 1989 [PG 2779]

105 James Tassie 1735–1799

Benjamin Bell (1749–1806)

Paste medallion · 7.9 cm high
Purchased 1989 [PG 2780]

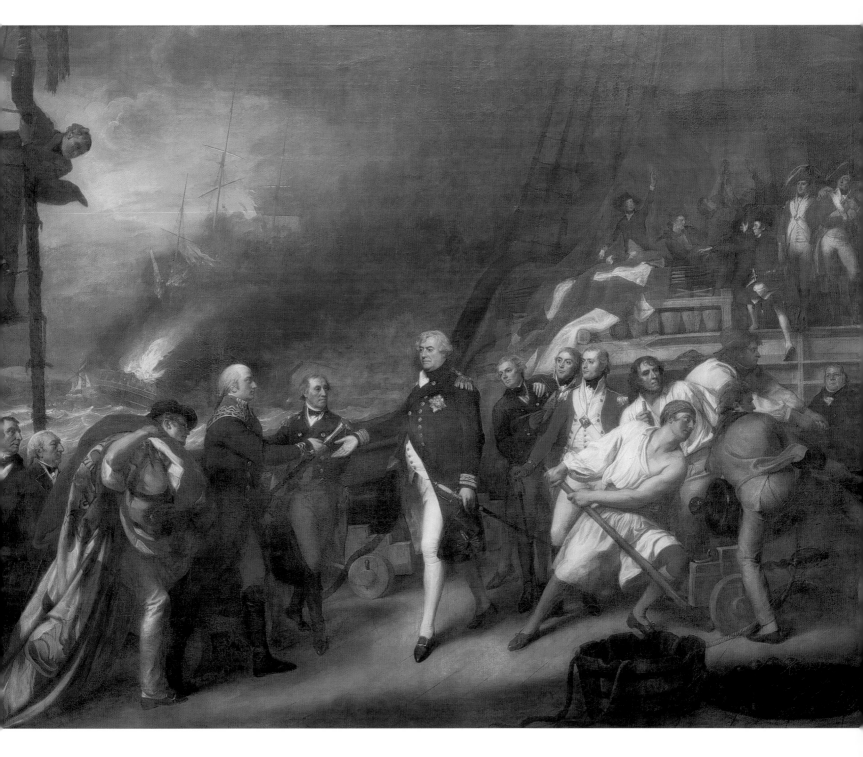

106 John Singleton Copley 1737–1815
The Surrender of the Dutch Admiral de Winter to Admiral Duncan at the Battle of Camperdown
(The Victory of Lord Duncan), 1799

Oil on canvas · 275 × 368.5cm · Acquired from the Countess of Buckinghamshire's Trust 1997
(date of formal concession of ownership) [NG 2661]

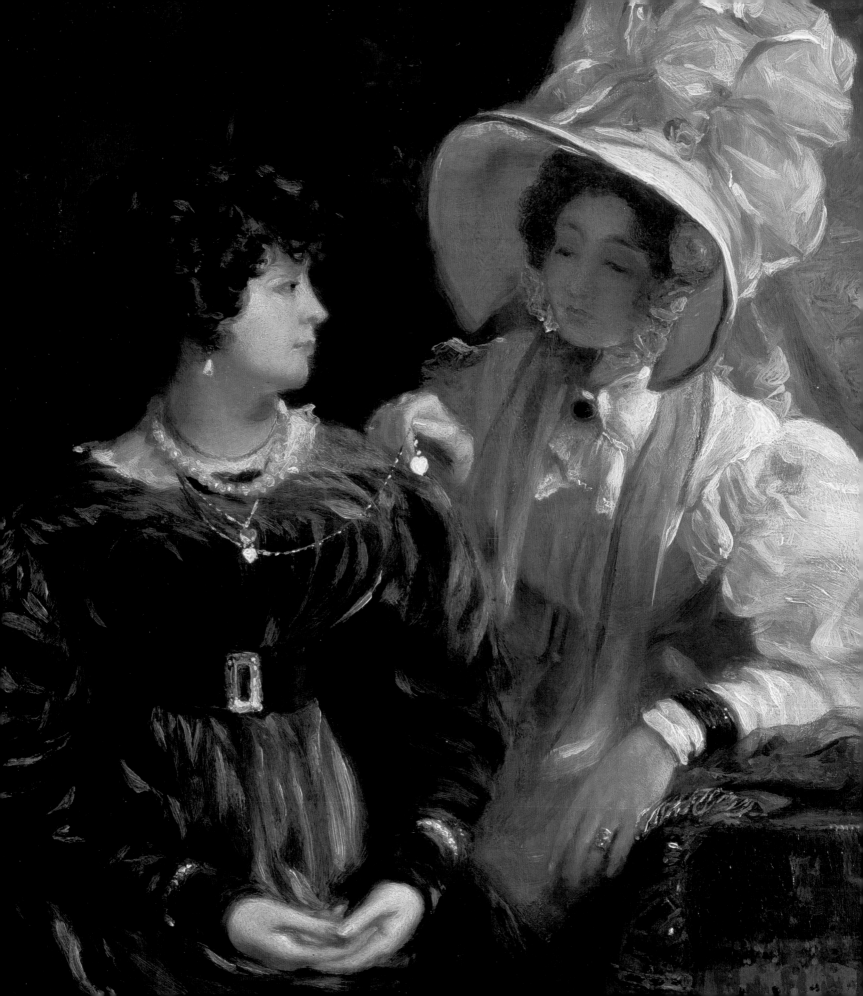

1800
1900

107 Thomas Girtin 1775–1802
The Village of Jedburgh, Roxburgh, 1800

Watercolour over pencil on paper · 30.2 × 52.1cm
Purchased with assistance from the National Heritage Memorial Fund,
the National Art Collections Fund and the Pilgrim Trust 1988 [D 5175]

108 Thomas Girtin 1775–1802
Stepping Stones on the Wharfe at Bolton Abbey, 1801

Watercolour over pencil on paper · 32.7 × 51.8cm
Accepted by HM Government in lieu of Inheritance Tax from the estate of Mr and
Mrs Tom Girtin and allocated to the National Gallery of Scotland 1997 [D 5438]

109 Philip James de Loutherbourg 1740–1812
The Battle of Alexandria, 21 March 1801, 1802

Oil on canvas · 106.6 × 152.6cm
Purchased 1986 [PG 2680]

110 Philip James de Loutherbourg 1740–1812
The Landing of British Troops at Aboukir, 8 March 1801, 1802

Oil on canvas · 106.4 × 152.8cm
Purchased 1986 [PG 2681]

153

111 John Crome 1768–1821 *Monmouth, Barges at Anchor*, 1805

Oil on canvas · 80 × 60cm · Purchased 2002 [NG 2594]

112 John Crome 1768–1821 *A Sandy Bank*, c.1820

Oil on canvas · 35.9 × 51.5cm · Purchased 1988 [NG 2459]

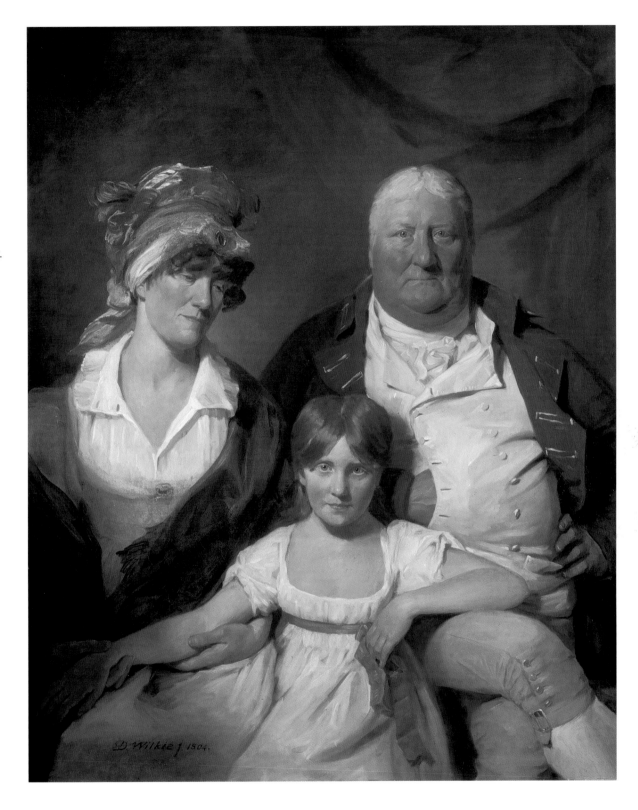

113 David Wilkie 1785–1841

William (Chalmers) Bethune, his Wife Isobel Morison and their Daughter Isabella, 1804

Oil on canvas · 125.7 × 102.9cm · Purchased with the Barrogill Keith Bequest Fund, supplemented
with the Rutherford, Laird McDougall and Cowan Smith Funds 1985 [NG 2433]

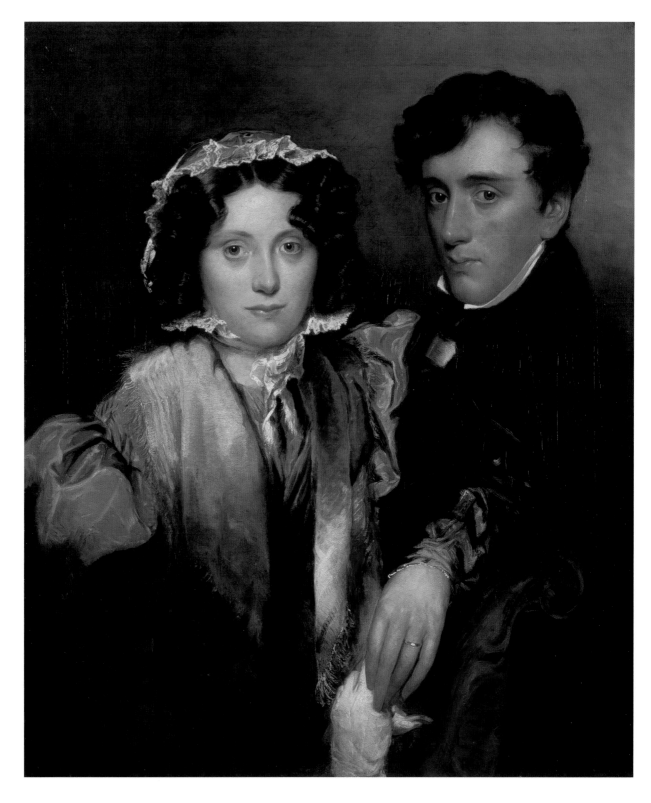

114 Robert Scott Lauder 1803–1869

John Gibson Lockhart (1794–1854) with Charlotte Sophia Scott,
Mrs Lockhart (1799–1837), c.1840

Oil on canvas · 76.8 × 64.8cm · Purchased 1985 [PG 2672]

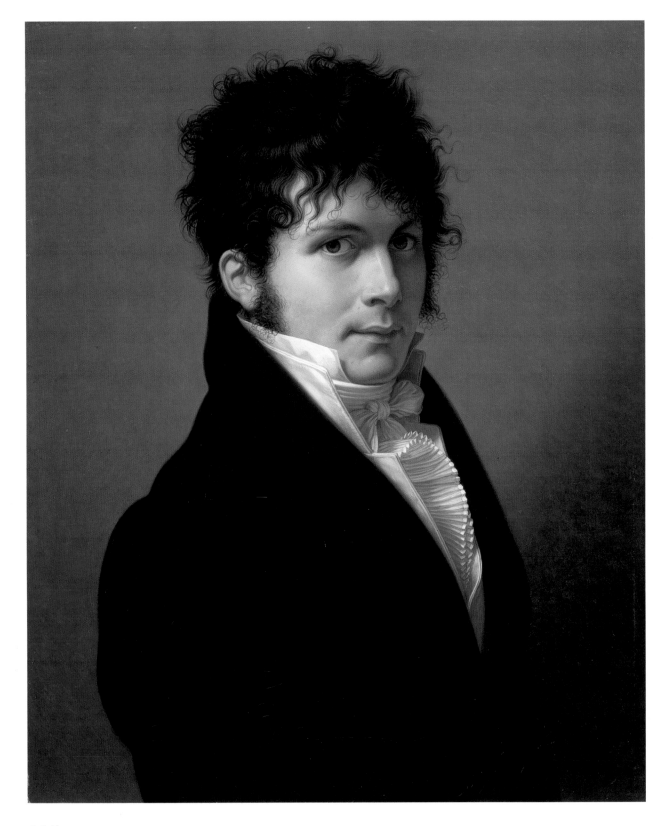

115 François-Xavier Fabre 1766–1837 *Portrait of a Man*, 1809

Oil on canvas · 61.5 × 50cm

Purchased with assistance from the National Art Collections Fund (Scottish Fund) 1992 [NG 2548]

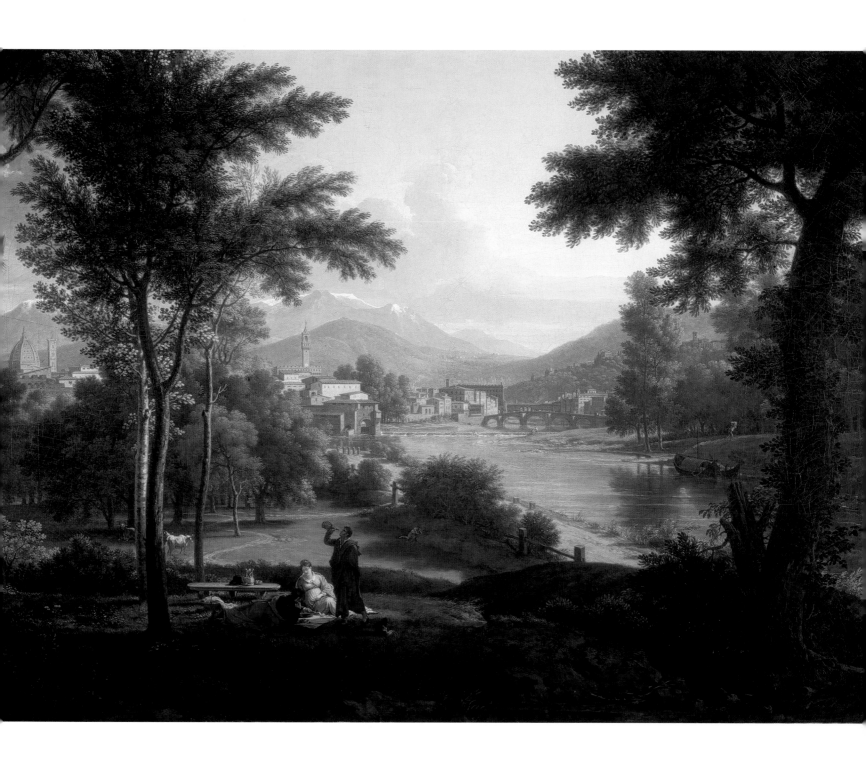

116 François-Xavier Fabre 1766–1837

A View of Florence from the North Bank of the Arno, 1813

Oil on canvas · 96 × 135cm
Purchased with assistance from the Galloway Anderson Fund
and the National Art Collections Fund 1998 [NG 2692]

31 May 1800.

117 Henry Fuseli (Johann Heinrich Füssli)
1741–1825
Portrait of Mrs Fuseli 31 May 1800

Brush and grey wash over traces of black chalk on paper
22 × 15.4cm
Purchased by Private Treaty sale 1987 [D 5146]

118 Francois-Pascal-Simon Gerard
1770–1837
*Madame Mère (Maria Laetitia Ramolino
Bonaparte, 1750–1836), c.*1800–4

Oil on canvas · 210.8 × 129.8cm
Purchased with assistance from the National Art
Collections Fund 1988 [NG 2461]

119 Antonio Canova 1757–1822
Sketch-model for a Standing Figure of 'Peace',
c.1811–12

Terracotta · 40 × 17 × 14cm
Purchased by Private Treaty with assistance from the
National Heritage Memorial Fund and the National
Art Collections Fund 1996 [NG 2649]

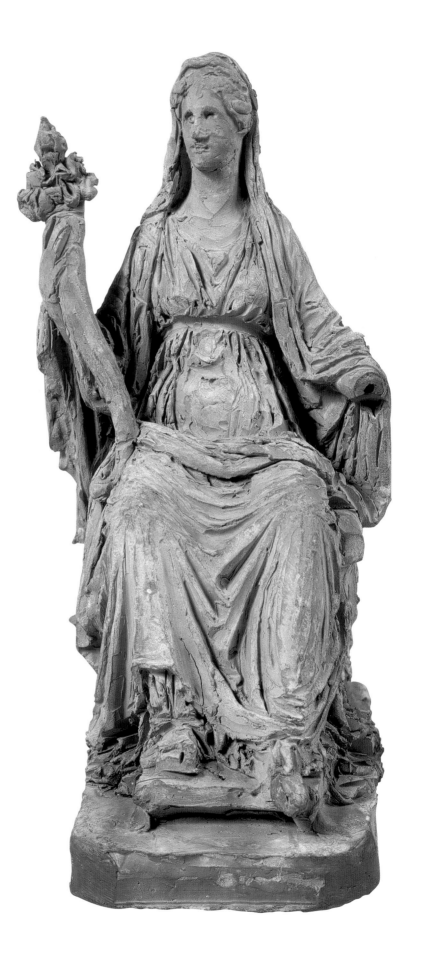

120 Antonio Canova 1757–1822

*Sketch-model of Maria Luisa Buonaparte
as 'Concordia', c.*1810–12

Terracotta · 39 × 20 × 23cm
Purchased by Private Treaty with assistance from the
National Heritage Memorial Fund and the National
Art Collections Fund 1996 [NG 2648]

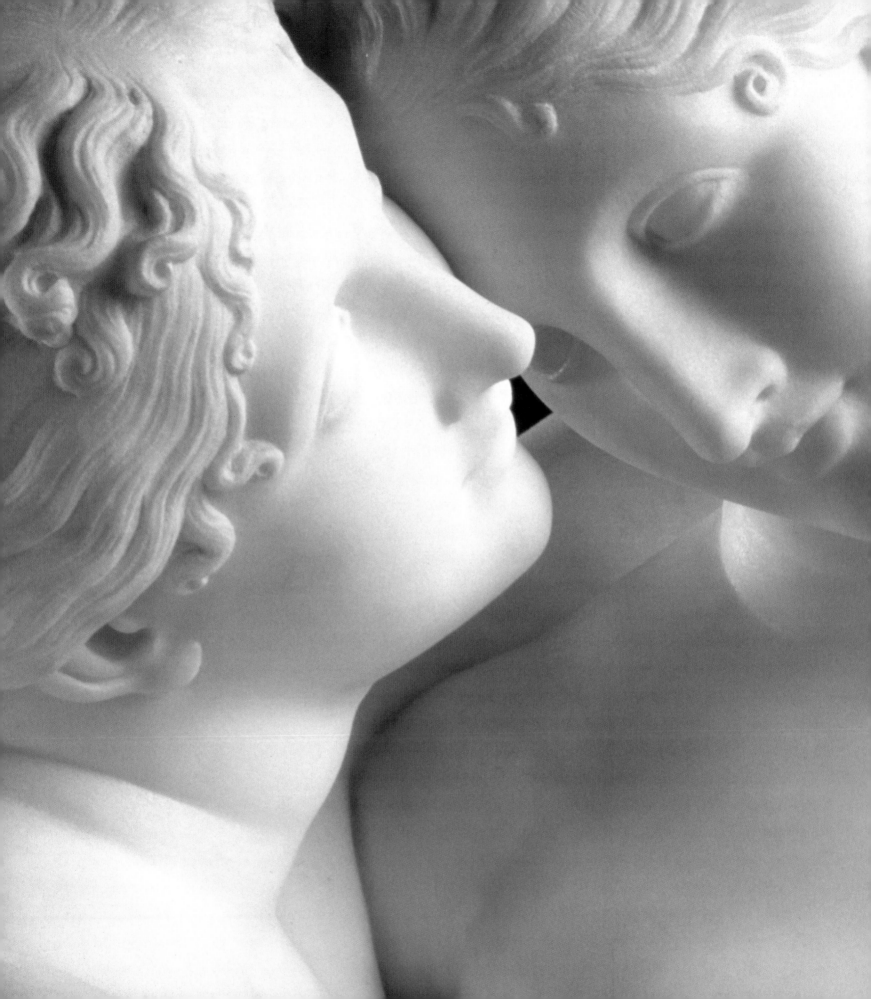

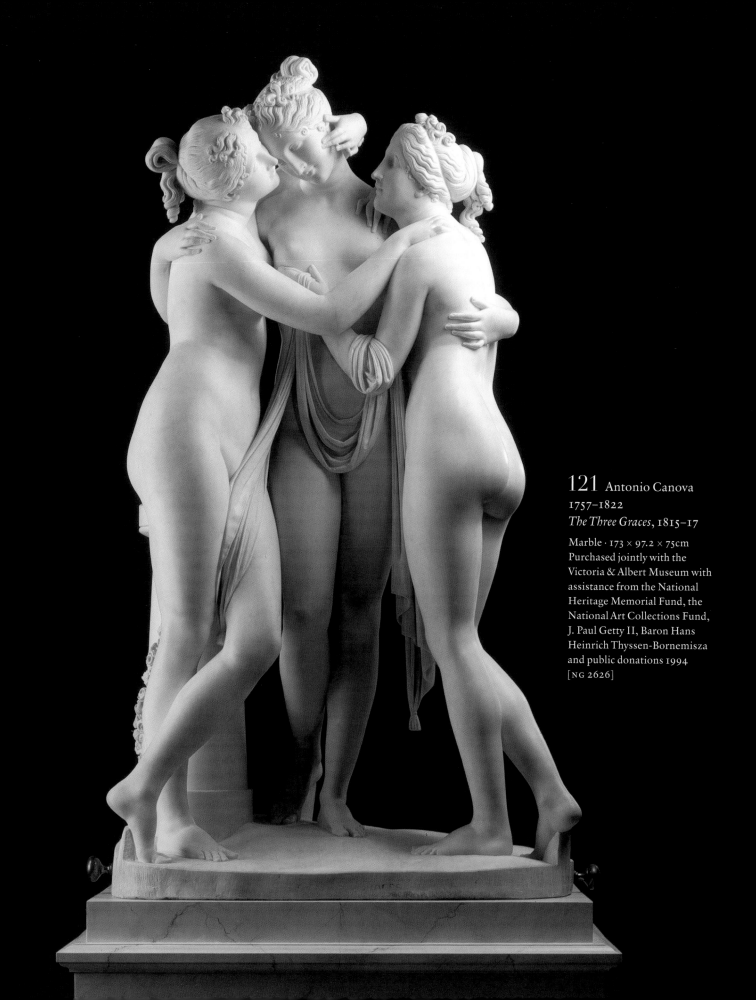

121 Antonio Canova
1757–1822
The Three Graces, 1815–17

Marble · 173 × 97.2 × 75cm
Purchased jointly with the
Victoria & Albert Museum with
assistance from the National
Heritage Memorial Fund, the
National Art Collections Fund,
J. Paul Getty II, Baron Hans
Heinrich Thyssen-Bornemisza
and public donations 1994
[NG 2626]

Songe d'Ossian

122 Jean-Auguste-Dominique Ingres 1780–1867
The Dream of Ossian, 1811

Pencil, black and white chalk on green-blue washed paper · 26 × 20.5cm
Purchased 1994 [D 5369]

123 Francis Towne 1740–1816
Edinburgh Castle and the Calton Hill, 13 August 1811

Pen and ink and watercolour, over traces of pencil,
on two joined sheets of paper · 17.2 × 51cm
Purchased 1991 [D 5326]

124 Joseph Mallord William Turner 1775–1851
*Edinburgh from Calton Hill, c.*1819

Watercolour on paper · 16.8 × 24.9cm
Purchased by Private Treaty with assistance from the National Lottery
through the Heritage Lottery Fund and the National Art Collections
Fund 1998 [D 5446]

125 Joseph Mallord William Turner 1775–1851
Heriot's Hospital, Edinburgh, c.1819

Watercolour on paper · 16.6 × 25cm
Purchased by Private Treaty with assistance from the National Lottery
through the Heritage Lottery Fund and the National Art Collections
Fund 1998 [D 5447]

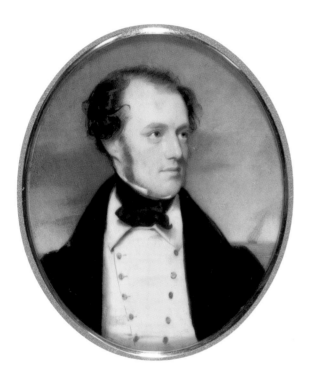

126 Attributed to William Grimaldi 1751–1830

Rear-Admiral Sir Frederick Lewis Maitland RN (1777–1839), c.1810–15

Watercolour on Ivory in original gilt-metal frame · 8.5cm high
Bequeathed by Miss Joan Constance Maxwell 1992 [PG 2891]

127 Edward Robertson born 1809– died after 1837

Captain Charles Robertson RN (1808–1888), 1837

Watercolour on ivory in original gilt-metal slip and
closing red leather case · 7.5cm high
Purchased 1994 [PG 2949]

128 Andrew Geddes 1783–1844

Portrait of Two Women (possibly Adela Geddes (1791–1881), the Artist's Wife, and a Friend), *c*.1820–30

Oil on panel · 20 × 17cm
Purchased with funds from the Scottish Postal Board through the
Patrons of the National Galleries of Scotland 1986 [NG 2438]

129 Alexander Nasmyth 1758–1840
Princes Street with the Commencement of the Building of the Royal Institution, 1825

Oil on canvas · 122.5 × 165.5cm
Presented by Sir David Baird 1991 [NG 2542]

130 David Roberts 1796–1864
View of Edinburgh from the Ramparts of the Castle, Looking East, c.1846

Watercolour with gum arabic over pencil, heightened with white bodycolour on two sheets
of blue-green paper, joined together; faintly squared in pencil · 28.5 × 80cm
Purchased 2000 [D 5508]

131 Christen Købke 1810–1848
*Copenhagen, a View of the Square in the Kastel
Looking Towards the Ramparts, c.1830*

Oil on canvas · 30 × 23.4cm
Purchased with the assistance from the National
Art Collections Fund 1989 [NG 2505]

132 Emilius Ditlev Baerentzen
1799–1868
The Winther Family, 1827

Oil on canvas · 70.5 × 65.5cm
Purchased by the Patrons of the National
Galleries of Scotland 1987 [NG 2451]

133 Bertel Thorwaldsen
1770–1844
Sir Walter Scott (1771–1832), 1833/4

Marble · 58cm high (including socle)
Purchased with assistance from the
National Heritage Memorial Fund and
the National Art Collections Fund 1993
[PG 2933]

134 David Wilkie 1785–1841
General Sir David Baird Discovering the
Body of Sultan Tippoo Sahib after
having Captured Seringapatam, on the
4th May, 1799, 1839

Oil on canvas · 348.5 × 267.9cm
Presented by Irvine Chalmers Watson 1985
[NG 2430]

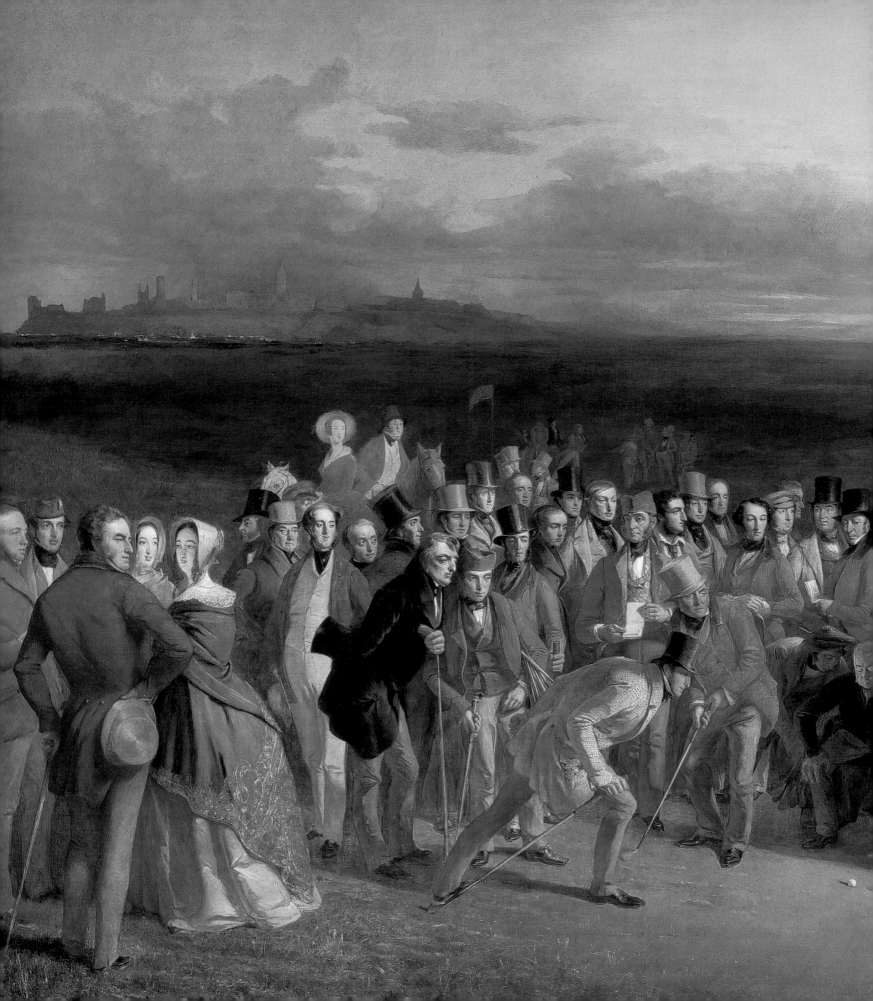

135 Charles Lees 177
1800–1880
The Golfers, 1847

Oil on canvas
131 × 214cm
Purchased with assistance
from the Heritage Lottery
Fund, the National Art
Collections Fund and
The Royal and Ancient
Golf Club 2002
[PG 3299]

136 Edward Lear 1812–1888

Athens, 1849

Pen and brown ink with watercolour and gouache on grey paper · 19.7 × 31.5cm
Accepted by HM Government in lieu of Inheritance Tax from the estate of the Hon. Sir Steven
Runciman C H and allocated to the National Gallery of Scotland 2003

137 Karl Friedrich Schinkel 1781–1841

Design for a Palace at Orianda in the Crimea: Perspective View of the Sea Terrace,
Showing the Caryatid Portico and Glazed Semi-circular Side Bay, published 1847

Colour lithograph on paper · platemark size 48 × 49cm
Purchased with assistance from the National Lottery through the
Heritage Lottery Fund 1997 [P 2910.2]

Ansicht des Schlosses auf der Terrasse nach dem Meere zu.
Man sieht die Karyatiden-Halle in der Mitte desselben, und
die zwei vorspringenden Seiten-Cabinets.

Erfunden v. Schinkel. Lithogr. W.Loeillot.

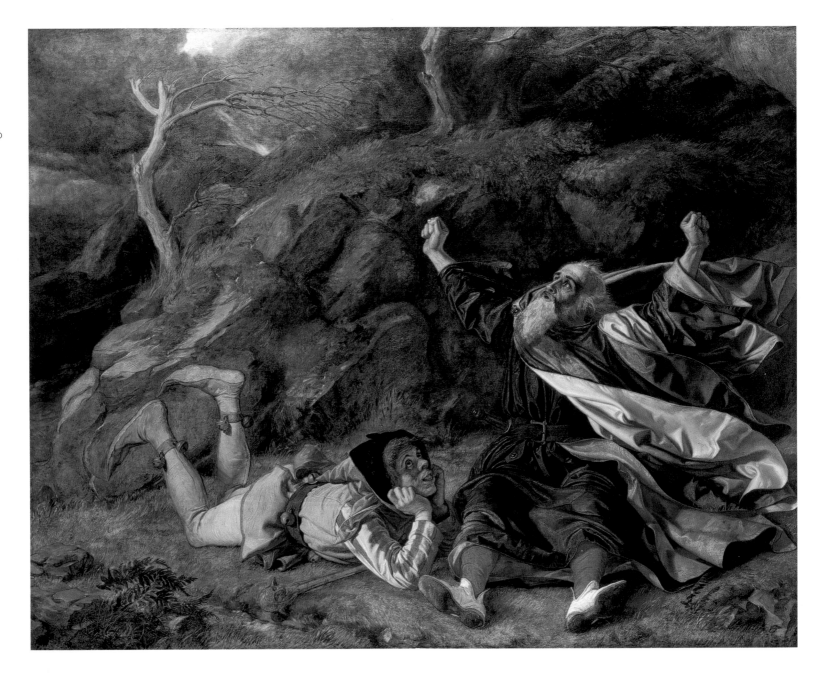

138 William Dyce 1806–1864

King Lear and the Fool in the Storm, c.1851

Oil on canvas · 173 × 136cm
Purchased with assistance from the National Art Collections Fund 1993 [NG 2585]

139 Robert Macpherson 1811–1872 *Via de Sugherari, the Theatre of Marcellus, Rome, c.1860*

Albumen print · 40.4 × 29.1cm · Purchased 1990 [PGP 32.3]

140 Roger Fenton 1819–1869 *Lieutenant-General Sir Colin Campbell*, 1855

Salt print from a collodion negative · 23 × 18.8cm
Purchased with assistance from the National Art Collections Fund 1999 [PGP 237.7]

141 Francis Grant 1803–1878
Anne Emily Sophia Grant (known as 'Daisy' Grant), Mrs William Markham (1836–1880), 1864

Oil on canvas · 223.5 × 132.3cm
Purchased with assistance from the National Art Collections Fund and the Patrons of the National Galleries of Scotland 2005 [NG 2783]

142 Charles-François Daubigny 1817–1878
Orchard in Blossom (Les Pommiers en Fleur), 1874

Oil on canvas · 85 × 157cm
Purchased 1993 [NG 2586]

143 Sir James Guthrie 1859–1930

Margaret Helen Sowerby
(known as Helen Sowerby), 1882

Oil on canvas · 161 × 61.2cm
Purchased 1999 [NG 2700]

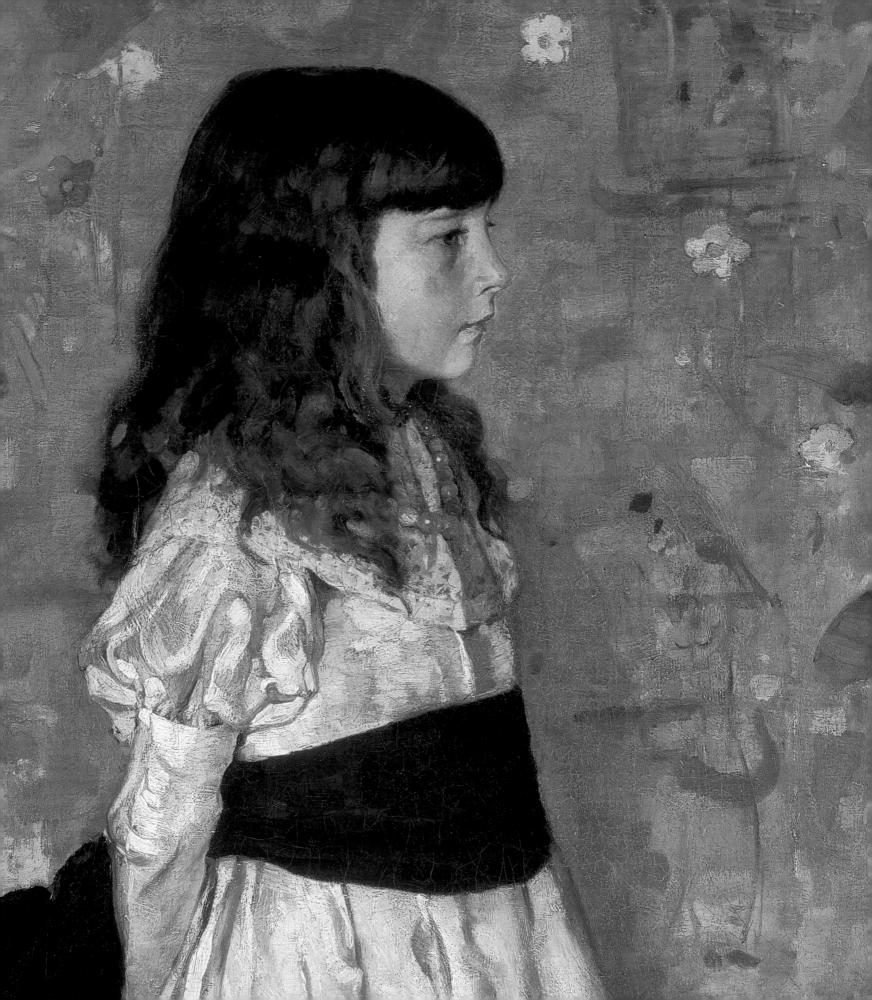

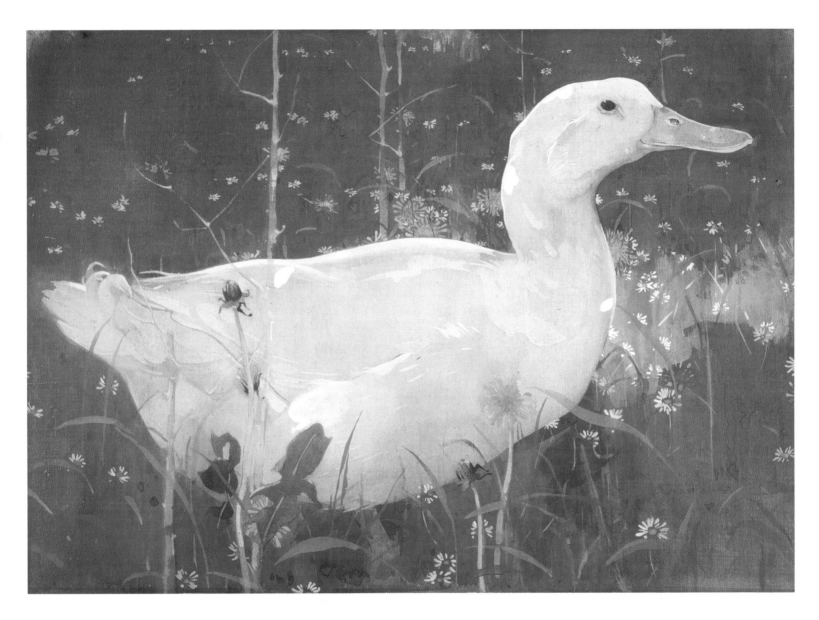

144 Joseph Crawhall 1861–1913 *The White Drake, c.*1895

Watercolour and gouache on unsized brown linen, laid onto a wood backboard · 40.7 × 57.1cm
Purchased with assistance from the National Lottery through the Heritage Lottery Fund
and the National Art Collections Fund 1996 [D 5415]

145 Alphonse Mucha 1860–1939 *Peonies,* 1897–8

Ink and watercolour on paper · 95 × 79.5cm
Purchased with assistance from the Patrons of the National Galleries of Scotland 2003 [GMA 4678]

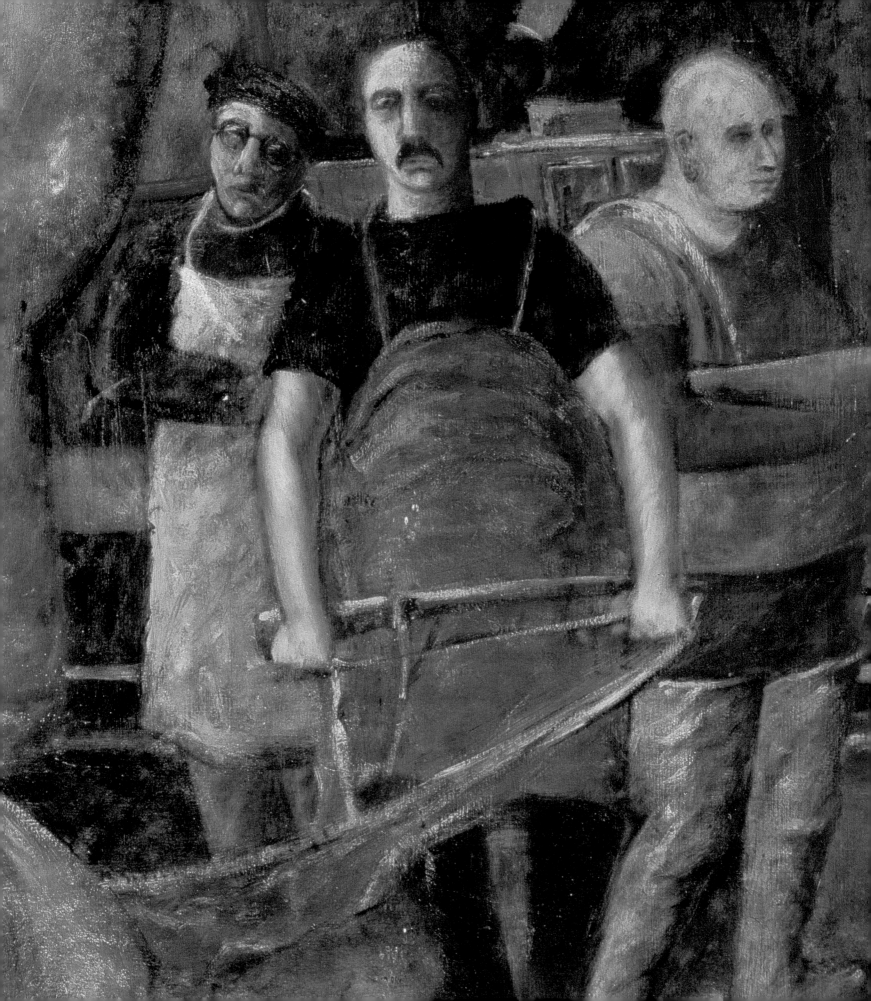

1900
2000

146 Charles Rennie Mackintosh 1868–1928
Revolving Bookcase for Hous'hill, Nitshill, Glasgow, 1904

Wood, painted · 122 × 46 × 46cm
Purchased 1989 [GMA 3447]

147 Gustav Klimt 1862–1918
*Schwangere mit Mann nach links
(Pregnant Woman with Man), c.1903–4*

Black chalk on paper · 44.7 × 30.6cm
Purchased 1985 [GMA 2946]

148 Alfred Stieglitz 1864–1946
The Steerage, June 1907

Photogravure · 19.5 × 15.7cm
Presented by Mrs Elizabeth Uldall in memory
of her sister, Ruth Anderson, 1998 [PGP 232.1]

149 Alfred G. Buckham 1880–1953
Aerial View of Edinburgh, c.1920

Silver gelatine print · 45.8 × 37.8cm
Purchased 1990 [PGP 197.1]

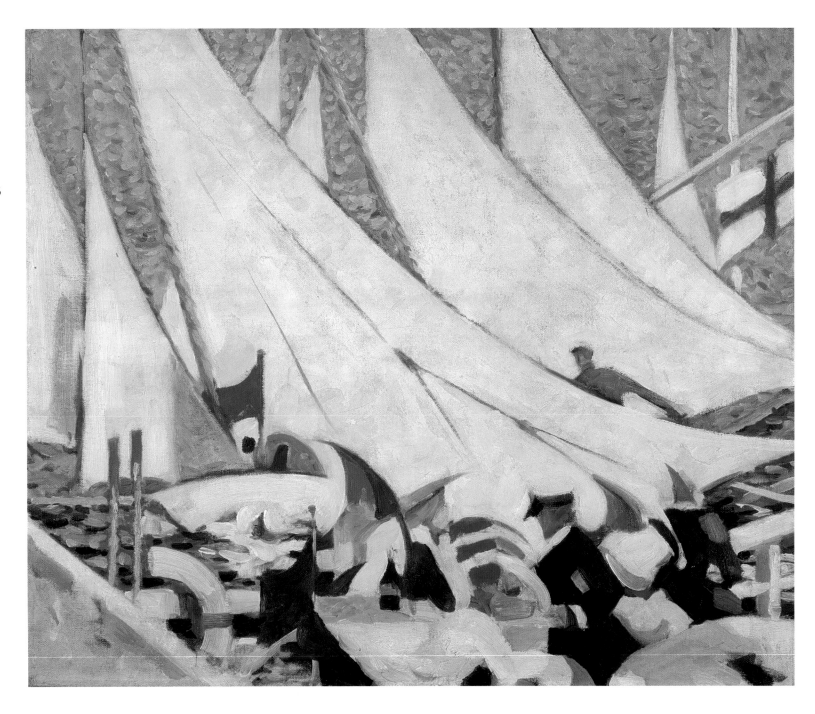

150 Stanley Cursiter 1887–1976 *The Regatta*, 1913

Oil on canvas · 50.4 × 60.8cm · Purchased 1987 [GMA 3034]

151 Lyonel Feininger 1871–1956 *Gelmeroda III*, 1913

Oil on canvas · 100.5 × 80cm · Purchased 1985 [GMA 2951]

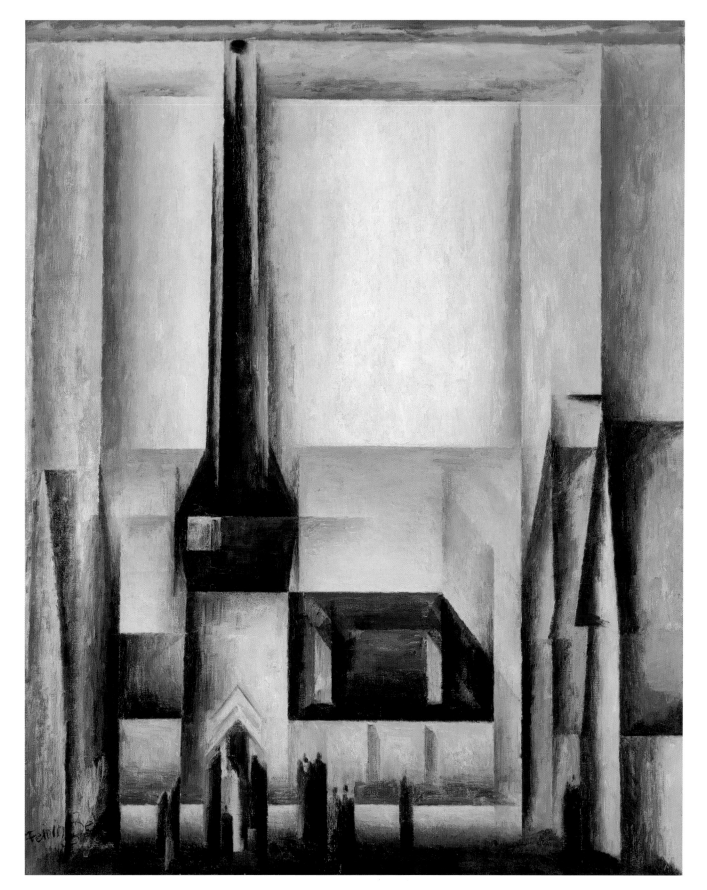

152 Oskar Kokoschka 1886–1980 *Alma Mahler, c.1913*

Black chalk on paper · 39.2 × 31.5cm
Purchased 1987 [GMA 3037]

153 Pablo Picasso 1881–1973 *Tête [Head]*, 1913

Papiers collés with black chalk on card · 43.5 × 33cm

Purchased with assistance from the Heritage Lottery Fund and the National Art Collections Fund 1995 [GMA 3890]

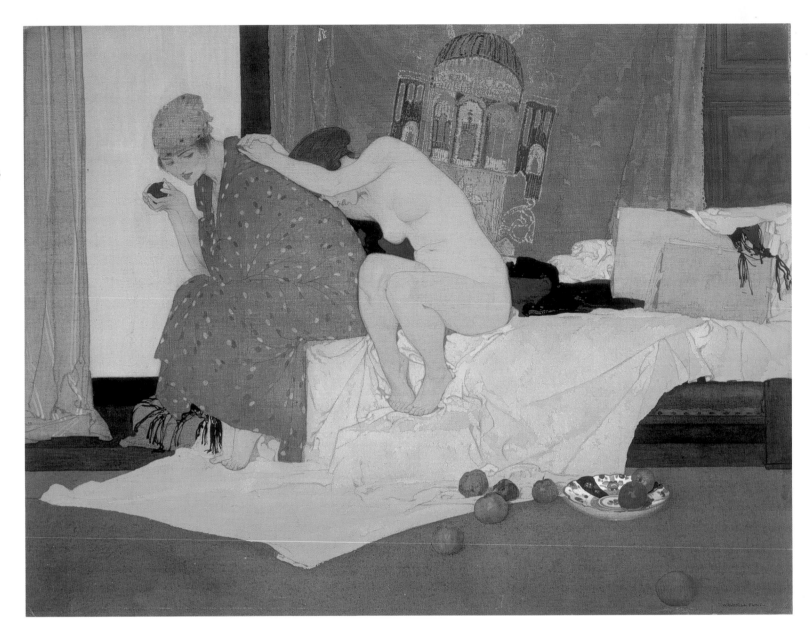

154 Sir William Russell Flint 1880–1969
Two Models in a Studio, 1920

Watercolour on linen · 49.9 × 67.1cm
Purchased 2003 [GMA 4682]

155 Stanley Cursiter 1887–1976
Twilight, 1914

Oil on canvas · 152.5 × 214cm
Purchased 1987 [NG 2452]

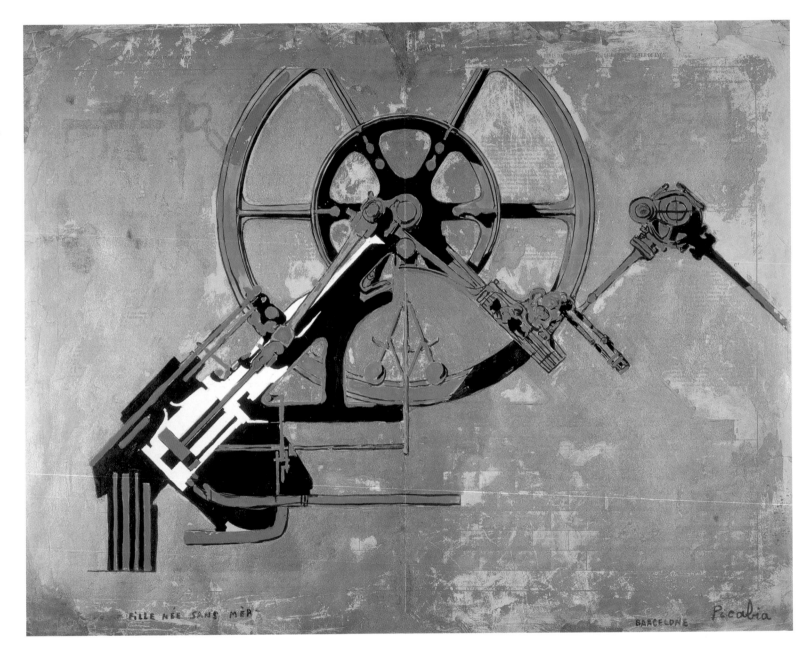

156 Francis Picabia 1879–1953

Fille née sans mère [Girl Born without a Mother], c.1916–17

Gouache and metallic paint on printed paper · 50 × 65cm
Purchased 1990 [GMA 3545]

157 Max Ernst 1891–1976

Katharina Ondulata, 1920

Gouache, pencil and ink on printed paper · 31.5 × 27.5cm
Purchased with assistance from the Heritage Lottery Fund and the National
Art Collections Fund 1995 [GMA 3885]

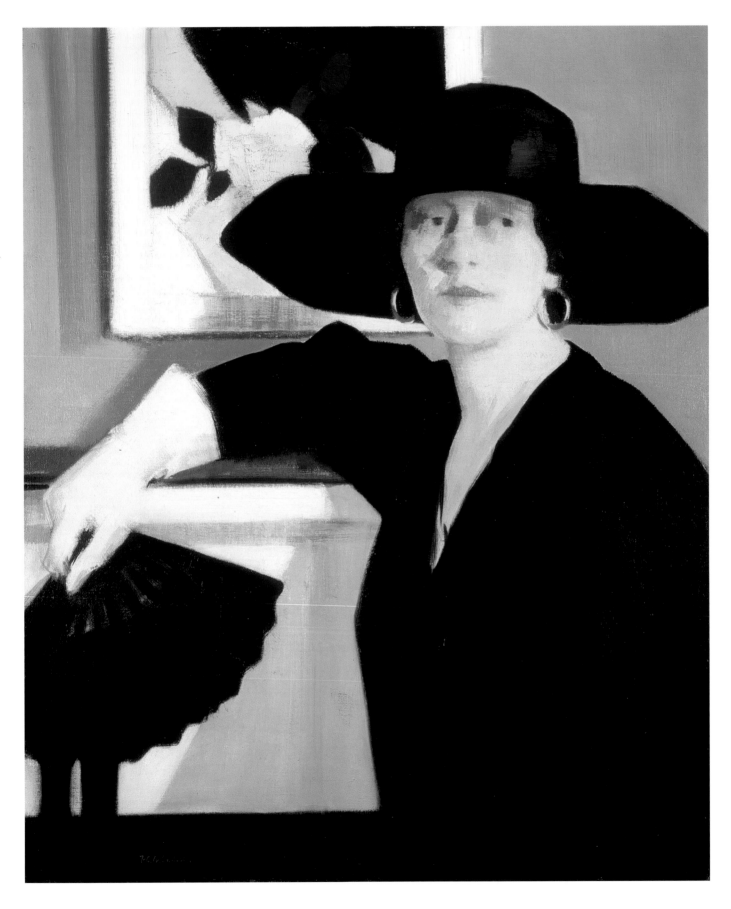

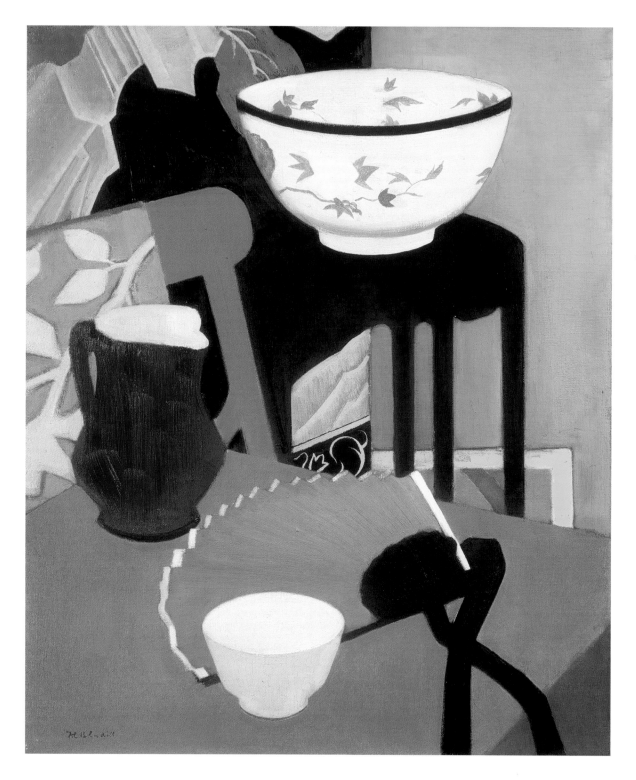

158 Francis Campbell Boileau Cadell 1883–1937 *Portrait of a Lady in Black*, *c.*1921

Oil on canvas · 76.3 × 63.5cm · Bequeathed by Mr and Mrs G.D. Robinson through the National Art Collections Fund 1988 [GMA 3350]

159 Francis Campbell Boileau Cadell 1883–1937 *The Blue Fan*, *c.*1922

Oil on canvas · 61 × 50.5cm · Bequeathed by Dr James T. Ritchie 1999 [GMA 4290]

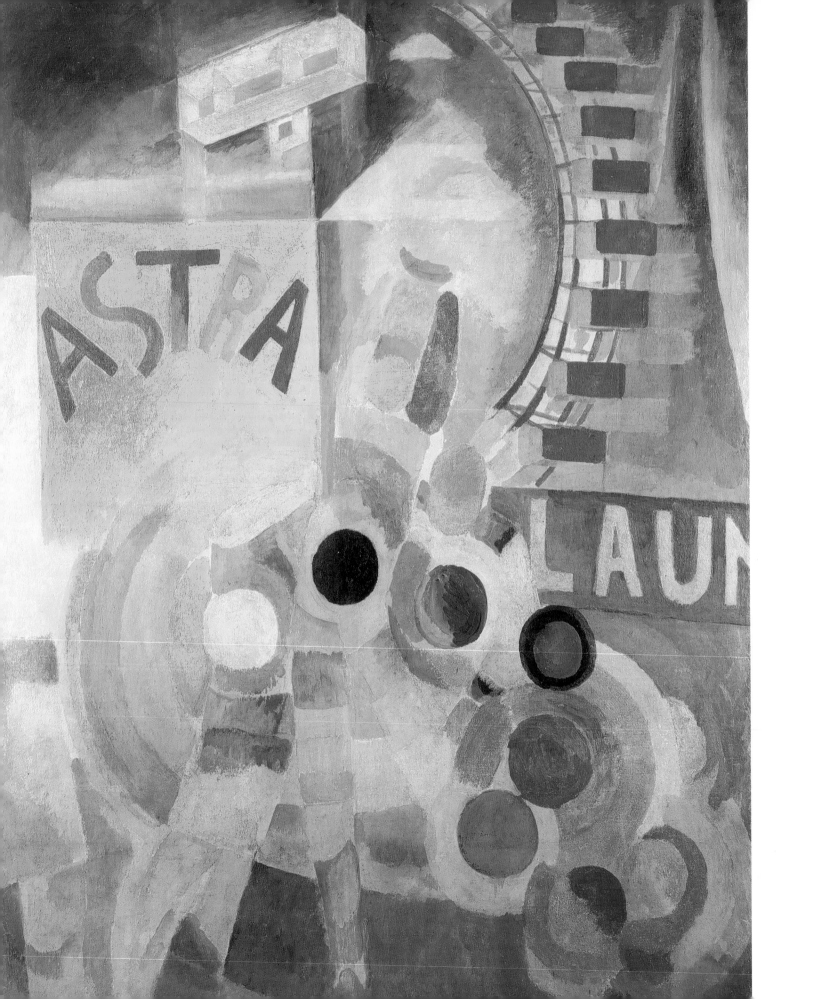

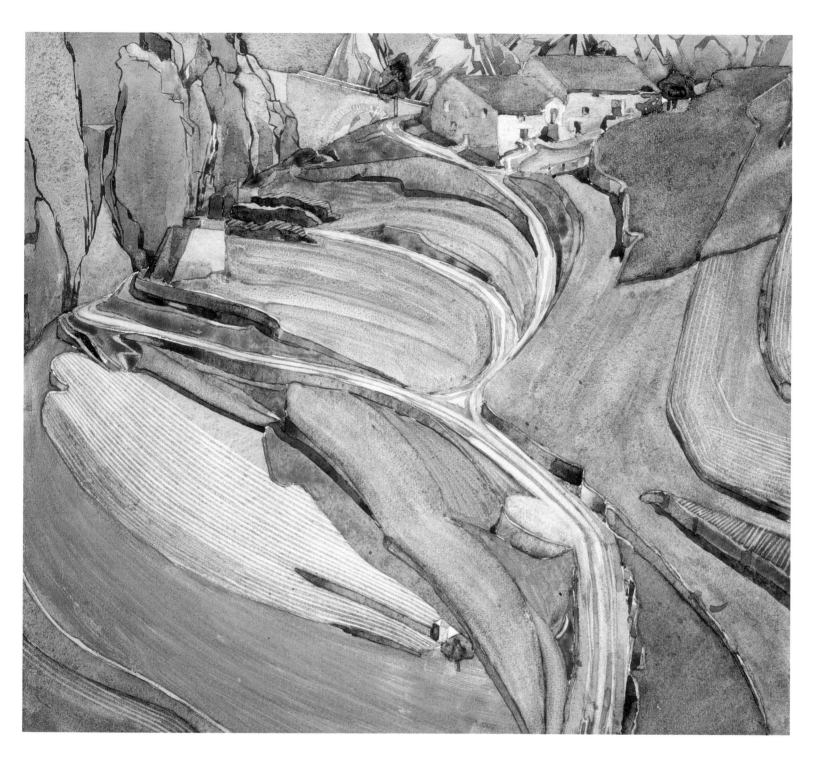

160 Robert Delaunay 1885–1941
L'Équipe de Cardiff [The Cardiff Team], 1922–3
Oil and tempera on canvas · 146.8 × 114.2cm · Purchased 1985 [GMA 2942]

161 Charles Rennie Mackintosh 1868–1928
Mont Alba, c.1924–7
Watercolour on paper · 38.7 × 43.8cm · Purchased 1990 [GMA 3533]

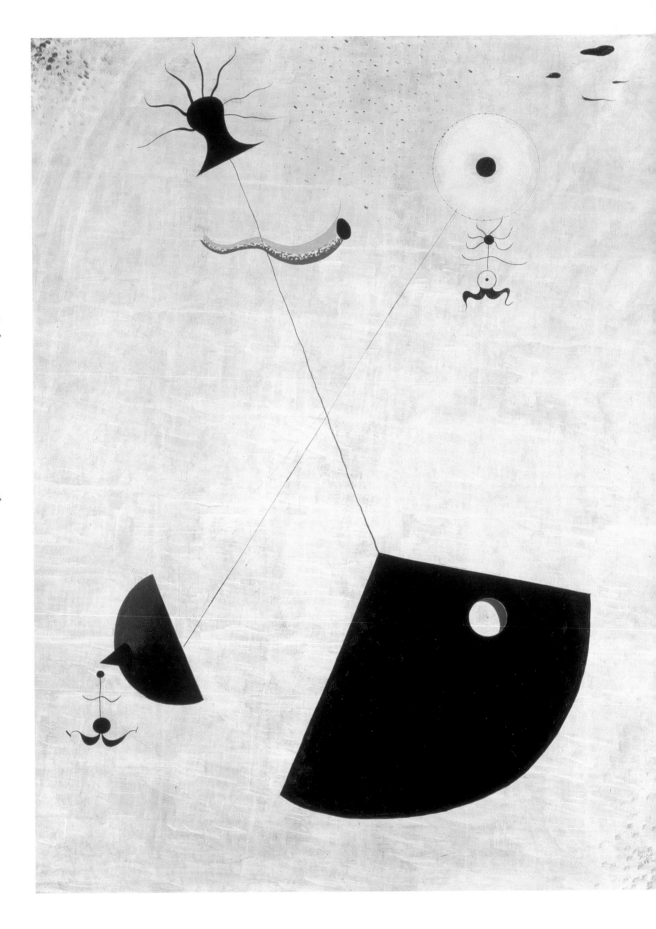

208 **162** Joan Miró 1893–1983
Maternité [Maternity], 1924

Oil on canvas · 92.1 × 73.1cm
Purchased with assistance from the
National Heritage Memorial Fund,
the National Art Collections Fund
(William Leng Bequest) and
members of the public 1991
[GMA 3589]

163 Joan Miró 1893–1983
*Head of a Catalan Peasant
[Tête de paysan Catalan]*, 1925

Oil on canvas · 92.4 × 73cm
Purchased jointly with Tate Gallery,
with assistance from the National
Art Collections Fund 1999
[GMA 4252]

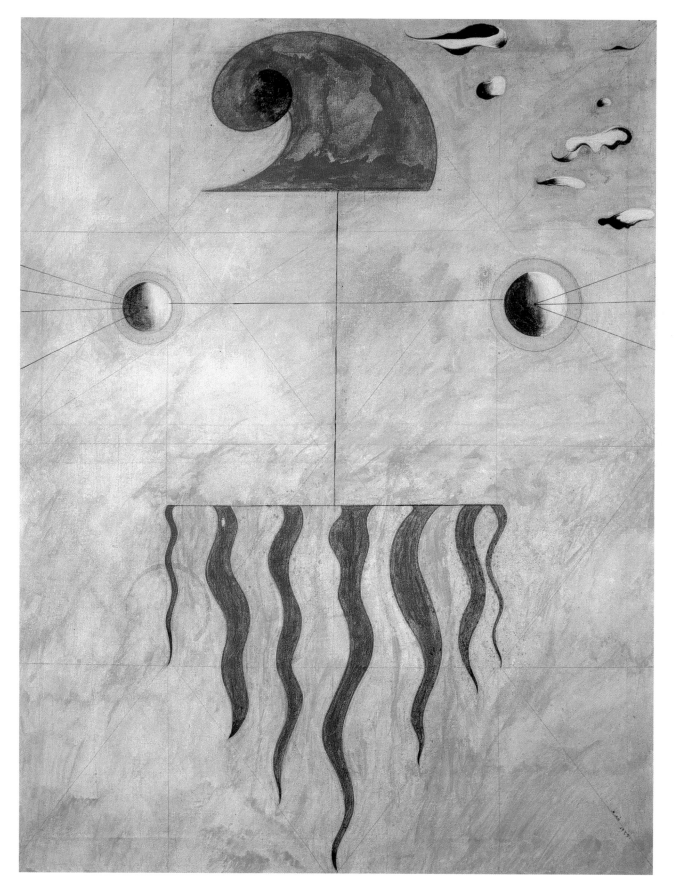

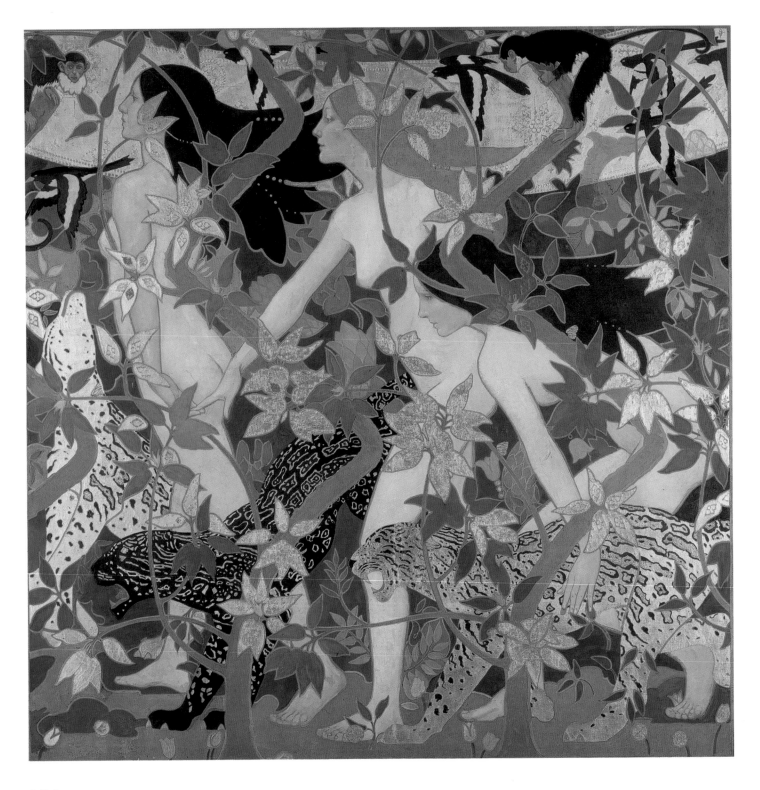

164 Robert Burns 1869–1941
Diana and her Nymphs, c.1926

Oil or tempera on canvas · 198.1 × 198.1cm
Purchased 1987 [NG 2450]

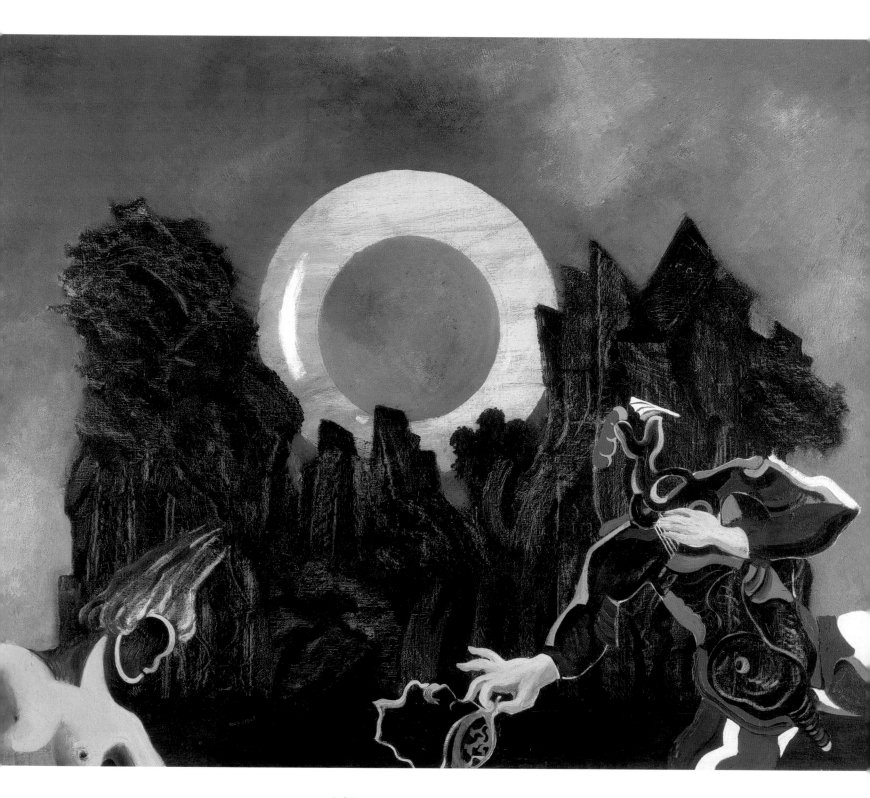

165 Max Ernst 1891–1976 *Max Ernst montrant à une jeune fille la tête de son père*
[Max Ernst Showing a Girl the Head of his Father], 1926/7

Oil on canvas · 114.3 × 146.8cm · Accepted by HM Government in lieu of Inheritance Tax
from the estate of Gabrielle Keiller and allocated to the Scottish National Gallery of Modern Art 1998 [GMA 3972]

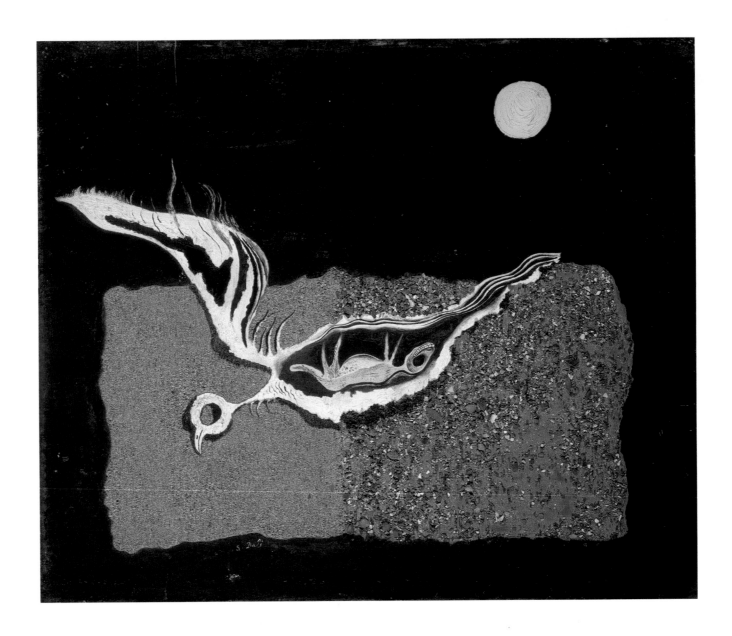

166 Salvador Dalí 1904–1989
Oiseau [Bird], 1928

Oil, sand, pebbles and shingle on board · 49.7 × 61cm
Purchased with assistance from the Heritage Lottery Fund
and the National Art Collections Fund 1995 [GMA 3883]

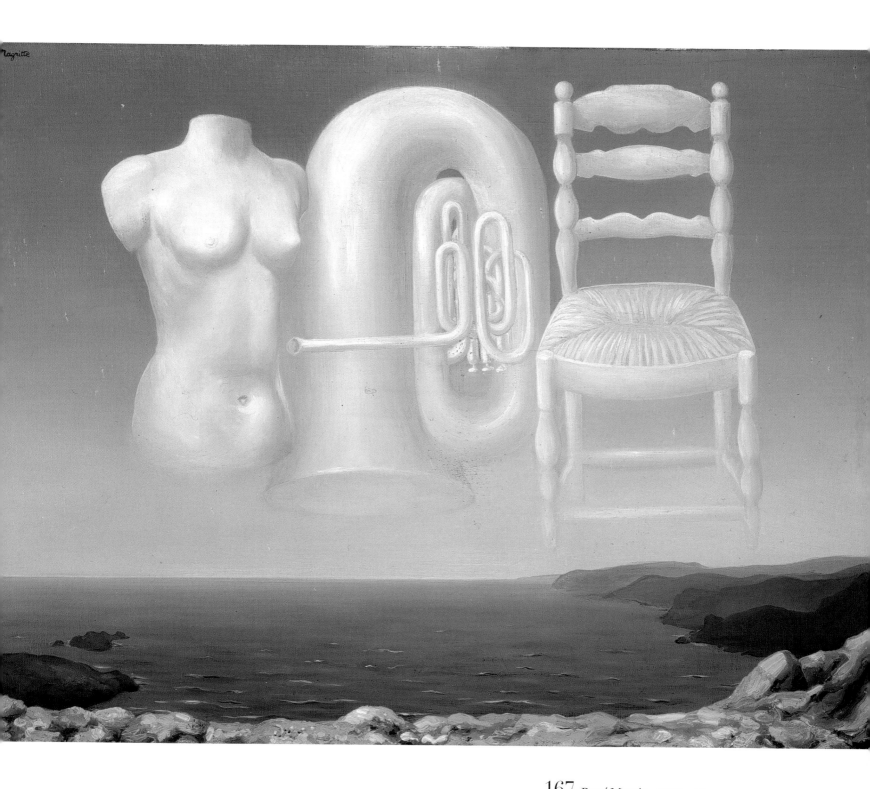

167 René Magritte 1898–1967
Le Temps Menaçant [Threatening Weather], 1929

Oil on canvas · 54 × 73cm
Purchased with assistance from the Heritage Lottery Fund and
the National Art Collections Fund 1995 [GMA 3887]

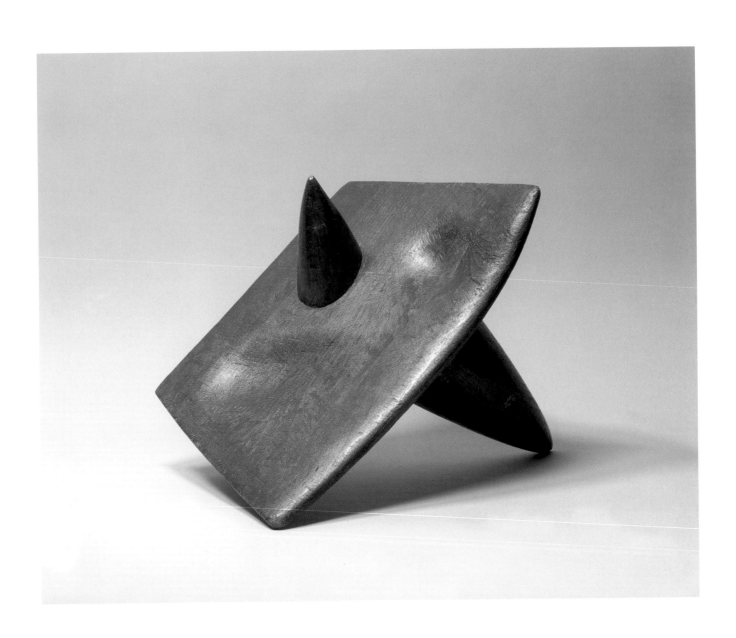

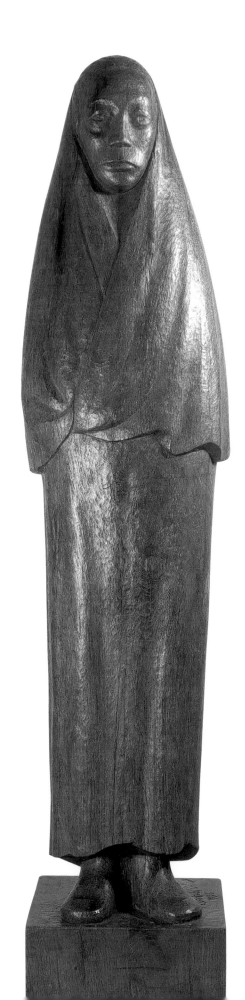

168 Alberto Giacometti 1901–1966
Objet désagréable à jeter
[Disagreeable Object to be Thrown Away], 1931

Wood · 19.6 × 31 × 29cm
Purchased 1990 [GMA 3547]

169 Ernst Barlach 1870–1938
Das schlimme Jahr 1937
[The Terrible Year 1937], 1936

Wood (oak) · 142 × 31 × 28.5cm
Purchased with assistance from the National Art
Collections Fund (William Leng Bequest) 1987
[GMA 3036]

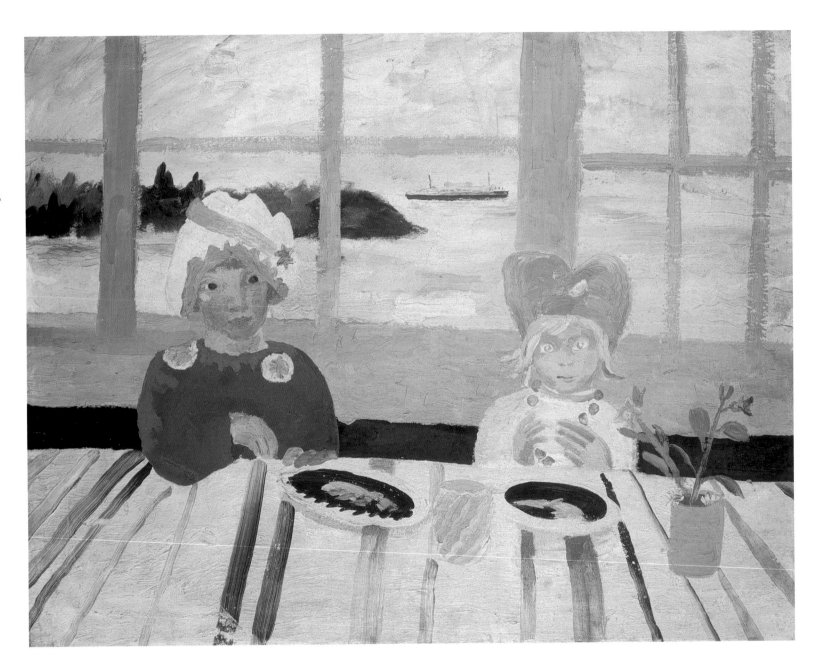

170 Winifred Nicholson 1893–1981
Jake and Kate on the Isle of Wight, 1931

Oil on canvas · 68.5 × 89cm
Presented by the trustees of Winifred Nicholson's estate
in accordance with her wishes 1985 [GMA 2964]

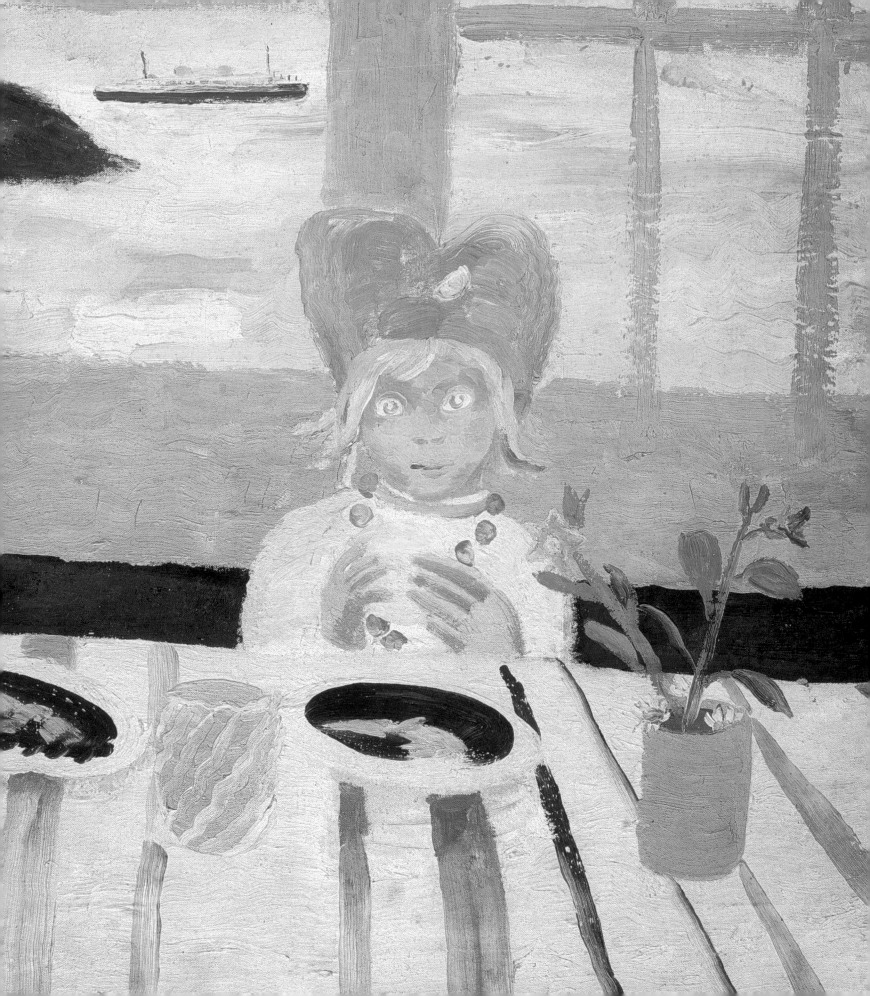

171 Marcel Duchamp 1887–1968
La Boîte-en-Valise [Box in a Suitcase],
1935–41

Leather-covered case containing miniature
replicas and photographs of Duchamp's
works (De-luxe edition no. 2/20)
10 × 38 × 40.5cm (closed)
Presented by Gabrielle Keiller 1989
[GMA 3472]

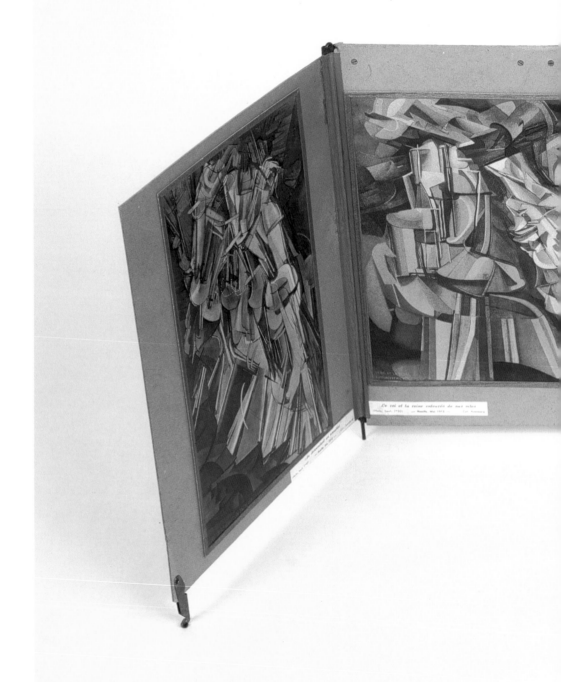

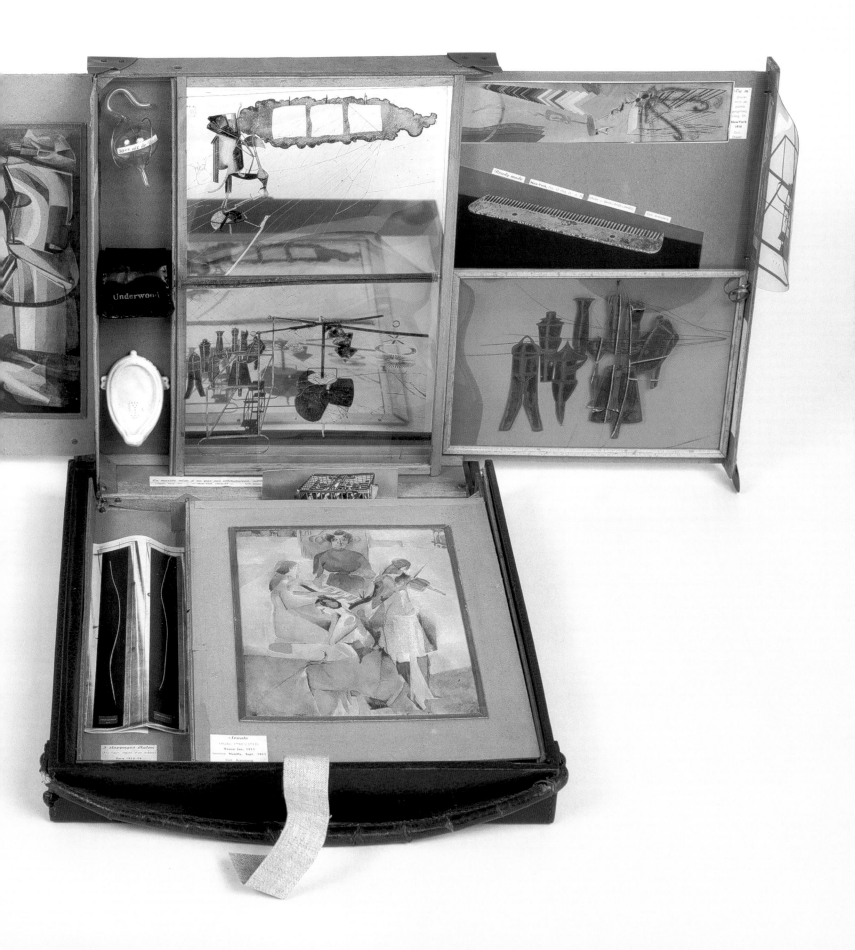

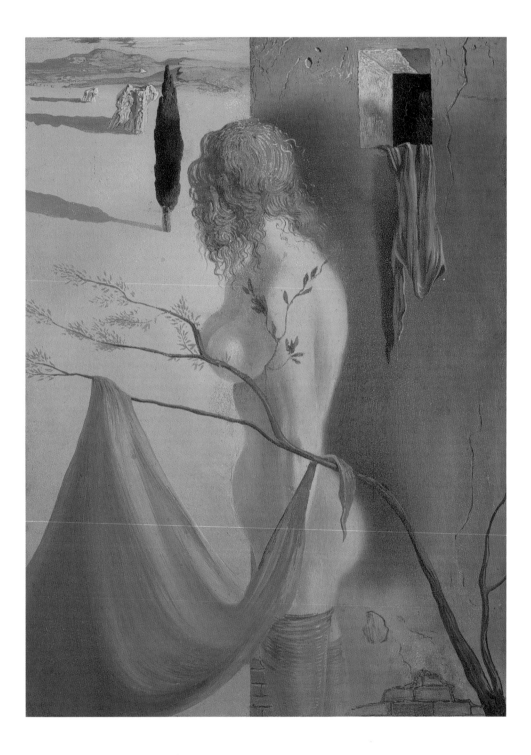

172 Salvador Dalí 1904–1989
Le Signal de l'angoisse [The Signal of Anguish],
1936

Oil on wood · 21.8 × 16.2cm
Bequeathed by Gabrielle Keiller 1995 [GMA 3956]

173 René Magritte 1898–1967
La Représentation [Representation], 1937

Oil on canvas laid on plywood · 48.8 × 44.5cm
Purchased 1990 [GMA 3546]

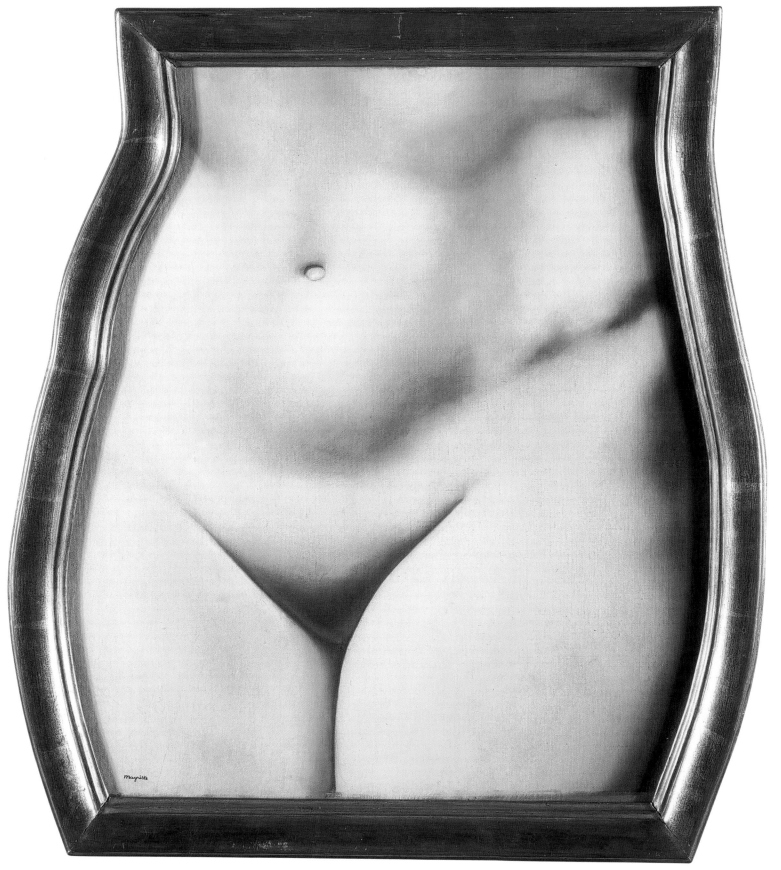

222

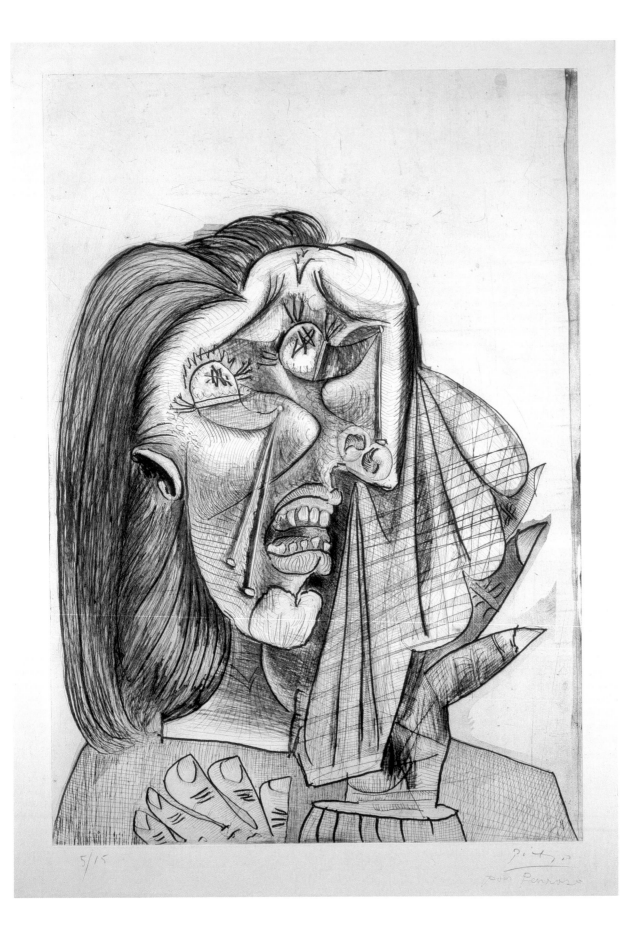

5/15

174 Pablo Picasso 1881–1973
La Femme qui pleure I [Weeping Woman I], 1937

Drypoint, aquatint and etching on paper, 7th state (5/15) · 77.2 × 56.9cm
Accepted by HM Government in lieu of Inheritance Tax from the estate of Joanna
Drew and allocated to the Scottish National Gallery of Modern Art 2005 [GMA 4774]

175 Pablo Picasso 1881–1973
La Fin d'un monstre [The Death of a Monster], 1937

Pencil on paper · 38.6 × 56.3cm
Purchased with assistance from the Heritage Lottery Fund and the
National Art Collections Fund 1995 [GMA 3891]

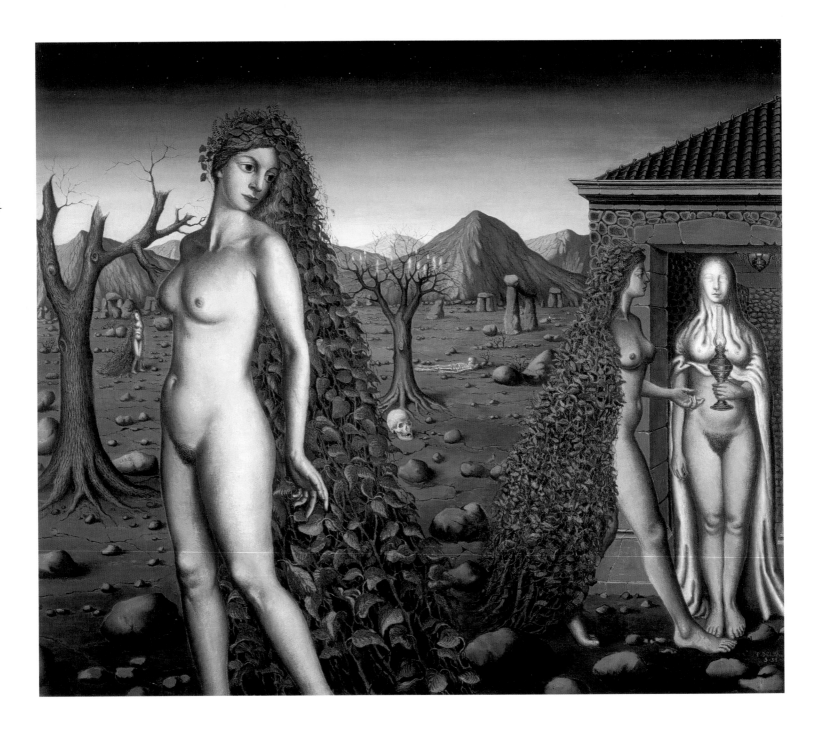

176 Paul Delvaux 1897–1994

L'Appel de la nuit [The Call of the Night], 1938

Oil on canvas · 110 × 145cm · Purchased with assistance from the Heritage Lottery Fund
and the National Art Collections Fund 1995 [GMA 3884]

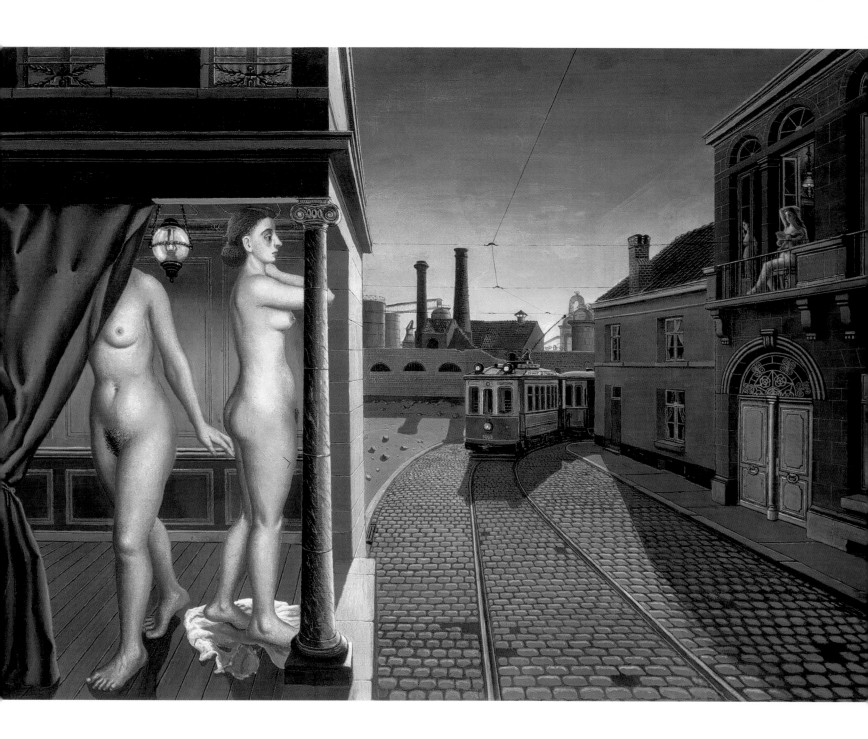

177 Paul Delvaux 1897–1994
La Rue du tramway [Street of the Trams], 1938–9

Oil on canvas · 90.3 × 131.3cm
Bequeathed by Gabrielle Keiller 1995 [GMA 3962]

178 Oskar Kokoschka 1886–1980 *Prague, Nostalgia*, 1938

Oil on canvas · 56 × 76cm · Accepted by HM Government in lieu of Inheritance Tax from the estate of Lord Croft and allocated to the Scottish National Gallery of Modern Art 2000 [GMA 4322]

179 Fernand Léger 1881–1955 *Etude pour 'Les Constructeurs': l'équipe au repos*
[Study for 'The Constructors': The Team at Rest], 1950

Oil on canvas · 162 × 129.5cm · Purchased 1984 [GMA 2845]

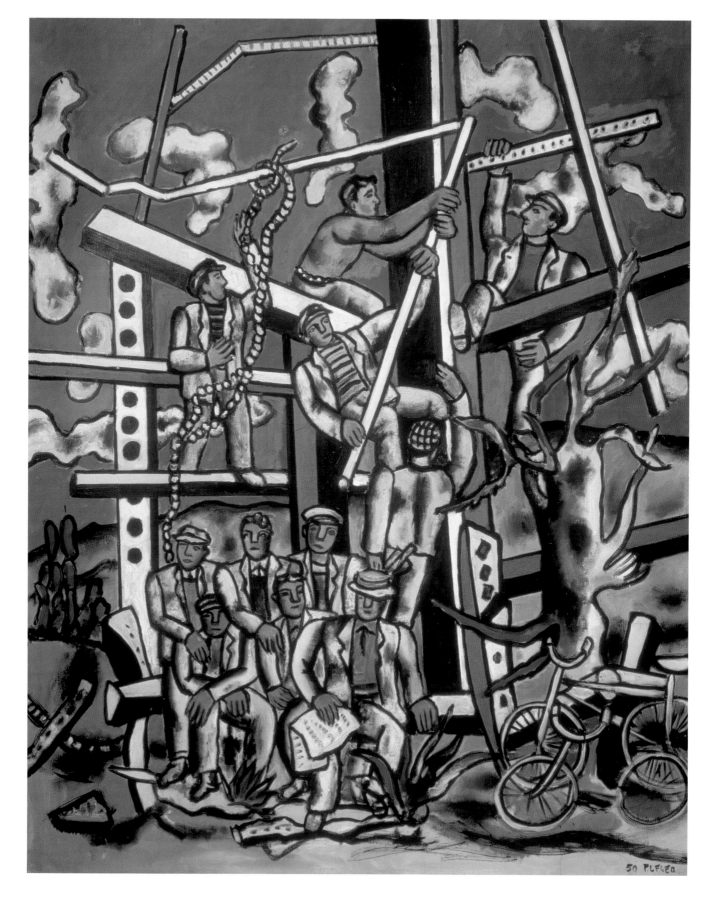

180 Henry Moore 1898–1986
The Helmet, 1939–40

Lead · 29.1 × 18 × 16.5cm (excluding base)
Purchased with assistance from the
National Heritage Memorial Fund, the
National Art Collections Fund (Scottish
Fund) and the Henry Moore Foundation
1992 [GMA 3602]

181 Francis Bacon 1909–1992
Figure Study I, 1945–6

Oil on canvas · 123 × 105.5cm
Accepted by HM Government in lieu of
Inheritance Tax from the estate of
Gabrielle Keiller and allocated to the
Scottish National Gallery of Modern Art
1998 [GMA 3941]

182 Alan Davie b.1920 *Blue Triangle Enters*, 1953

Oil on masonite (board) · 153 × 192cm · Purchased with assistance from the Heritage Lottery Fund
and the National Art Collections Fund 1997 [GMA 4111]

183 Sir Eduardo Paolozzi 1924 – 2005 *St Sebastian I*, 1957

Bronze · 214.5 × 72 × 35.5cm · Purchased 1993 [GMA 3700]

232 184 John Bellany b.1942
Allegory, 1964

Oil on hardboard (triptych)
212.4 × 121.8cm · 213.3 × 160cm
212.5 × 121.8cm
Purchased 1988 [GMA 3359]

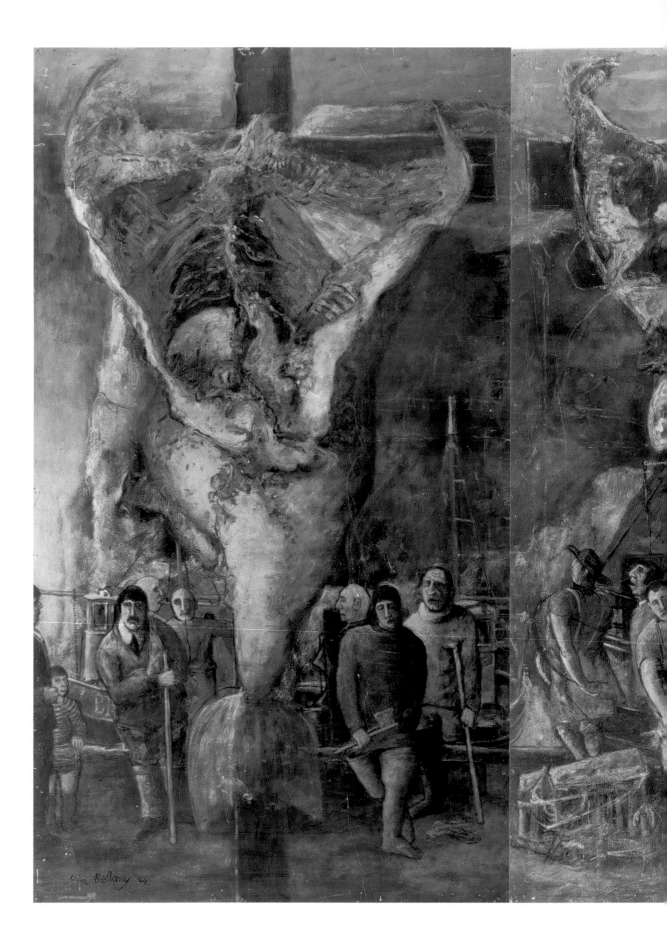

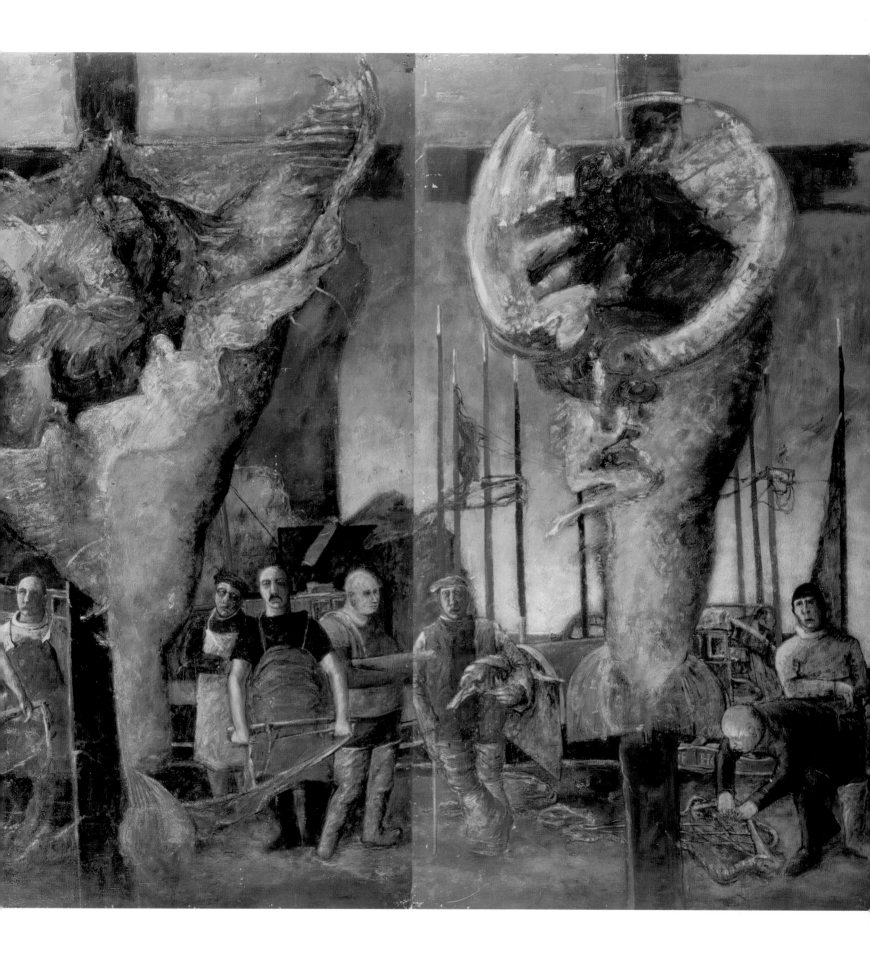

185 Joseph Beuys 1921–1986 *Sled*, 1969

Wooden sled, felt, belts, flashlight, fat and rope · 35 × 90 × 35cm
Purchased with assistance from the National Heritage Memorial Fund
and the National Art Collections Fund 2002 [GMA 4545]

186 Joseph Beuys 1921–1986 *Felt Suit*, 1970

Felt, sewn, stamped · 170 × 60cm (approx)
Purchased with assistance from the National Heritage Memorial Fund
and the National Art Collections Fund 2002 [GMA 4552]

234

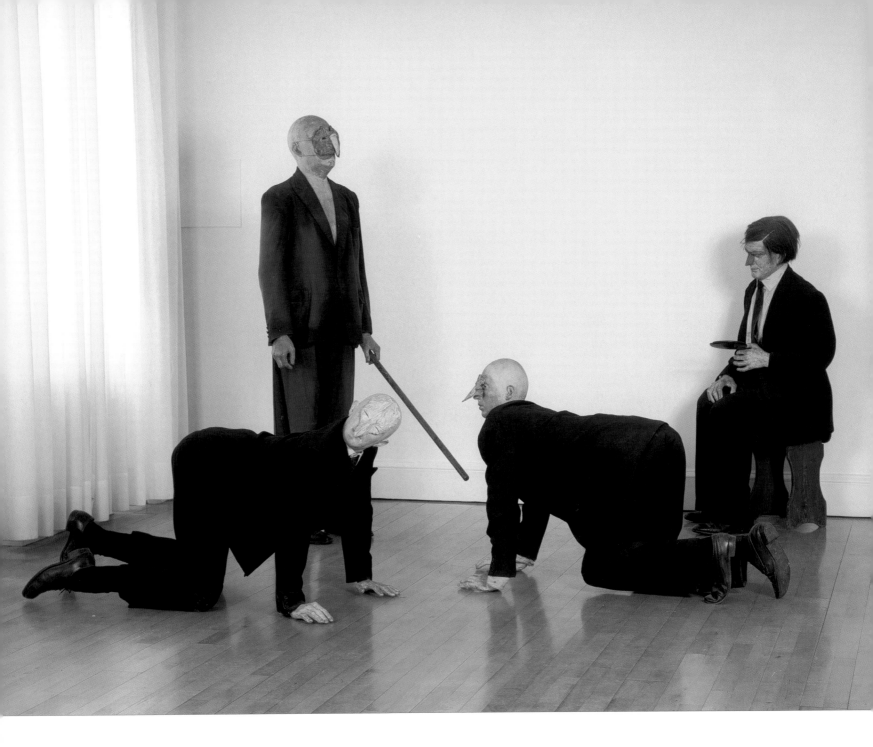

187 John Davies b.1946 *For the Last Time*, 1970–2

Mixed media · four figures maximum height of each 181cm · 137cm · 82cm · 75cm
Purchased 1989 [G M A 3450]

188 Ian Hamilton Finlay b.1925 *Even Gods have Dwelt in Woods*, 1976
Stone · 23 × 28.1 × 7.4cm
Scottish Arts Council Collection; presented 1997 [GMA 4180]

189 Andy Warhol 1928–1987
Portrait of Maurice, 1976

Synthetic polymer paint and silkscreen ink on canvas · 65.8 × 81.4cm
Bequeathed by Gabrielle Keiller 1995 [GMA 4095]

190 Georg Baselitz b.1938
Ohne Titel
[Untitled (Figure with Raised Arm)],
1982–4

Wood, painted · 253 × 71 × 46cm
Purchased with assistance from the
National Art Collections Fund (William
Leng Bequest) 1989 [GMA 3530]

191 Steven Campbell b.1953 *A Man Perceived by a Flea*, 1985

Oil on canvas · 272 × 242cm · Purchased 1987 [GMA 3049]

192 Tony Cragg b.1949 *Kahzernarbeit*, 1985

Wooden coat-stand with brass hooks; plastic waste-pipe elements; suitcase in imitation leather with metal hinges and fixtures; metal milk churn with plastic top and string · 184.5 × 259 × 103cm

Purchased 1999 [GMA 4293]

242

193 Lucian Freud b.1922
Two Men, 1987–8

Oil on canvas · 106.7 × 75cm
Purchased 1988 [GMA 3410]

194 John Byrne b.1940
Robbie Coltrane, b.1950,
(as Danny McGlone), 1988

Oil on board · 30 × 21.3cm
Purchased 1998 [PG 3116]

244

195 Michael Andrews 1928–1995

Edinburgh (Old Town), 1990–3

Oil on canvas · 183 × 274.3cm
Purchased with assistance from the National Art
Collections Fund 1993 [G M A 3697]

246

196 Glenys Barton b.1945
Jean Muir (1928–1995) 1991

Ceramic with glazed slip · 44 × 19 × 12cm
Purchased 1994 [PG 2939]

197 Damien Hirst b.1965
Beautiful C Painting, 1996

Gloss household paint on canvas
182.6cm diameter
Purchased 2002 [GMA 4477]

198 Sir Howard Hodgkin b.1932 *Memories*, 1997–9

Oil on wood · 119 × 175.7cm
Purchased 2005 [GMA 4761]

199 Sir Eduardo Paolozzi 1924–2005 *Vulcan*, 1998–9

Welded steel · height 730cm
Commissioned 1999 with assistance from the Patrons of the
National Galleries of Scotland [GMA 4285]

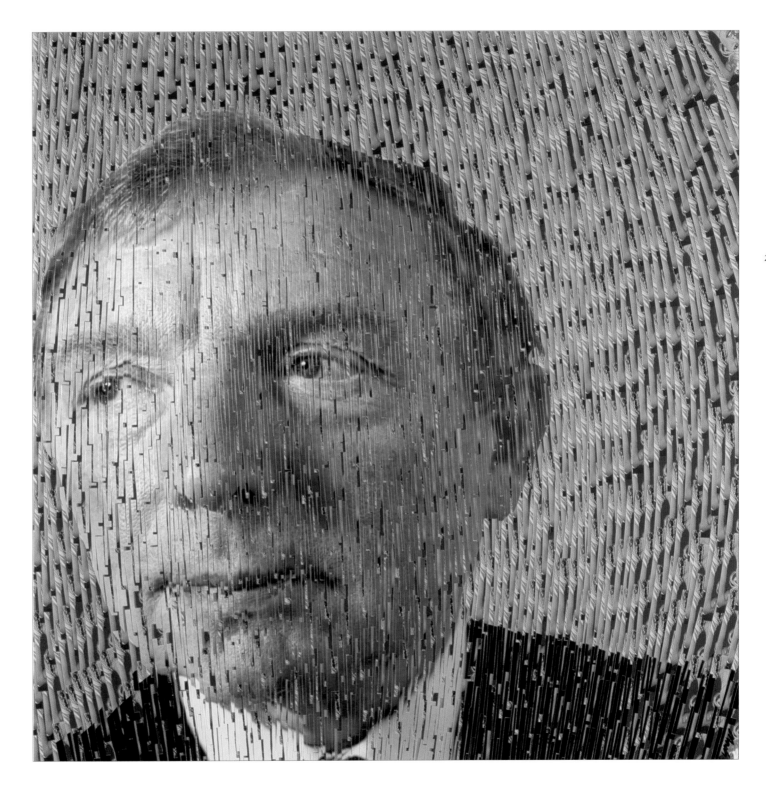

200 Alan Davie b.1920 *The Magician's Mirror No. 3 [Opus 1450]*, 2000

Oil on canvas · 183 × 152cm · Presented by the artist 2000

201 David Mach b.1956 *Sir Tom Farmer (born 1940)*, 1999

Postcard and photograph collage · 135.9 × 135.9cm · Purchased by commission 1999 [PG 3172]

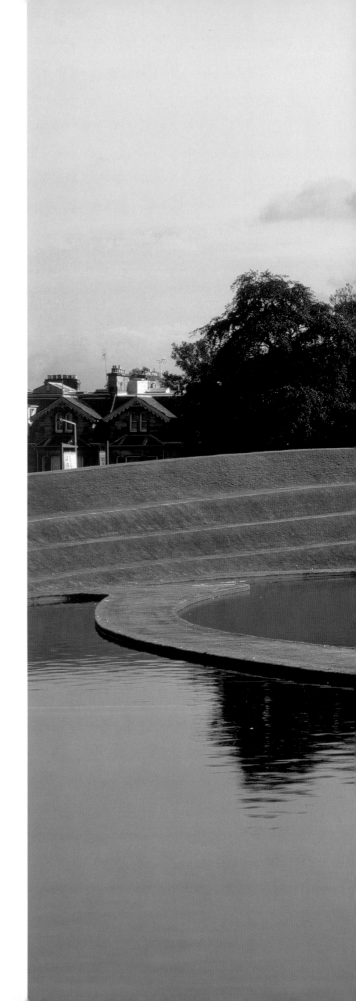

202 Charles Jencks b.1939
Landform UEDA, 2001–3

Commissioned for the grounds of the Scottish
National Gallery of Modern Art 2001

252

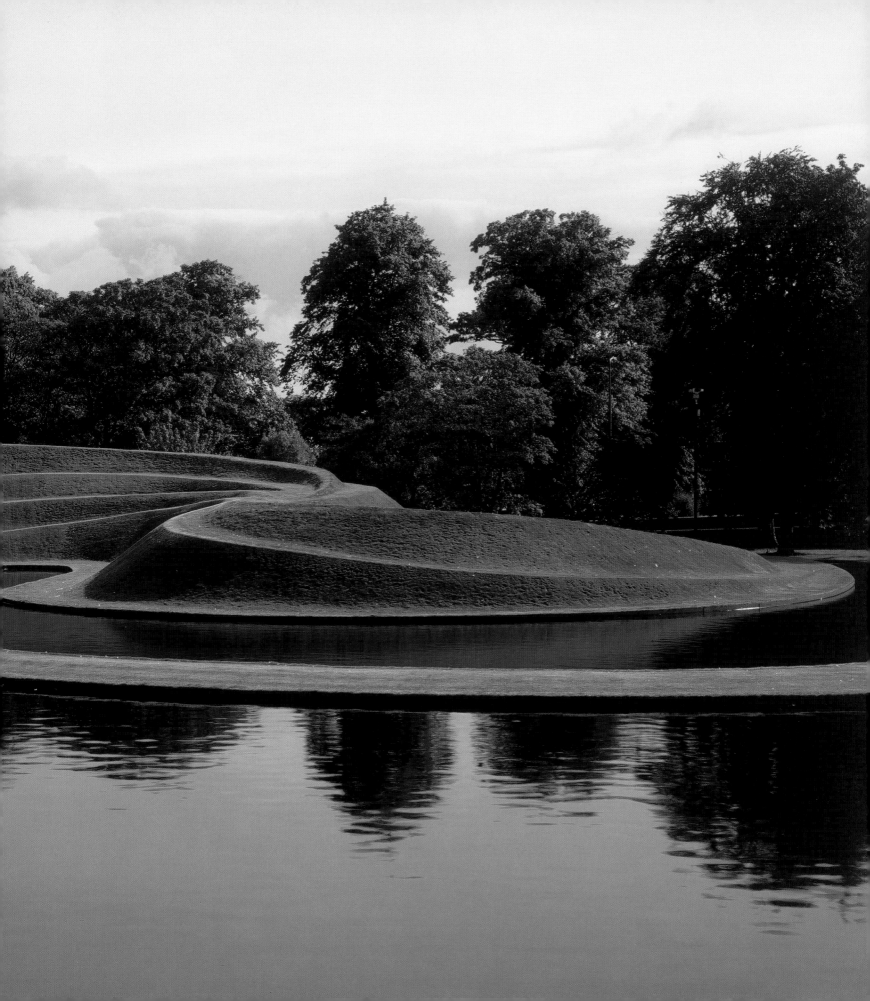

203 Bill Viola b.1951 *Surrender*, 2001

Diptych, video on plasma flat panel displays · overall size 206.5 × 63 × 22.5cm
Presented by Anne and Anthony d'Offay through the National Art Collections Fund 2003
[GMA 4683]

204 Mona Hatoum b.1952 *Slicer*, 1999

Varnished steel and thermoformed plastic · 104 × 117.5 × 93cm
Purchased with assistance from the National Art Collections Fund 2005 [GMA 4782]

Photographic and Copyright Credits